# CHILKOOT

**University of Calgary Press**
**Parks and Heritage Series**
ISSN 1494-0426

# CHILKOOT

## AN ADVENTURE IN ECOTOURISM

by
Allan Ingelson,
Michael Mahony, and Robert Scace

University of Calgary Press and University of Alaska Press

University of Calgary Press
2500 University Drive N.W.,
Calgary, Alberta, Canada
T2N 1N4
(403) 220-7578
www.uofcpress.com

University of Alaska Press
P.O. Box 756240
Fairbanks, Alaska, U.S.A. 99775-6240
orders.uapress@uaf.edu
(907) 474-5831
(888) 252-6657
www.uaf.edu/uapress

**National Library of Canada Cataloguing in Publication Data**

Ingelson, Allan, 1958-
Chilkoot

(Parks and heritage series, ISSN 1494-0426 ; 4)
Includes bibliographical references and index.
ISBN 1-55238-055-6 (bound). – ISBN 1-55238-030-0 (pbk.) University of Calgary Press
ISBN 1-889963-55-0 (bound). – ISBN 1-889963-54-2 (pbk.) University of Alaska Press

1. Chilkoot Trail – Guidebooks. 2. Chilkoot Trail – History. I. Mahony, Michael, 1957-
II. Scace, Robert C., 1942- III. Title. IV. Series.
FC4045.C45I53 2001      971.9′1      C2001-910713-7
F1095.C45I53 2001

Canada We acknowledge the financial support of the Government of Canada through
the Book Publishing Industry Development Program (BPIDP) for our publishing
activities.

Printed and bound in Canada by Friesens Corporation
∞ This book is printed on acid-free paper.
Book design by Cliff Kadatz.

The Canada Council for the Arts
Le Conseil des Arts du Canada

# CONTENTS

# List of Figures

# ACKNOWLEDGEMENTS

We would like to thank Mrs. Kitty Grant and Ms. Heather Jones (Coordinator), Carcross-Tagish First Nation; Deborah DeCoste and Mr. Michael Evick, Curator (retired), Glenbow Alberta Institute; Mr. Tom Elliott, Mr. Glenn Kubian, and Mr. David Neufeld, Parks Canada; Karl Gurcke and Tim Steidel, U.S. National Park Service; Ms. Marilyn Croot, Sun Mountain Graphics; Dr. Ashis Gupta, Dr. Anne Kleffner, Dr. Brent Ritchie, and Mr. Lorne Sheehan, Faculty of Management, University of Calgary; Mr. John King and Mr. Walter Hildebrandt, University of Calgary Press; Mr. Leslie Adler, Ms. Karen Amonson, Mr. Kevin Brayford, Ms. Lorna Espanto, Mrs. Dora Ingelson, Ms. Willa Ingelson, Mr. David Ingelson, Ms. Michelle Telford, and Ms. Makiko Yamaguchi.

Permission to reproduce historical photographs has been granted courtesy of the following institutions:

1. *American Museum of Natural History:* p. 34 (#13989).
2. *Yukon Archives:* p. 45 (E.A. Hegg #2561), p. 85 (Frank Charman 89/64 #13), and p. 91 (MacBridge Museum #3567).
3. *Alaska State Library,* Juneau: p. 50 (PCA87-675) and p. 58 (PCA87-664).
4. *Glenbow Archives:* p. 59 (NA2615-7) and p. 70 (NA2615-11).
5. *Library of Congress:* p. 57 (US262 47977).
6. *University of Washington Libraries,* Special Collections: p. 56 (LaRoche #2030), p. 60 (LaRoche #2035), p. 63 (Hegg #73A), p. 66 (Child #11), and p. 84 (Hegg #460B).
7. *National Archives of Canada:* p. 71 (PA162903) and p. 88 (PA180745).

Figures 11 and 13 are reproduced from *The Alaska Boundary Dispute: A Critical Reappraisal* (1972), by Norman Penlington, courtesy of Patricia B. Marmon.

*They start early from Tagish, they go across Bennett. From Bennett they go across early to make other side, Dyea. The kids and all, walking, eh, snowshoes, pulling sleighs, things like that, winter time. In the summer time they got dog, dog pack, kids walking. But winter time they say it's really hard, it's really cold in the winter time...over that mountain. (Mrs. Lucy Wren, Carcross/Tagish First Nation. Chilkoot Trail Oral History Project, cited Sheila Greer, 1995)*

*I have roughed it for the past fifteen years in Siberia, in Borneo and in Chinese Tartary, but I can safely describe the climb over the Chilkoot as the severest physical experience of my life (Henry DeWindt, 1896)*

*The Chilkoot Trail is known around the world. The challenge we face, as with all the special places which make up this planet, is to keep the legacy of the past, and its lessons for the future, alive and healthy in the Chilkoot. It is only through understanding and care by present users, a continuing respect of all the different values resting in this special place, and an ongoing concern for the future, that the Chilkoot will remain a healthy and valued region (David Neufeld and Frank Norris, 1996)*

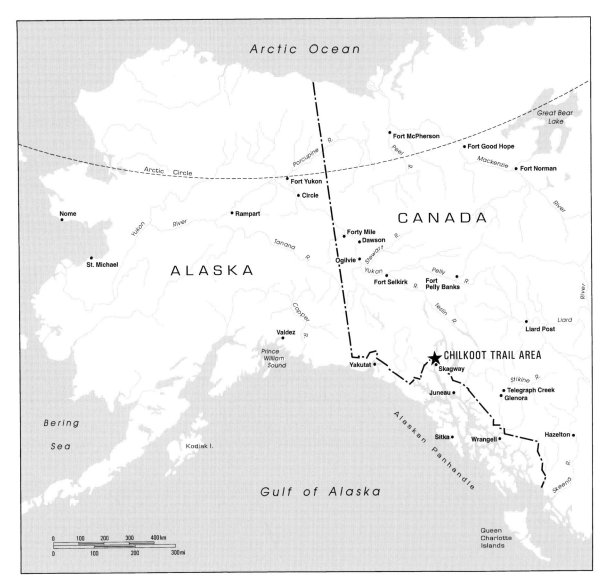

Fig. 1. Northwestern North America and Chilkoot Trail Location.

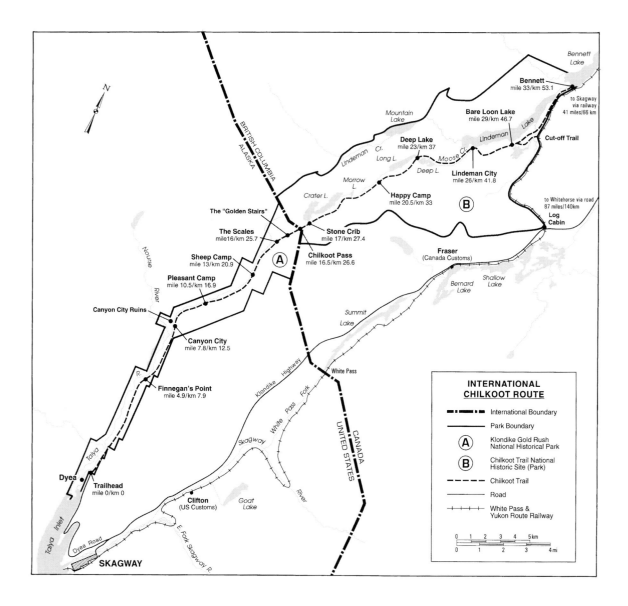

Fig. 2. The International Chilkoot Route.

# INTRODUCTION

## Unveiling a Triptych

The nineteenth century was ebbing away when a remarkable event suddenly and forever enshrined the Chilkoot Trail in the annals of North American adventure and folklore. For an eyeblink in history at the height of the Klondike Gold Rush, citizens from around the world joined in an international stampede, a human river flowing to the gold fields of Canada's Yukon Territory. En route, they trudged back and forth along the Chilkoot Trail in squelching mud and harsh winter snows, scrambling their supplies from tidewater in Alaska to the alpine heights of Chilkoot Pass and into British Columbia near the border of the northern territory. Their efforts have been immortalized in word and picture, no more so than those famous photographs that starkly record a dark thread of Klondikers struggling up the "Golden Stairs" to Chilkoot summit midst a white ocean of snow and cold.

These gold seekers brought instant international focus and everlasting fame to a challenging walking route, which for centuries was known intimately to First Nations people. Yet in the wake of the frenzy of 1897–98, the trail would largely fall silent until becoming a magnet for hikers in the late twentieth century. Today, the route again hosts visitors from the global village, drawn to a stunning landscape rich in cultural heritage, internationally protected through contiguous park areas, and a challenging recreational experience in an environment perpetually unforgiving to the unwary and unprepared. With its unique mix of natural and cultural resources, diverse scenery, limitations upon use and its protected status, the Chilkoot Trail now represents one of the great ecotourism experiences on the continent.

Our book is a triptych, a three-part written and visual exploration of the trail by three people of diverse backgrounds. Just as Wallace Stegner presented a history, story, and memory of the last plains frontier in his incomparable *Wolf Willow,* so in more humble vein we present the Chilkoot Trail. In this instance, however, our goals are to reflect on the route as epitome of that world-wide phenomenon – the ecotourism experience; to convey a sense of the physical grandeur and long history of the place, and to share our contemporary experience in word and picture. These goals are intertwined. Ecotourism is validated by personal experiences and appropriate behaviours that enhance knowledge, understanding, and empathy for a place. The presence of visitors as ecotourists must be borne by host landscape and human community without irreparable ecological, social, or economic cost to that locale. The institutional arrangements we create may reinforce our perceptions and responses, of course, as reflected for example in park status with its prescribed uses. Overall, it is what we value in a landscape and how we respond individually, as communities and institutionally, to an area's heritage attributes that determine the success of ecotourism as a defined activity. The Chilkoot Trail provides a spectacular opportunity to examine what ecotourism can be; to learn about Nature's storehouse there and human responses over time.

We provide both an introduction to the area for those who want to hike the trail and a vicarious experience for the armchair traveller. Our book originated in a search by Allan, his wife Debbie, and Mike for an illustrated guide to the trail prior to their 1997 trip. None could be found. Historical information other than for the well-documented gold rush period seemed scattered too. So was born the idea for a volume that would place the trail in historic context and provide a photo essay to convey the essence of the Chilkoot Trail landscape today.

That the Chilkoot presents the credentials of an ecotourism experience soon became apparent to Allan and Mike. Thus Bob, with a professional background in geography, parks, and tourism, was

invited to join the team. Bob hiked the Chilkoot in '98 (centennial year 1998, that is) and, to the chagrin of the others, could claim he had wolfed down pancakes in Bennett made from sourdough starter originally packed over the Chilkoot Pass a hundred years before his own lakeside breakfast!

All of us had travelled an international route; Chilkoot Pass lies on the boundary between the United States and Canada. We had passed from the Panhandle of the State of Alaska into the smaller and less-well-known panhandle of the Province of British Columbia. Had we followed the Klondikers' route along Lake Bennett to the small community of Carcross, we would have crossed 60 degrees North and into yet another jurisdiction – the Yukon Territory. Visitors to the region may find this convoluted political geography to be confusing on the ground without map in hand. Even then, there may be need to stop and think, particularly on matters of customs and immigration and converting from miles to kilometres and vice versa. Advance planning really helps in these matters!

Today's boundary was in dispute for decades after Russia ceded Alaska to the United States in 1867. For a time, Canadian and British interests placed all of the Chilkoot in Canada, as reflected for example in George Dawson's map of 1887 and the 1898 map provided to a Joint High Commission by British Commissioners. Eventually, however, the decision of the Alaskan Boundary Tribunal of 1903 would fix the boundary at Chilkoot Pass. An emphatic statement on Canadian sovereignty already had been made there a few years earlier by the North-West Mounted Police each time gold seekers reached the summit and sought entry from the United States.

We begin the triptych by presenting *Chilkoot: An Adventure in Ecotourism* as an ecotourism experience – not as the term is often misused, but truly reflecting key characteristics of modern ecotourism. Part One then, shows how the trail is an outstanding example of international ecotourism. Though adventure is involved, the Chilkoot is much more than adventure tourism. Rather, it provides for a unique interpretive blend of natural and cultural heritage, controlled numbers of visitors on the

trail and other management strategies designed to enhance personal experience and to avoid degradation of landscape and loss of artifacts. There is involvement of the local community in the management process, notably First Nations people, and co-operation among no less than five national, provincial, territorial, and state governments to achieve mutual objectives for the heritage area.

These contemporary collaborative arrangements and earlier international jousts and boundary-making endeavours follow an extended period of trail use by aboriginal people. In Part Two, we describe this long record of human use and identify the Chilkoot as a key route for coastal native people to travel and trade with those inhabiting inland environments. The coastal Tlingit Raven clan travelled the Chilkoot Trail twice or more in a year – winter and summer – to trade with principally the Tagish and Southern Tutchone people of today's northern British Columbia and southern Yukon. The Russians in the 1700s would spearhead contacts from beyond the region, followed variously by the Hudson's Bay Company, independent free traders, the American North-West Company, and prospectors from just about everywhere. Eventually would come the recreationists. Interestingly, access by modern ecotourists to and from the interior along the Chilkoot, now managed and monitored by national park authorities, recalls a time when the Tlingit similarly controlled movements across the Chilkoot and other passes in the region. Rarely has there been a time in history when control of the Chilkoot route has not been exercised by one group or another.

In Part Three, in a word and picture essay, we retrace our steps northwards, from the trailhead in the Alaska temperate rain forest, upward through subalpine and alpine ecosystems and over the Chilkoot summit into the Canadian boreal forest. This is the direction followed by most hikers so that they may emulate the footsteps of 1897–98 and relive the sequence of gold rush activities and visualize their effects upon the landscape. Each section of the modern trail is photographed and described in terms of its natural history, the human record, and general trail conditions. We say "modern" because today's

trail is really part of a broader route or corridor used by earlier travellers. Hitherto, winter travel might happen along the frozen Taiya River or across frozen lakes. Summer travel might follow routes higher on the valley slope and here and there up the rock-pocked surface of the Long Hill and boulder-dominated ascent to Chilkoot summit. Even today's trail, laid out in the 1960s, is likely to involve summer travel over snow patches with periodic rerouting by parks authorities to reduce damage to fragile ground cover or artifacts.

We hope this three-part presentation will enhance the reader's appreciation of the beauty, the historical significance, and the continuing physical challenge presented by one of the most famous trails in the world.

## Hiking the Trail Today: An Overview

One century after the gold rush, the trail provides outstanding scenery, a physical challenge, and an educational opportunity. There are artifacts, interpretive signs, and exhibits in both the American Klondike Gold Rush National Historical Park and in the Canadian Chilkoot Trail National Historic Site (also known as a National Historic Park). Visitors may photograph, but neither collect nor disturb, the artifacts strewn about in this unique outdoor historical museum. When hiking the trail, visitors encounter a variety of trail conditions that reflect their passage through several ecosystems, each with its particular flora and fauna. During summer use, the trail is well marked and is patrolled by rangers of the U.S. National Park Service along the Alaska section and by Parks Canada wardens in British Columbia. Between three and four thousand backpackers hike over Chilkoot Pass annually.

Some visitors complete day hikes on short sections of the trail; however, to complete the passage over Chilkoot Pass, a backpacking trip of three to five days should be anticipated. There is no customs station at the border on the trail; a backcountry permit is required to camp along the thirty-three miles (53.1 km) of trail. Designated campsites must be used and all litter be carried out by backpackers. The National Park Service and Parks Canada maintain an International Trail Centre in Skagway, Alaska, from which information on trail conditions and permits can be obtained.

Conditions along the trail vary according to the weather and time of year. Indeed, preparing for and responding to a spectrum of weather conditions is as much part of the Chilkoot experience as the physical effort involved. Waterproof boots, tents, and other pieces of rain gear are essential as rain is frequent along the trail and the weather can change very quickly. On the days we climbed over the Chilkoot Pass in 1997 and 1998, there was an abrupt change from a hot cloudless morning to freezing drizzle in the afternoon. At higher elevations near the summit, snow may be encountered at any time of the year. Warm clothing is essential for a safe and enjoyable trek. In this regard, it is very important to know that along the trail there is an elevation gain of 3,739 feet (1,140 m) for the northbound hiker. The trail is strenuous. Backpackers should be in excellent physical condition.

There is an ample water supply in creeks along the trail; hikers are advised, however, to boil, filter, or properly treat all drinking water. As open fires are not allowed along the trail, a light, portable stove is essential.

Backpackers usually camp at Sheep Camp before attempting to climb to Chilkoot Pass. The ground covered on the day on which the summit is approached is the most physically demanding along the trail. From Sheep Camp the trail rises more than 2,500 feet (762 m) in less than 3.5 miles (5.6 km). Artifacts discarded by Klondike gold seekers during the mad rush for gold are noticeably concentrated along this section of the trail. The final push to the summit requires a demanding scramble upwards

through a talus slope dominated by huge boulders. Averaging 35 degrees over the whole talus slope, the Golden Stairs as they became known in the winter of 1897–98, attain a maximum slope angle of 45 degrees near the summit.

From the Chilkoot Pass to Happy Camp, the trail gradually descends in open country, passing by Crater Lake and the watery sliver of Morrow Lake. The trail continues from Happy Camp to Lindeman City alongside Long Lake and Deep Lake. Lindeman City is located at the south end of the lake with the same name. After leaving Lindeman City, most backpackers continue on to Bennett. Some will use a cut-off trail near Bare Loon Lake to reach the railroad and reduce their travel on the main trail by four miles (6.4 km). Different modes of transport can be used by backpackers to return to Skagway or proceed to Whitehorse, by foot and road and by train and boat at certain times of the year.

We recommend that anyone planning to hike the trail obtain and carry with them a current copy of the pamphlet/topographic map *A Hiker's Guide to the Chilkoot Trail*, together with the *Chilkoot Trail National Historic Site Preparation Guide*, available from the respective national park authorities. At the conclusion of this book (Appendix A), we provide information that readers should review before embarking on a hike on the Chilkoot Trail. We want your international ecotourism experience to be safe and enjoyable!

*Part One*

# THE CHILKOOT AND ECOTOURISM

# THE
# CHILKOOT AND ECOTOURISM

## Getting a Fix on Ecotourism

Many who hike the Chilkoot Trail consciously think of themselves as participants in that global phenomenon, the ecotourism experience. We certainly did, and we believed, with good reason! Certainly there is consumption of energy resources to convey hikers to and from a location that is geographically remote for most trail users.[1] On site, however, are to be found key ingredients of the ecotourism experience – limited low user impact on the resource base fostered through limitations on access and residency, a unique fusion of natural and cultural heritage to be absorbed at trailside, established bilateral arrangements for environmental conservation and various benefits to the local community. Add to these a mix of personal challenge, physical risk, and self-mastery – more the hallmark of adventure tourism – and the raw emotive beauty and stark history of the place and the international appeal of the Chilkoot is readily apparent.

To appreciate the contribution of the Chilkoot to regional ecotourism and to understand how the rewards for today's visitors may be extended far into the future, we must reflect first on the term "ecotourism" and then on its specific application to the trail. It is said that:

---

[1]   Eighty percent of visitors are from Canada and the United States, the portion making up residents of Alaska and Yukon accounting for nineteen percent; the remaining twenty percent of all visitors is predominantly from Europe, notably Germany.

*Ecotourism, more than any other tourism activity, is sustainable development. As a corol-*
*lary, ecotourism is the most vulnerable of tourism activities; it has the most to lose when*
*practiced in an ill-conceived, uncontrolled, and insensitive manner. Accordingly, it is*
*now, and will continue to be, intensely scrutinized to justify its raison d'être and to con-*
*firm its on-the-ground policies, guidelines and practices. (Scace et al., 1992)*

The stakes are huge. The world is on the move. The World Tourism Organization forecasts there will be over one billion international arrivals in the year 2010 and 1.6 billion by 2020 – nearly three times the 592 million international trips made in 1996. Travellers of the twenty-first century will go even farther from home, and the natural environment will be the key resource for the most popular tourist destinations. In 1996, for example, 20 million Canadians spent $11.0 billion (Cdn.) *in Canada* to pursue nature-related activities, of which $7.2 billion was spent on outdoor activities in natural areas (Federal Provincial-Territorial Task Force, 2000: iii). When addressed in the context of protected landscapes with unique heritage resources such as Canada's Chilkoot Trail National Historic Site and contiguous United States Klondike Gold Rush National Historical Park, ecotourism takes on even more profound meaning.

Ecotourism has been presented in many guises, to the extent that critics observe one can go anywhere, do anything, and sell it in the name of ecotourism (see, e.g., Wight, 1993). This despite so much effort to understand, to define, and to guide appropriate initiatives. To serious students and practitioners, ecotourism has become synonymous with a preferred ethic and more pronounced environmental consciousness among tourists. There are several characteristics to modern ecotourism as the following compilation adapted from the Canadian Environmental Advisory Council (CEAC, 1991) attests:

1. It does not degrade the resource. There is no consumptive erosion of the natural environment visited. Development takes place in an environmentally sound manner.

2. It must promote positive environmental ethics – fostering preferred behaviour in its participants towards the natural and cultural environment.

3. It concentrates on intrinsic rather than extrinsic values. Facilities and services may "facilitate" the encounter with the intrinsic resource; they never become attractions in their own right, nor do they detract from the natural attraction itself.

4. It is biocentric rather than homocentric in philosophy. Ecotourists enter the environment accepting it on its terms, not expecting it to change or be modified for their convenience (i.e., recognition of limits and application of supply-oriented management).

5. It must provide long term benefits to the environment, the local community, and the industry. The question of whether or not the environment (not just people) has accrued "benefits" may be measured in a range of ways – socially, economically, scientifically, managerially, or politically. If the environment has not at least achieved a net benefit toward its sustainability and ecological integrity, then the activity is not ecotourism.

6. It is a first-hand, participatory, and enlightening experience with the environment.

7. It has an "expectation of gratification" that is measured in terms of education and/or appreciation rather than in thrill-seeking or physical achievement.

8. It has a high cognitive and affective experiential dimension. Ecotourism involves a high level of preparation and knowledge from both leaders and participants, and the satisfaction derived from the experiences is felt and expressed strongly in emotional and inspirational ways.

Ecotourism signals a more friendly side of the wildland (green) tourism spectrum, and is a model to be followed by visitors and tourism developers alike. Since first coined in Mexico City in 1983, "ecotourism" has been variously defined. Much of the debate centres upon whether ecotourism should be active or passive. The former "avers that ecotourism should contribute to the improvement of the environment while fostering a positive environmental ethos among participants" (Weaver, 1997). The latter eschews the "transformational mandate," requiring only that environments have not been negatively affected by participants' activities. Many definitions of ecotourism are available, most of them subtle variations seeking to encompass the characteristics identified above.

We have selected the definition provided by CEAC (Scace et al., 1992):

> *Ecotourism is an enlightening nature travel experience that contributes to conservation of the ecosystem while respecting the integrity of host communities.*

This definition lends itself to the Chilkoot experience in several ways, as noted below, but at first sight may seem to be less compatible with the commemorative intent of the historic parks. The latter places a premium on the anthropocentric approach, viewing and interpreting the trail primarily in terms of human experience and values. That visitors respond very much to a combination of natural and cultural history triggers attests to the uniqueness of this place. Factors lending themselves to the ecotourism experience include the following:

- Users prepare themselves and secure advance information on physical, ecological, and cultural-historic characteristics of the trail, translating this background into a first-hand learning experience when they actually travel along the route.

6

- Park rules, management practices, and onsite facilities, together with behaviours required by trail users, reinforce protection and conservation, both to sustain the existing ecosystem and to preserve heritage artifacts for future ecotourists.

- The trail provides a net benefit in respect of regional sustainable development and ecological integrity, occupying a unique role in the regional assembly of state, provincial, and territorial borders, tourism nodes, and routes and modes of travel that link tidewater and coast range in Alaska to the interior plateaus and mountain ranges of British Columbia and Yukon.

- There is a wonderful fusion of education and appreciation with physical endeavour, an integrated experience that grows as travellers negotiate Pacific Northwest coastal rain forest, alpine tundra and boreal forest through the 3,739 vertical feet (1,140 m) and thirty-three miles (53.1 km) of trail from Dyea to Bennett.

- Though inevitably drawn to the dramatic and widely known events of 1897–98, which indelibly tie the Chilkoot to the Klondike Gold Rush, today's traveller cannot but sense a much larger canvas that captures landscape evolution, profound changes in climate and weather, and extended human use of a rare glacier-free corridor between salt water and the interior. Indeed, nature's reclaiming of an environment so bruised and depleted a century ago seems to mock the audacious presumptions of a fleeting, careless, and ill-equipped population consumed by the thought of gold. Neither can the visitor escape the irony that a route used for hundreds of years was abruptly abandoned in 1899, to remain almost silent until its resurrection in the 1960s as a summer hiking trail.

We suspect there to be a strongly anthropocentric focus in visitor planning for an initial Chilkoot experience. The local landscape at first is perceived as merely a formidable stage setting upon which vagaries of

**How Important Were Each of the Following?**

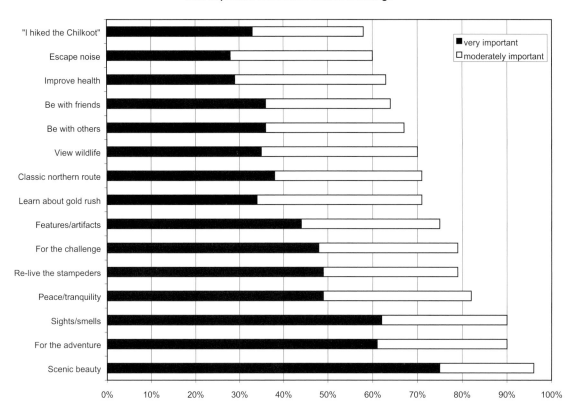

Fig. 3. Visitor Motivations for Hiking Chilkoot Trail. Source : Parks Canada 1998.

the human condition have been played out. Upon direct, individual experience on the trail, however, there emerges in the visitor recognition of the route as a profound expression of nature in its own right and a greater sense of the relationship over time between nature and the passage of successive human populations.

This view is borne out in a recent survey that included visitor motivations for hiking the Chilkoot Trail (fig. 3). The 1998 summer recreational use study reveals many reasons. The five most important reasons – scenic beauty, for the adventure, enjoying the sights/smells of nature, experiencing peace/ tranquility, and to relive the stampeders' hike – were very important to moderately important to eighty percent or more of respondents.

Ecotourism as sustainable tourism and ecotourists as its thoughtful ambassadors are held by many as ideal vehicles to promote global responsibility and action for environmental conservation. No-where can this thought be more happily entertained than in the circumstance of the international, transnational, or border park whose origins can be traced to other parts of North America and beyond early in this century (Thorsell, 1990). Today, such protected areas are held to possess three primary functions:

- the promotion of peace,
- protection and management of resources and environments, and
- preservation and enhancement of cultural values.

In sum, we view the Chilkoot Trail to be one of those rare places on Earth that can successfully incubate ecotourism and peace for humankind. It is therefore a model to be appropriately used and studied in the new millennium.

# The Chilkoot Trail

So profound was the overall impact of the Klondike Gold Rush upon the sensibilities of North Americans that within thirty years of its happening, there were calls for formal commemoration of an historic event. Recommendations of the Historic Sites and Monuments Board of Canada (HSMBC) from 1926 onwards recognized the national historic significance of gold rush sites in Canada (Parks Canada, 1996). In Alaska, the idea of a "Chilkoot National Park" originated with Skagway civic and business leaders in the 1930s (Satterfield 1978: 170, Neufeld and Norris, 1996: 161). Thirty years or more would elapse before physical works began on Chilkoot Trail by authorities in both countries, and collaborative institutional initiatives result in formal historic designations. A bill establishing Klondike Gold Rush National Historical Park passed the U.S. Congress and was signed into law on June 30, 1976. Notwithstanding collaborative studies by the National Park Service and Parks Canada from 1967 onwards, establishment of Canada's Chilkoot Trail National Historic Site was delayed until April 7, 1993. In another five years would come international designation of the trail, though once again this idea had been in circulation for at least thirty years (Norris, 1996).

The interest of the HSMBC was in the social, economic, and political role of the gold rush in shaping the Yukon region. Thus, although Chilkoot Trail demonstrates a long history of human use, it is the social aspects of the mass movement of newcomers to the Yukon during the Klondike Gold Rush that is commemorated at Chilkoot Trail National Historic Site. Parks Canada's Commemorative Integrity Statement for the site, the document presenting the principal management objective of the area, recognizes the commemorative intent of Chilkoot Trail as follows:

*The Chilkoot Trail was designated a national historic site because of the role it played in the mass movement of people to the Yukon during the Klondike Gold Rush.*

This, too, is the intent of the Chilkoot Trail and other units of the Klondike Gold Rush National Historical Park – White Pass, Skagway Historic District, and Pioneer Square, Seattle. Norris (1996) describes how the idea of Chilkoot Trail as protected area evolved very much in concert with goals for the other gold rush landscapes inside and beyond gold rush communities.

The primary directive of both countries, to commemorate the Klondike Gold Rush as a social phenomenon, has been reinforced by the physical evidence that remains along the Chilkoot Trail or is harboured elsewhere, and the large body of written and photographic evidence from the period. (Indeed, the gold rush may have been the greatest photographic event in nineteenth-century North America!) Protection and presentation of Chilkoot Trail as a place and through its artifacts become central to management and use of the trail, for as Canada's National Historic Sites Policy states, "without protection there can be no historic site to be enjoyed, and without presentation there can be no understanding of why the site is important to our history."

This principle of protection and presentation cannot be restricted to the gold rush era alone; history did not begin and end with stampeders. Neither can environment be treated as a little-modified ecosystem nor visitors denied access to witness for themselves the wonder of the route. The solutions that have emerged provide a context not only to perpetuate historic and natural values, but also to lay the basis for an effective demonstration of *in situ* ecotourism.

First, the other heritage values associated with the Chilkoot Trail have been recognized and introduced to trail management and interpretation. These include the evolution and condition of the area's natural environment, its history and continuing use as a First Nations travel and trade route and homeland, the pre-rush use of the trail by prospectors moving through the upper Yukon River basin, links to other gold rush sites from Seattle to Dawson City, and post-gold rush recreational use. The effect has been two-fold; not only does the visitor gain insight to landscape evolution and the interplay

11

between humans and nature, there is the knowledge that they are now part of an ageless but ephemeral human presence on the route – for trade goods and exploration, then for gold and now for recreation.

The second solution has been to identify and respond to indicators that will sustain both physical and symbolic attributes of the trail. The geographic character – the linearity – of the historic corridor has to be maintained, providing a visual sense of containment in its own valley. The evolution of the corridor's natural environment is to be managed as a relict landscape. The relationship between the commemorated trail and natural stopping places and local topography is to be maintained; and viewscapes from Chilkoot summit and the historic trail corridor are to be unimpaired, with under-standing and support from the community for these directions.

Finally, a formal context for visitor appreciation and appropriate behaviour on the Chilkoot is nested within the coordinated administration of the Canadian and American national park services. Overuse of the Chilkoot and other popular hiking routes – West Coast Trail in Pacific Rim National Park Reserve, for example – could impair heritage resources and diminish the visitor experience. In a procedure that inevitably will spread to other highly popular but vulnerable trails where user numbers are as yet uncontained, Canada permits only fifty visitors per day to cross the Chilkoot Pass into British Columbia. Forty-two advance reservations are taken for each day, with the remaining eight spaces made available on the day on a first-come, first-served basis. Also, should the trail become overly crowded or conditions deteriorate, the park service has the ability to hold back groups, to start out on another day. The reservation system plays a vital role during the key hiking season, from late May to early September. Each year, this system enables almost 4,000 persons to hike the trail and appears to be generally well received by trail users.

A number of visitor surveys circulated by Parks Canada during the 1990s have explored attitudes toward the permit and fee system as well as opinions about current conditions along the trail,

motivations, perception of problems, and opinions about various management activities. There is strong support for the fee and permit system in place, that it is good value for money. Similarly, current fees and limits on hiker numbers are considered reasonable. The results of the 1998 survey are shown on figure 4.

Other key requirements challenge individuals and groups to practice low-impact, leave no trace behaviour during their hiking, camping, and interpretive experiences. Some are universal to any such behaviour; others take on characteristics peculiar to the Chilkoot Trail.

- Camping takes place only at designated campgrounds, located mainly on former gold rush town sites, now lightly groomed and with tent pads.

- Foodstuffs at campgrounds must be placed atop bear-proof poles (visitors provide their own ropes) or in food storage caches.

- Warm-up shelters, so essential in a region where weather conditions may deteriorate suddenly and for extended periods, are also the cookhouses and diners of the Chilkoot Trail. Here, food is to be prepared and consumed, effectively minimizing habituation among grizzly and black bears and other wildlife species.

- The campgrounds on the Canadian part of the trail are equipped with dishwater or grey water pits, to minimize degradation of water quality in adjacent streams and lakes. The practice has been discontinued in the U.S. section. The grey water pits there failed to function properly due to near-surface groundwater. Hikers are urged to disperse their dishwater in the rapid current of the Taiya River.

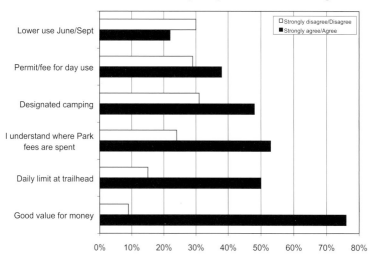

**How much do you agree with the following:**

Lower use June/Sept
Permit/fee for day use
Designated camping
I understand where Park fees are spent
Daily limit at trailhead
Good value for money

☐ Strongly disagree/Disagree
■ Strongly agree/Agree

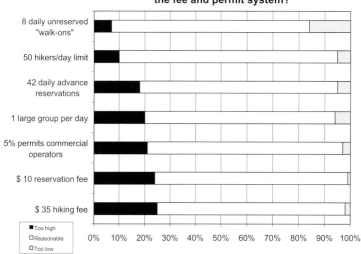

**What is your opinion about specific elements of the fee and permit system?**

8 daily unreserved "walk-ons"
50 hikers/day limit
42 daily advance reservations
1 large group per day
5% permits commercial operators
$ 10 reservation fee
$ 35 hiking fee

■ Too high
☐ Reasonable
☐ Too low

Fig. 4. Visitor Opinion about the Fee and Permit System. Source: Parks Canada 1998.

- All litter from campgrounds and other sites must be packed out. There are no garbage receptacles. Plastic bags are provided by the national park services and the garbage-free condition of the trail bespeaks common respect for this ground rule.

- Some of the campgrounds, Sheep Camp and Lindeman City, for example, provide detailed information on aspects of the Chilkoot's national and cultural heritage, dispensing with the plethora of trailside tableaux found along some interpretive trails.

- Outhouses are maintained in excellent condition. Faeces are airlifted out from high altitude sites where underlying bedrock has severely limited the number of sites to be dug for outhouse use. The arrangement also serves to offset the extremely slow breakdown of waste matter.

- Beyond campground and shelter nodes, there is limited intrusion of modern artifacts. Such as do exist – footbridges across streams, occasional directional signs, and route poles among boulders on the avalanche slope to Chilkoot summit – are there primarily for safety and to confirm trail routing. Artifacts of the modern period do not compete with the array of historic heritage evidence scattered along the trail.

- Open fires are prohibited on the trail, but they are permitted at Dyea. Wood stoves are provided in most warm-up shelters. Happy Camp does not have a stove. The local wood supply is inadequate there and flying in fuel is not feasible. Hikers should bear this fact in mind. They must have the means with them to stay dry and warm and their euphoria at crossing Chilkoot summit may be replaced by realization there remain four miles (6.49 m) of potentially cold and wet travel over uneven ground until they reach Happy Camp.

The Chilkoot Trail has been dubbed the world's longest museum. This description is apt. Throughout its length, an astonishing array of gold rush artifacts persists. The best have been recorded, removed, and preserved by parks authorities. Those left along the trail excite the imagination about what was contained in the "ton of goods" the North-West Mounted Police required each stampeder to possess upon entry into Canada at Chilkoot summit. Today, the list of items to be discovered on the hike seems endless; rusted spades, picks and shovels, gold pans, harnesses, broken cook stoves, tobacco cans, houndstooth cloth, remnants of animal feed, high-buttoned dress boots, and the stark skeletons of boats abandoned inside British Columbia. Add to these more dominant artifacts such as tramway cable and steam boiler, telephone wire, and remnants of those briefly frenetic communities – Dyea, Canyon City, Sheep Camp, Lindeman City, and Bennett among them – and the commotion of a population in transit and dangerously out of its element can be easily visualized.

The archaeological searches continue, but time gradually will reduce those cultural resources most vulnerable to the elements – log cabins, clothing fabric, and footwear. Eventually, even metal must succumb, notwithstanding the cold northern climate. Some attrition is expected through thoughtless and selfish removal of artifacts, though collection and removal of any object or heritage resource is an offence and completely inimical to the spirit of ecotourism.

The ecotourist will find terrain, relief, gradient, season of the year, and climate and weather imposing a variety of conditions upon segments of the Chilkoot Trail. The rugged conditions of the Chilkoot demand adequate personal preparation, also respect for the future state of the trail. Along certain segments, and particularly in Canada where gradients are less pronounced and surface conditions vary widely, there is potential for trail braiding. Adherence to the principal route will be of long-term benefit to future travellers. Even walking sticks and ski poles are discouraged, to minimize erosion. Their use should be strictly on snowfields or for obvious safety needs.

Weather conditions may profoundly affect the status of the trail and visitor responses. Heavy rainfall, hail, sleet, thunderstorms and fog, snow fields, ice and ice bridges, and even blinding sunshine(!) may be encountered at various times. The trail route may have to be reworked frequently, especially in June and July when snowfields rapidly melt and judicious route selection is required of the traveller. The same situation applies when tackling the boulder-strewn ascent from the Scales to Chilkoot summit. It is when conditions such as these are at their most challenging that interpretations of ecotourism may seem to give way to that of adventure tourism. In the spirit of the Klondike, however, it must be remembered that the challenge also was faced by stampeders of a century ago – albeit their equipment was cumbersome and their motivation more acquisitive than altruistic!

Rapid transitions from coastal rain forest to alpine tundra and boreal forest bespeak profound changes in elevation, geomorphology, and plant and animal life. Weather patterns, ground conditions, the potential to interact with bears and other wild land influences remind us that human presence here is fleeting and responsive to, rather than an arbiter of the rhythms of nature. As the average hiker takes his or her three to five days to complete the trip, nature becomes less a backdrop and more the centre stage for enjoyment and appreciation of the Chilkoot. There is always an element of physical risk to reinforce nature's prominence, of course, but as this is not a wilderness hike, there is ample room for biocentrism and personal enlightenment.

Much of the economy of this corner of Alaska, British Columbia, and Yukon relies upon a mix of seasonal tourism activities. Skagway, Alaska, and Whitehorse, Yukon, and various road, rail, and air links epitomize a regional tourism framework fleshed out by ferry and cruise ship populations, highway coach and motor-home travellers, and fly-in visitors who place assorted demands on transportation and accommodation infrastructure. The Chilkoot Trail occupies a unique role in this regional mosaic of facilities and services. It is fundamentally a case of supply-driven ecotourism, and as an example of

sustainable tourism, its continued success will be assured through constant evaluation of resource-base capability, management of visitors, and their capacity to directly benefit from what for most of us will be a vicarious trail experience.

## Recreational Visitors on the Chilkoot Trail

Completion of the White Pass & Yukon Route railway to Bennett in the summer of 1899 and on to Whitehorse in the following year closed the short, tumultuous chapter of Klondike Gold Rush on the Chilkoot Trail. Gone was the pandemonium of the gold rush. Gone too were the earlier, regular trade journeys of First Nations, culminating in their vital role as packers for outsiders from the 1880s. The rhythm of use of the Chilkoot was gone, to be restored only in a pattern of recreational use as the twentieth century itself ebbed away.

Tourism gradually emerged in the region, spearheaded by the railroad out of Skagway, a gradual build-up in cruise ship lines, and construction and improvement of the regional road system, notably the Alaska Highway and more recently the Klondike Highway. Recreational use of the Chilkoot was sporadic for decades, however. Difficulties of access, overgrown trails up much of the Taiya River valley and southwards from Bennett discouraged but did not entirely inhibit recreational use. Not until the state of Alaska and Yukon territorial government cleared the trail on either side of the border and introduced some facilities did the modern era of recreational use begin. Neufeld and Norris (1996) report that:

> In 1968, fewer than 100 people signed the log book left in the newly-constructed cabin at Lindeman Lake. But in 1970, close to 500 hikers traversed the trail and by 1973, when both the National Park Service and Parks Canada began to place staff along the trail, the number had risen to almost 1,100.

Though the number of recreational users has matched and surpassed that of the stampeders, there is little to compare in the way of their respective impacts on the landscape. Where once surrounding forest was wiped out and possessions recklessly abandoned, the focus now is upon personal steward-ship, husbanding a heritage resource that will witness visitation likely in perpetuity.

## Summer Use

The Chilkoot Trail is travelled in all seasons, but predominantly in the summer. Annual records of summer use are available for the period 1977–2000. The data originally were derived from self-registration and other survey methods, but, with the reservation system in place since 1997, visitation information in that and succeeding years is considered particularly accurate. The visitors are predominantly self-organized groups, although a number of commercial guides do bring a few parties through each year. Also, the vast majority of trail users – some would say ninety-nine percent – set out from the trailhead in Alaska with few travelling in the opposite direction.

For the period of record, annual summer use ranges from a low of 1,400 (1985) to a high of 3,918 (1998) persons, the latter being the centennial year of '98 and following about three years of sus-tained promotion of the centennial of the Klondike Gold Rush. Levels of use have varied across three time periods responding variously to marketing efforts, northern road conditions, efficiency of regis-tration procedures, and whether or not the White Pass & Yukon Route railway was operating and therefore could return hikers from trail's end to Skagway.

First, use rose annually from 1977 to 1982 and in total doubled over that period (1,733 to 2,594 persons) as shown in figure 5. Second, from 1983 to 1989, the trend changed. Annual visitation fell, ranging from 1,400 (1985) to 2,081 (1989). The third trend apparent in figure 5 is for the 1990s and shows annual use exceeding 3,000 in each of the last six years, up to and including 2000. The decline in 1982 and resurgence of use in 1989 is attributed principally to closure of the White Pass & Yukon

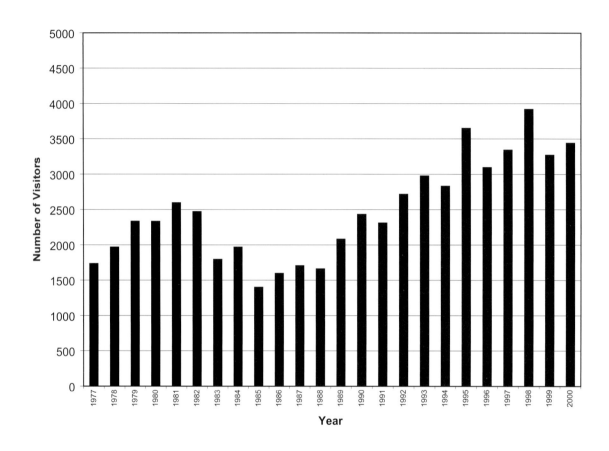

Fig. 5. Summer Visitation to Chilkoot Trail National Historic Site, 1977-2000.

Source: Parks Canada 2001.

Route railway in the former year and its reopening seven years later. This hiatus eliminated for a time a popular means for hikers to leave the Chilkoot Trail once they reached Bennett. Now that a daily service has been restored in June, July, and August, more than sixty percent of hikers in 2000 are estimated to have left Chilkoot Trail in the passenger car specifically provided for their use by the railway company.

The registration and permit system will facilitate management of recreational user numbers in the future and we expect growing ecotourism interest in Chilkoot Trail. It is interesting to note, however, that the record number of visitors in the centennial year has not been sustained in 1999 and 2000. The data in figure 5 show that approximately 60,000 persons used the trail from 1977 to 2000, an average of 2,600 persons per year. Of this total, almost 34,000 travelled the trail during the 1990s, an average of 3,400 persons per year.

The data presented above include those persons who hike the entire trail, together with visitors who travel only on the American portion. There are also those, however, who travel by railroad to the Canadian terminus of the trail at Bennett in British Columbia. In 2000, the White Pass & Yukon Route railway brought almost 2,000 of its 300,000 passengers to the lakeside from Skagway, to briefly explore the site. The railway company has now extended its service along Lake Bennett to Carcross, Yukon Territory. This arrangement likely will add to the number of railway passengers visiting the end of the trail at Bennett and elevate the role of the site in delivery of interpretive services.

These statistics are instructive in a general sense, but key factors in maintaining the ecotourism experience arise from management decisions by parks authorities – including maximum daily numbers allowed across the border into Canada, restricting maximum group size to twelve and one large group (9-12 people) per day over Chilkoot Pass.

# Winter Use

Winter use of the Chilkoot Trail area broadens the scope of recreational use from the summer emphasis on hiking. By the same token, it brings a more diversified group of stakeholders to the management table and imposes some interesting considerations from an ecotourism perspective. The focus of winter activity is very much in Canada, however, where there is better access to the trail and protected area generally and where conditions are more amenable to various winter recreation pursuits. Indeed, the U.S. National Park Service reports only a handful of people will attempt the trail from November to March because of the adverse conditions. And though there are no prohibitions on motorized recreational access in the Klondike Gold Rush National Historical Park, difficult terrain and streams that do not completely freeze add to the list of travel impediments.

In Canada, winter brings an array of recreational interests to the Chilkoot Trail corridor though the total number of users and those for select recreational activities are small in comparison to summer use. But seasonal conditions and areas affected are different too, and there are different sets of management challenges accompanying both motorized and non-motorized categories of recreational use and traditional land-use interests, notably trapping. The user groups, the sights, sounds, landscape impacts, and esthetics of the long winter period are so different from those of summer. There are quite different noise imprints between summer and winter, for example, and potential for winter use conflicts that are unimaginable in summer – trail conflicts among cross-country skiers, dog sledders, and motorized recreationists, for instance. And the users themselves are predominantly from the region around Chilkoot. Good roads make the Chilkoot readily accessible to the larger populations of Whitehorse and Skagway as well as smaller communities in the region.

The categories of winter recreational use identified by Parks Canada for a recent survey are impressively large, though actual numbers of users in any one category may be minimal. The categories

included are: oversnow vehicles (OSVs – "snowmobiles"); OSV-assisted skiers and snowboarders; alpine skiers; cross-country skiers; snowboarders; snowshoers; dog mushers; front-country campers; back-country campers, and walkers/hikers.[2]

During the 1990s, Parks Canada, in concert with stakeholder groups, developed a Winter Recreational Use Management Strategy (table 1). The strategy has been built on an interest-based approach to define needs and resolve conflicts among stakeholders within the context of Parks Canada's mandated obligations and criteria. These include protection and maintenance of Chilkoot Trail National Historic Site's commemorative integrity; First Nations traditional activities; the site's cultural and natural resources and associated values; public safety, and the quality of experience of all winter users. A consensus-based strategy has emerged from the suite of mandated responsibilities and stakeholder needs and interests.

[2]   The limited survey information available for the Canadian portion of the trail suggests an average number of visitors on monitored days for the period 1996-99 to range from 24 to over 50. Non-motorized users exceeded motorized users in two of the four years. The data are indicative, and additional survey activity is desirable to refine winter recreational use statistics.

# Table 1.

## Winter Recreational Use Management Strategy, Chilkoot Trail National Historic Site

| | |
|---|---|
| *Winter use scheduling* | Motorized and non-motorized use is accommodated according to a scheduled use system, including specific non-motorized use week-ends, multi-use periods, special use weekends, and zoning of areas for respective activities. |
| *Designated access/use trail corridors* | Separate corridors for motorized and non-motorized users, particularly to reduce conflict potential during multi-use periods, track set ski areas are complemented by separate access/use trail corridors for snowmobiles and/or dog sledders. |
| *Formal and temporary closures* | Permanently closed areas will provide protection to the site's heritage resources (e.g., at Bennett and Lindeman City) and to trapping activities (cabin, trapline); temporarily closed areas may be invoked for a variety of reasons – inadequate snow cover, wildlife presence (e.g., moose, goats, caribou for winter/spring range) – based on stakeholder consultations. |
| *Public safety* | Winter users are responsible for their own safety and should recognize the need for backcountry travel skills, avalanche hazard evaluation skills, route-finding skills, and self-rescue capability. |
| *Education awareness* | A synopsis of the strategy is posted at key locations (e.g., Log Cabin), together with a winter-use code of ethics; winter-use scheduling regarding motorized and non-motorized use periods also is posted. |
| *Monitoring and feedback* | The strategy is monitored and evaluated by the Chilkoot stakeholders working group through formal meetings before and after the winter season. |
| *Failure to comply implication* | Should participants in any one of the current winter users fail to comply with the strategy, that use will be excluded as a permitted activity within the national historic site. |

*Source: Parks Canada, 1995*

The winter strategy is believed to have generally worked well to date, and the co-operative and voluntary efforts upon which it so much depends appear to have been successful. Does the strategy meld with an ecotourism concept for Chilkoot Trail, however? We believe it does for the following reasons: the strategy owes much to a consensus-based approach; there is minimal provision of facilities or services, and the requirement for a high level of preparation and self-reliance. Site and area use takes into account cultural considerations at both community and national levels, and there is provision to respond to critical elements of the natural environment (e.g., wildlife movements, route locations relative to the tree-line). Ultimately, though a lead agency has mandated responsibilities, the contribution of the winter recreational strategy to a state of ecotourism is rooted in the continuing respect and behaviour of the stakeholder groups for the heritage values of the Chilkoot corridor. This is the foundation for year-round longevity of the Chilkoot Trail as a contribution to North American ecotourism.

## Ecotourism Challenges

Today's recreational users have high regard for their overall experiences along the international Chilkoot Trail. The route receives a very good/good rating from almost one hundred percent of summer season users, and ninety-two percent accord a similar rating to trail maintenance. Indeed, this satisfaction rating is seventy-five percent or more for all but one of sixteen categories identified in the 1998 survey (fig. 6). Particularly heartening to Canadian and American managers must be perceived improvements in aspects of environmental stewardship over the early 1990s, before the registration/permit system was instituted. Improvements are recognized in protection of the water supply, vegetation, and historic artifacts; fewer problems are identified with the numbers of hikers using the trail and numbers of groups seen at campsites, notwithstanding a twenty-three percent increase in trail

**How Satisfied were you with...**

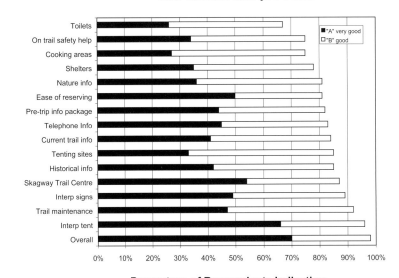

**Percentage of Respondents Indicating
Slight to Very Serious Problem**

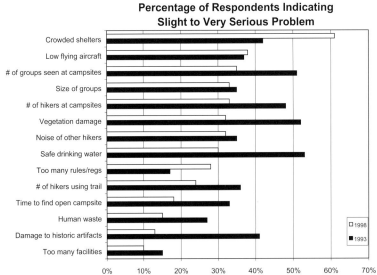

Fig. 6. Chilkoot Trail Summer Use and Satisfaction and Problem Identification, 1998.

Source: Parks Canada 1998.

use between the two years of survey. The basis for this improved ecotourism experience is likely rooted in several contributing factors; growing international co-operation and individual agency improvements to the trail itself and the limited visitor facilities there, as well as an effective information/registration/permitting system, and enhanced visitor preparedness for the trip. All told, it is no small feat to combine the commemorative intent of this relict historic landscape, a geographical area considerably modified by those very persons who gave it special culture meaning, with contemporary environmental stewardship supportive of natural ecological processes and minimum human impact. Over time, as artifacts disintegrate and vegetation cover expands and intensifies, visitors increasingly will move through a corridor landscape more akin to pre-gold rush days and sights and sounds that would have been familiar to aboriginal people.

How many annual travellers can the Chilkoot Trail sustain in the future without degrading heritage resource and user satisfaction? Potentially over 6,000 persons could hike the trail from mid-to-late May to early September under present access rules, perfect trail conditions, and maximum use participation. What stresses would unfold relative to facility needs, trail maintenance, infrastructure costs, and visitor safety and enjoyment? No definitive response is possible here; rather the challenge is upon park authorities to monitor stresses and their effects and to reach management decisions accordingly.

The trail is not without its contemporary management challenges. These arise in three principal areas: visitor facilities and services, park administrative matters, and regional development and land rights. Of pre-eminent concern to visitors are conditions at the overnighting spots along the trail – the locations of the ephemeral gold rush communities. The shelters, which also serve as cooking places, became crowded and accumulate hiker groups variously warming up, drying out, eating, and socializing. During inclement weather, there is an understandable reluctance to vacate the shelters as additional parties arrive. Each location has its particular problems. The shelter at Finnegan's Point is small,

windowless, and gloomy. At Sheep Camp, which is more spaciously laid out, the groups bunch up prior to their assault on Chilkoot Pass and concentrate around the shelters and nearby tables and food poles. Most will end the day at the dubiously titled Happy Camp, where the small shelter, frequently cold and wet weather conditions, and hiker weariness combine to test one's good humour and interpersonal relationships.

Increased hiker traffic during the 1990s undoubtedly has contributed to the crowding problem, although the data in figure 6 taking issue with the number of individuals and the number and size of hiking groups at campsites suggest visitors aspire to a thoroughly cognitive and biocentric experience. They are disappointed when the essential service nodes impinge upon sensibilities focussed on the heritage resources and powerful landscape present throughout the trail corridor.

Aircraft sights and services are likewise intrusive and are an ongoing and unwanted element of regional tourism activities penetrating the ambiance of the route.

In winter, the largest single user issue, at least in Canada, is motorized access. The consensus-based winter use strategy previously discussed appears to be working reasonably well among the participating groups, recognizing that access is for both subsistence and recreational use. Future circumstances such as increased recreational use and First Nations land claims are likely to continue the debate on appropriate winter use. There is throughout the region, however, a broadly based interest in appropriate resource management decisions for the Chilkoot, and the apparent success of the consensus-based approach to date is a hopeful indicator for future agreement among stakeholders.

There is some evidence of increasing visitor resistance to regulations imposed by park authorities. Requirements to abide by the registration and permitting system probably are a major influence and, with costs to increase in future, more commentary on the subject may be expected. The system confers benefits, however, that may not be readily apparent to users. It has brought the two national park

services into a much closer working relationship than otherwise might have existed, users receive up-to-date information about trail conditions when they register in Skagway, and the system even can be used to reach those who have reserved if adverse conditions bring about trail closure. Finally, the registration system can be viewed as the common denominator that makes the Chilkoot work effectively as an international entity. Though administered by the respective national park authorities, the Chilkoot Trail received formal international recognition on August 5, 1998, when it was declared to be a component of the Klondike Gold Rush International Historical Park with units extending from Seattle to Dawson City. The designation is a fitting tribute to human endeavour over thousands of years connecting tidewater with interior plateau. It is, too, a promising framework within which an ecotourism experience may be successfully managed and enjoyed for a long time to come.

*Part Two*

# THE TRAIL IN HISTORY

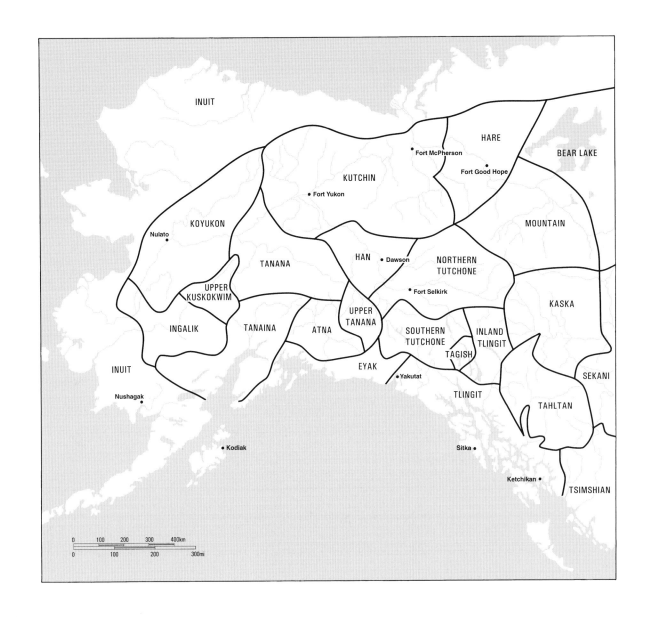

Fig. 7. First Nations in the Northwest (after McClellan, 1975).

# THE TRAIL
# IN HISTORY

For travellers on a new-found trail, inevitably, there is curiosity about those who have gone before. Not the passages marked in yesterday's snowflakes or this morning's dew drops, but rather the larger view of human occupancy, activities, and settlements. So it was for us as we followed the slender thread leading us from Taiya Inlet at the head of Lynn Canal over the Coast Mountains to the headwaters of the Yukon River. Who had passed this way before in history? What were their reasons? What heritage had we inherited by way of landscape and artifact? We discovered our fleeting presence would echo the footsteps of centuries past and give pause to reflect on what motivates humankind through the ages to move about and imprint itself upon the land. We learned too that, when the gold rush period came, it was as if the Chilkoot Trail, long a sinew preferentially linking coastal and interior aboriginal communities of the Northwest, suddenly became a common property roadmap for populations across the continent and many that lay far beyond.

## First Nations and the Chilkoot

Long before the Klondike Gold Rush, the north country was occupied by many native groups. Among those occupying future Yukon territory were the Tlingit, Tutchone, Tagish, Kasha, Upper Tanana, Kutchin, Han, Inuit, and Koyukon in Alaska (see fig. 7). Among these groups, the Chilkoot Trail was familiar to native communities inhabiting the Pacific coastline and those in the interior – populations who occupied and travelled through today's southern Yukon and Alaska and

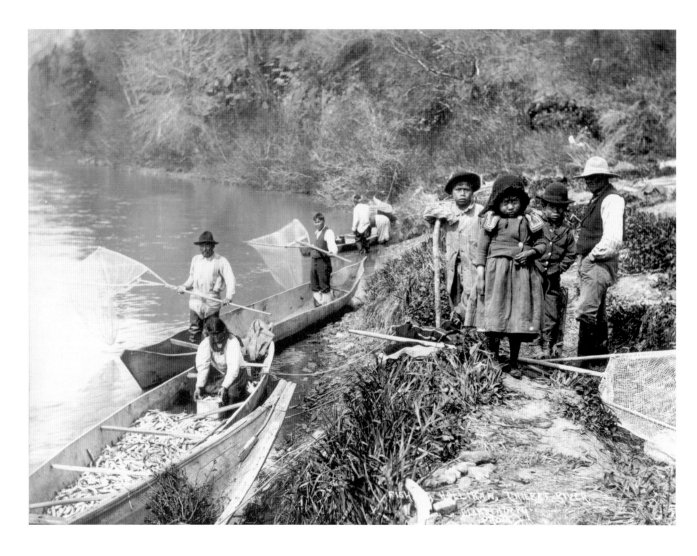

An abundance of eulachon, harvested in spring, ca. 1895,
on the Chilkat River near Klukwan.

northern British Columbia. To the Tlingit, Chilkoot Pass was *A Shaki*, to the Tagish it was *Kwatese*, or "over it" in both languages.

The trail was both travel and trade route and remained so over a very long but untold period of time. Occupancy of the region dates back several thousand years. The trail itself was a conduit for the coastal Tlingit (including the Chilkoot, Chilkat, and Taku kwans – tribal or regional groups) to meet, trade, and eventually form marriage bonds with Southern Tutchone and Tagish peoples. These inland populations occupied forests, rivers, and lakelands in the upper watershed of the Yukon River basin and the Taku River basin in British Columbia. There is a persisting living legacy of these earlier times. The Carcross/Tagish people for whom it is homeland, view the Chilkoot as their route because their history is so closely linked to it. The Tagish, who spoke an Athapaskan language in common with most other Yukon First Nations when Tlingit contacts began, gradually integrated the language of the coastal Tlingit. When outsiders came through Chilkoot Pass in the 1880s, they encountered a bilingual Carcross/Tagish population. A few decades later, the families familiar with Tagish were speaking Tlingit and the old people spoke Tagish among themselves. Today, the Carcross/Tagish people with their neighbours the Teslin and Atlin (Taku River) Tlingit constitute a grouping of interior Tlingit-speaking peoples.

When the lust for gold and resultant gold rushes endemic to the nineteenth century finally washed along the rivers and valleys of British Columbia, Alaska, and Yukon, patterns of native culture and livelihood would be dramatically impacted. The European presence, hitherto muted and focussed upon coastal trade and a few fur-trading posts along major inland waterways, gathered momentum after mid-century. The gold rush of 1897–98 brought a large and sudden wave of non-natives to the Yukon, precipitating upon aboriginal peoples often deleterious consequences, and accelerated exploitation of vast coastal and interior areas of northwestern North America.

# Early Eighteenth- and Nineteenth-Century Trade Alliances

The Russians were the first non-natives to establish regular trade with natives in the Yukon. Russian traders entered the waters off southern Alaska in the early 1700s, trading with the Aleuts by the 1740s. The Russian-American Company expanded into areas occupied by the Tlingit by the late 1700s, establishing settlements at Sitka and Yakutat. Although initial trade alliances with the Tlingit and other coastal groups were strained, by 1833, a Russian trading post and mission had been established at St. Michael not far from the mouth of the Yukon River. An additional mission was built farther upstream in 1845.

The Russians continued to trade along the southern coast of Alaska with the Koyukon and Tlingit into the middle of the nineteenth century. Sea otter pelts were a staple of this trade, but, when overhunting caused a decline from the late 1700s, the demand increased for furs from the interior. Furs and other trade items were brought up the Yukon River by the Tlingit for trade with the Russians, and later with the British. In 1839, the Hudson's Bay Company (HBC) struck an agreement with the Russian-American Company to lease its lands along the Alaskan Panhandle. Trading with the HBC continued until the purchase of Alaska by the United States in 1867. Notwithstanding the purchase, trade with the Tlingit continued well into the 1880s. Independent U.S. traders increased in numbers, while the American North-West Company established six trading posts in the region.

While British traders often attempted to gain control over trade lines from the Tlingit, these attempts, while disruptive, were unsuccessful. For example, in 1848, the HBC, when attempting to expand its interior trade network, established Fort Selkirk on the Yukon and Pelly rivers, a traditional Tlingit trading site. The Tlingit undersold the HBC for four years, creating a very tense relationship. When the HBC constructed a more substantial trading post across the river from the original post, relations were further strained. The new post was destroyed by the Chilkat in 1853 and was not rebuilt.

When the earliest prospectors arrived in the interior Yukon in the 1870's, the Tlingit had firm control over the mountain passes and interior trade routes:

> *Until 1880 the coastal Tlingit prevented non-Tlingit and Tagish people from gaining access to the interior Yukon via this route, determinedly maintaining control through the first forty years of European trading and proselytizing even as prospectors sent word out that they had found gold in the riverbeds of the interior. This frustrated many early explorers and prospectors since all agreed that the Tlingit controlled the shortest and easiest route to a large fur-bearing and possibly a gold-bearing region. (Porsild, 1998: 30)*

The Yukon and Alaska had been prospected for gold long before the Klondike rush. Mr. J.E. Spurr and Mr. T.A. Rickard, a mining engineer, have described the early gold prospecting and mining activities taking place more than a decade before the gold discovery near Dawson that precipitated the Klondike Gold Rush:

> *More than a century earlier the occurrence of gold in Alaska was known to the Russians, but they discouraged the search for it, thinking it might interfere with their lucrative fur trade. Soon after the purchase of Alaska from Russia by the United States in 1867, the Alaska Commercial Company acquired a lease of the sealing rights on the Pribilof Islands and with this concession the company secured a practical monopoly of the fur trade to the Yukon region, where sable of unusual quality was found. A little steamer, the Yukon, was sent up the river from St. Michael, and by aid of her such men as Jack McQuesten, Arthur Harper, and Al Mayo, names famous in the story of the early days, were enabled*

*to penetrate the northern wilderness in 1871. Two years later McQuesten established a post at Fort Reliance, six miles below the junction of the Klondike River with the Yukon. The site of Dawson Fort Reliance served as a winter resort for prospectors.*

*The Chilkats, in southeastern Alaska, notably at the head of the Lynn Canal, long controlled the trade with the interior and exacted their tribute. The natives prevented the intrusion of the prospector until in [1880] a party of nineteen men, led by Edmund Bean with the assistance of a small American gunboat from Sitka, persuaded the Chilkats to make an agreement to allow prospectors to proceed unmolested over the Dyea [Chilkoot] Pass into the Alaskan [and Yukon] hinterlands.*

*In 1885 some rich gravel was discovered on the Stewart River, a tributary of the Yukon, and prompted a small gold rush there. At the end of that year there came news of a discovery of coarse gold at Forty Mile, so named because it was on the Yukon forty miles below Fort Reliance. As a result the Stewart River prospectors moved to Forty Mile. It is said that a man named Williams, accompanied by an Indian and three dogs, brought the news to Dyea, on the southeastern coast of Alaska. This party was overwhelmed by a snow storm on the summit of the Chilkoot Pass and remained there for three days. When the weather cleared, Williams found himself unable to walk, so he was carried by his Native comrade four miles to Sheep Camp; there a sled was procured and he was taken by some Indians to Dyea, only to die soon afterward.... The dogs were never recovered. The miners wintering at Dyea were curious to know what caused Williams to risk the journey at such an inclement period. His Indian companion picked up a handful of beans and said "Gold all same like this." His statement caused intense excitement and in the spring*

*of 1886 more than 200 miners went over the pass to Forty Mile. These diggings continued*

*to be productive, on a small scale, until 1893. (Rickard, 1944: 304-305)*

In August, 1896, the discovery of gold near Dawson prompted the Klondike stampede over the Chilkoot Trail. The Chilkoot Trail was one of the key access routes to the Klondike gold fields in Canada's Yukon Territory. A great many of the gold seekers were Americans travelling to what they thought were American gold fields. Thousands of men, women, and children who hiked during the Klondike Gold Rush were caught up in a frenzy to strike it rich during an international economic recession. Of those who would eventually reach Dawson 600 miles northwest of the Chilkoot Pass, very few obtained any gold! The rich gold-bearing areas had been staked before most of the Klondike stampeders arrived and even as they sat out the winter along the Chilkoot Trail.

Prospectors from throughout the world clambered over the Chilkoot Pass. Most of the Klondike gold seekers travelled along the trail during the late winter or early spring. Most did not anticipate the difficult trail conditions and avalanches in the Alaska and British Columbia wilderness.

Early European–First Nations trade alliances were advantageous not only to the Russians, British, and Americans, but also to the Tlingit. The fur trade remained an important part of Tlingit economy until the late 1880s. This relationship, however, also exemplifies one of the most somber results of European–First Nations contact – disease was introduced into the area. In 1839, it was reported that smallpox, brought by the Russians, exterminated more than half of the Koyukon people residing at the mouth of the Yukon River. Smallpox, whooping cough, tuberculosis, polio, and influenza also devastated the Tlingit throughout the eighteenth and nineteenth centuries.

# The Tlingit Trade Network and the Chilkoot Trail

In the pre-mining Yukon economy, there were two major lines of native trade. From the southwest, the coastal Tlingit groups of the Chilkat, Chilkoot, and Taku travelled over the mountains to the interior to trade eulachon oil, grease, fungus, medicinal roots, abalone and dentalia shells, dried clams, seaweed, spruce root baskets, and cedar boxes for caribou and moose hide, fur garments, goat wool, lichen dyes, bone, birchwood boxes, decorated moccasins, metal arrowheads, and native copper. The bulk of this trade involved the Tagish and Southern Tutchone people. In the northern Yukon, the Gwich'in dominated as intermediaries, trading goods obtained from other Gwich'in, Han, and Northern Tutchone for oil, grease, fungus, medicinal roots, abalone and bone and tusks from the Alaskan Koyukon and Inuit people (Porsild, 1998: 25).

The Tlingit were very successful in developing and maintaining trade alliances prior to the Klondike Gold Rush. The Tlingit had a strong sense of cultural identity and community, developed largely through the command and management of their rich environment. Tlingit trade routes into the interior were well established long before the advent of the European trader. The Tlingit traded with numerous interior Yukon and northern British Columbia native groups, or Athapaskans. Abundant marine resources provided the Tlingit not only with basic subsistence items, but also with wealth and power within trade relationships. Importantly, these relationships went far beyond simple economic exchange. Through their trading alliances, the Tlingit gained the loyalty of other native groups as trading partners. Marriages between groups strengthened these trading bonds.

Most important in these trading arrangements, however, was Tlingit control of access to and from the interior through the Coast Mountains. The Tlingit used several major routes from the coast to the interior (fig. 8). Each route was owned by a specific clan or nation rather than the larger kwans, and trade through it was managed by the clan leader (Olson, 1991: 34).

Farthest north was the Tatshenshini River route, from coastal Dry Bay to the Southern Tutchone village of Shäwshe or Neskatahin (later Dalton Post). To the south was the Taku River route, controlled by the Taku River Tlingit. This route eventually branched, leading to Atlin Lake, on the one hand, and to Teslin Lake along the eastward extension. The Stikine River also was an important eighteenth and nineteenth century coast-interior trading route.

The remaining routes led from the inlets at the head of Lynn Canal. Farthest west was the Chilkat Trail, owned by the Tlingit Wolf clan of the village of Klukwan.

> *The Chilkat was actually at least two trails: the western portion of which led to the Southern Tutchone village of Shäwshe or Neskatahin.... From Shäwshe the trail went north via Dezadeash Lake to Hutshi and then north or northwest, via Aishihik to the Fort Selkirk area on the Yukon River. The eastern Chilkat route also went through Southern Tutchone lands to Kusawa Lake. From Kusawa the Chilkats traveled down the Takhini River to the Yukon River to other trading destinations. (Greer, 1995: 31)*

The Chilkoot, who are generally considered to have been a regional sub-group of the Chilkat Tlingit, also controlled more than one route to the interior. Their principal trail is that which followed the Taiya River valley now included within Chilkoot Trail National Historic Site and Klondike Gold Rush National Historical Park. The trail did have variations; travellers crossed Chilkoot Pass via today's higher and well-marked hiking trail or through another slightly lower pass just to the west. Ownership of the trail on the coast side of the mountains rested with the Raven clan of the village of Chilkoot.

There were two additional routes controlled by the Chilkoot:

> *The second trail the Chilkoots claimed was the route later known as the White Pass. The White Pass and Yukon Route railway line and the South Klondike Highway (Carcross–*

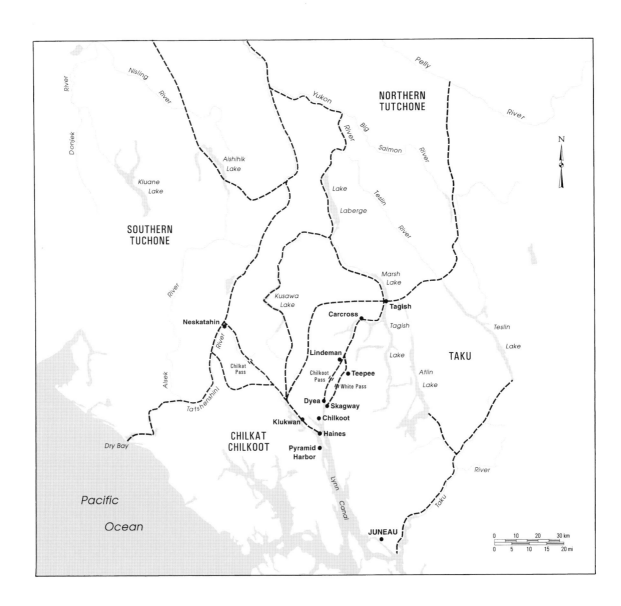

Fig. 8. Native Travel and Trade Routes.

*Skagway road) essentially follow this trail through the mountains. The stories recorded from Chilkoot and Carcross-Tagish people suggest that this trail was little-used in the 18th and 19th century fur trade.*

*The third route claimed by the Chilkoots was situated west of the Chilkoot Trail. It went from the coast, probably the Chilkoot Lake or Yendstuki areas near Haines, over the glacier ice into the Wheaton River basin, then down the Wheaton River to Annie Lake and then down the Watson River. The trail came out of the Coast Mountains by Bear Creek, near Robinson on the South Klondike Highway. From Bear Creek the trail went over the high country to Tagish. A carved wooden or tree trail marker can be found on this trail, the only Tlingit trail marker in the Carcross-Tagish area believed to be intact.*

*This third route was a dangerous one since it involved going over glacier ice. Khajinik (Tagish John) once had to rescue his partner who had fallen through an ice crevasse. His daughter, Mrs. Angela Sidney, told the story of how he rescued his partner. He braided four pieces of pack string into a rope.*

*"He lower that string down to his partner, and then when he got it he tied it around his waist, and he pull that string to make sign, and that's the way my father start to pull that string. He keep pulling, pulling, until he got [him] out." Mrs. Angela Sidney, Council for Yukon Indians, 1988. (Greer, 1995: 31-32)*

Most of the Tlingit in the upper Lynn Canal lived along the Chilkat River (Krause, 1956: 68). Fish was harvested in abundance. Game was trapped and hunted, while a variety of plant life adequately

supplemented the diet. The Tlingit lived in villages comprised of impressive wooden plank houses. Klukwan and Deishu were the principal Chilkat villages; Dyea, Yandostaki, and Chilkoot were the principal villages of the Chilkoot. Their descendants still reside in Klukwan and also in Haines. Timber, abundant in the coastal rainforest, not only proved a great asset in building shelters, but also in constructing canoes. Trade and military excursions along the coast were regular features of Tlingit life. Status was measured in real wealth – the number of caribou skins, and later, woolen trade blankets an individual could distribute at a potlatch, a celebration involving one-sided gift presentation (Neufeld and Norris, 1996: 25).

Today's backpacker is expected to prepare thoroughly for a Chilkoot Trail hike. Even the most diligent effort likely pales in comparison to those undertaken by the Tlingit. Journeys to the interior by the Chilkat and Chilkoot, Taku, and Stikine Tlingit were carefully planned affairs, tuned to the seasonal rhythms of both Tlingit and interior Athapaskans. Indeed, these trips to the interior were fundamental elements of community life. Two or three trips were made annually to the interior, each journey taking from ten to thirty days. The first, in mid-winter, was to make arrangements for the succeeding spring trading trip. Taking place in April, the second trip occurred after winter furs had been taken and prepared in the interior and before arrival of the eulachon on the coast. Most of a village's able-bodied men participated, representing clan ownership of a particular route.

Preparations for a trip also consumed weeks of activity. There were trade goods to be accumulated, travel rations to prepare (bundles of dried fish, notably salmon and fish oil, flour), and rituals to perform. There were large snowshoes for winter travel over snow and ice; a staff for balance, testing ground conditions, and to deal with snow accumulations and dense shrubbery in different seasons; a shoulder blanket as padding; forehead (tump) and shoulder straps, which bound packing bundles tightly to the back; a gun and axe, as well as personal items of clothing.

291.a
W&S

The aboriginal population contributed to the gold rush

impressive traditional skills in transmontane packing.

The Tlingits' ability to carry loads that might exceed ninety kilograms (200 lbs.) astonished outsiders. It was a capability that would prove beneficial to both aboriginals and outsiders when the latter attempted Chilkoot Trail. Even more astonishing would be capacity of aboriginal women packers to similarly hoist huge loads onto their backs.

Once in the interior, time would be spent locating Athapaskan trading partners at familiar meeting places such as fishing camps. There followed an important series of trading and social activities; these included individual exchanges between established trading partners, ceremonial gift exchanges, feasting and story-telling, and arrangements for marriages. Notwithstanding their capacity to carry large loads on their backs, the Tlingit were selective in the choice of trade goods with which to return to the coast. Marten and lynx pelts would be preferred to beaver, for example, because they were lighter and easier to pack (McClellan, 1975: 511).

Not all passage between coast and the interior was necessarily on foot or universally a backpacking affair. Once into the interior, rafts might be used on lakes and rivers. In a similar eerie precursor to events of the gold rush, it is reported that skin boats obtained in trade from the Yakutat Tlingit were knocked down, portaged over Chilkoot Pass, and reassembled on Lake Bennett (Greer, 1995: 29). Occasionally, sleds might be used but did not prove to be an exemplary mode of transport.

Opportunities for interior peoples to cross Chilkoot Pass in the opposite direction would be denied until influences beyond the region broke the Tlingit hold on this and other routes and effectively ended their role as middle men. This would occur towards the end of the nineteenth century. Likely, it was in the 1880s after the packing industry for outsiders was well under way and the Chilkoots and Chilkats had allowed outsiders to open stores or trading posts in their territory. Freedom to move through the mountain passes enabled the Southern Tutchone and Tagish, already interior middle men, to extend their geographical field of endeavour.

*The Haines Indians [Chilkats, Chilkoots] did not go to Pelly. We went that way from Tagish. We would pack our store on the back-gun, shells, tobacco – things we could pack on our back. They would pay lots of furs to us for those things. I would get more for them than I paid. I would buy from the coast people when they come in, and then I charged more for the things at Pelly because I had to pack the things there. We got a good trail. It goes Teslin way and then to Marsh Lake. I've been to Pelly Banks and Ross River. Ross River Indians are "Stick Indians." We would trade up there in summer or in the winter with a dog team; then we would not have to pack on the back. The Indians there would be glad to see us. They want to smoke. That time there were lots of beaver there.... We leave them be. The skin was too heavy. (McClellan, 1975: 511)*

Once reverse travel was possible on the Chilkoot and other trails to the coast, trade goods could be imported directly from there. Mrs. Dora Wedge and Mrs. Angela Sidney, both Tagish people, respectively recalled:

*They go get shells, gun ... they get cloth material, calico they call it, blankets, then they pack it in, down to Ross River, Pelly. They trade it in, and they get fur, marten skins, fox skin, lynx, all different kinds of fur.... They take it out to Dyea, and trade it in again, for things. (Mrs. Dora Wedge, Chilkoot Trail Oral History Project, cited in Greer, 1975: 39)*

*Well, people used to go down to deal with those Coast Indians. They used to go down after beaver season closed in springtime; then they would go to Dyea. Then they would go over the summit – they've got a little boat – everybody's got their own boat to cross Lake*

*Lindeman, I guess, and when they got to the other end, that's the time they would go over*

*the summit and down to the coast, to Dyea. (Cruicksank et al., 1990: 150)*

While the Tlingit maintained strict control over coastal-to-interior trading routes throughout most of the nineteenth century, the Tlingit monopoly began to erode in the 1870s and early 1880s. Many early prospectors involved themselves in the very lucrative fur trade upon their arrival in the Yukon. Importantly, these trade ventures established capital, which later drove the prospecting endeavours of other miners. As the arrival of prospectors increased, so did tensions between the Tlingit and non-native groups. Miners demanded access to the interior through Tlingit territory, resulting in increased pressure on the Tlingit to defend against outside claims on their resources.

As a result of this increased friction, an agreement was reached between the Tlingit and Americans in 1880. The Tlingit agreed to lift their blockade to the interior on three conditions:

(1) prospectors would hire the Tlingit as packers;

(2) miners would not interfere in any way with the fur trade, and would be accompanied by Tlingit guides to ensure that the Tlingit trade stronghold was not disrupted, and;

(3) prospectors would use the Chilkoot Pass rather than the Chilkat Pass, which was considered a more important Tlingit trading route.

*After forty years fiercely protecting their territory, the coastal Tungit allowed a party of*

*nineteen prospectors to climb the Chilkoot Pass, arriving at the headwaters of the Yukon*

*River in June of 1880. The result was that the interior of the Yukon was now accessible*

*from all directions: upstream from the mouth of the Yukon at St. Michael, downstream*

*from its headwaters at Lake Lindeman, and from the Mackenzie basin to the east. The floodgates were open. (Porsild, 1998: 3)*

## A Change in Economy

With the opening of the Chilkoot Trail to miners, a dramatic shift in Tlingit economy ensued. The agreement between the Tlingit and the miners in 1880 resulted in the inauguration of a lucrative packing enterprise for the Tlingit. Following the discovery of large gold deposits along the Fortymile River in 1885, miners arrived in the region with increasing frequency, culminating in the Klondike rush of 1897–98 (fig. 9). Porsild observes that:

> *Between 1898 and 1900 tens of thousands of people passed through the Tlingit villages of Dyea at the foot of the Chilkoot Pass and Skagway at the White Pass before crossing the mountains to the northeast. The result was a sustained period of dramatic and important change for the coastal communities of the Lynn Canal. (Porsild, 1998: 38)*

The Tlingit of upper Lynn Canal seized the opportunity to traverse the steep and treacherous Chilkoot Trail, packing the miners' supplies and equipment for considerable fees. Through the early 1880s, prices were established and small groups of prospectors were regularly accompanied through the pass as far as Lindeman Lake (Neufeld and Norris, 1996: 43). Rates were negotiated, generally ranging from $9 to $13 per hundred pounds.

Revenue from their new packing enterprise effectively offset losses due to new trading competition from non-native fur traders in the interior. Packing also supplemented the traditional hunting and fishing economies. The enterprise was not without its problems, however, most often to the

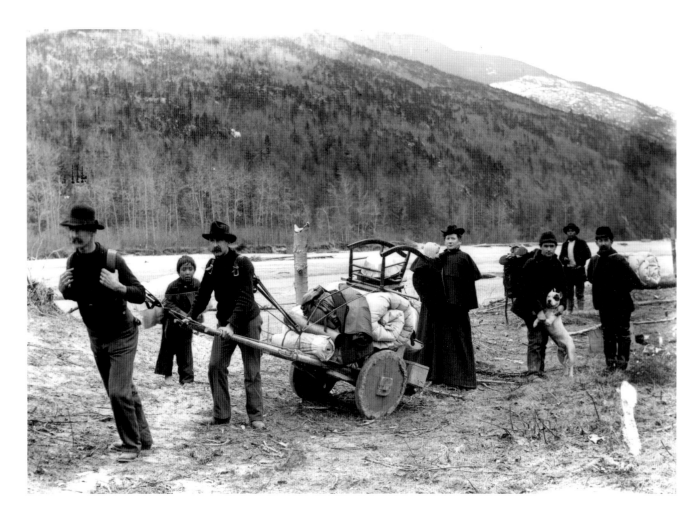

Rigours of the trail were as yet unknown to these stampeders fresh landed at Dyea.

detriment of the miners. As prospectors arrived in greater abundance, longer and more frequent delays were encountered as the Tlingit packers struggled to meet demands. Cultural differences also caused delays in crossing the pass; work would effectively cease when native men were busy with the fall hunt or when the whole village was preoccupied with marriage or other celebrations (Porsild, 1998: 41).

Increasing delays and high wages continued to challenge the Lynn Canal Tlingit monopoly. By the late 1800s, other Tlingit clans were involved in the packing trade, as were natives from throughout the Yukon. Other transportation measures were implemented, including a sled tramway for the pass and the arrival of pack horses. As the gold rush progressed, demand for Tlingit packers greatly diminished.

The search for gold had a dramatic impact on native groups throughout the Yukon. While the Tlingit occupying the Chilkoot Trail area witnessed a measure of economic gain throughout the early gold-prospecting era, these gains were secured at great detriment to their society and their health. The Tlingits' traditional subsistence base was disrupted, their territory was scarred through fires and tailing deposits, water was contaminated, disease decimated their population, and racist attitudes spread farther afield.

# Klondike Diversity: An International Stampede

The Klondike invokes images of rugged, determined men of mostly American heritage in search of fortune and lifelong wealth. Upon inspection, however, the Klondike presents itself as a mixture of men and women of diverse nationalities, ethnicities, and working backgrounds. The first census in the Yukon was taken in 1898 by the North-West Mounted Police. Concern regarding security and the need for electoral information prompted the census and resulted in questions related

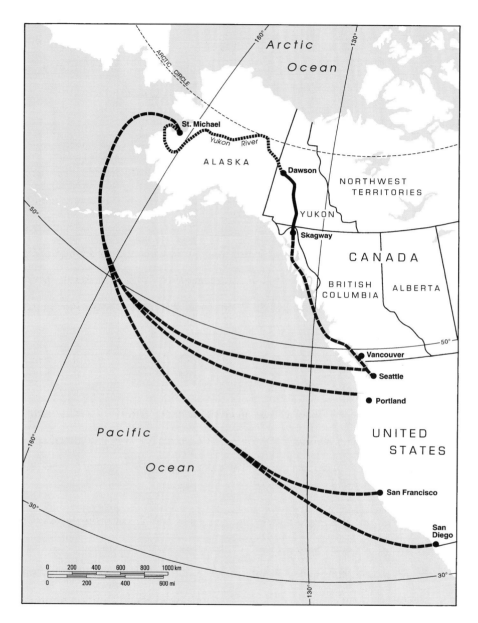

Fig. 9. Sea Routes to the Gold Fields.

largely to gender and citizenship of Klondike settlers. The results of the census showed that over 9,000 of the 15,000 people counted stated themselves to be American citizens. Almost 5,000 were recorded as British, including Canadians and others recognized as British subjects. Another 360 people reported themselves citizens of foreign countries.

This information led to the assumption that most Klondikers were American. A more thorough and detailed census undertaken by the Dominion government in 1901 revealed a different mix of nationals, however. This second census questioned Klondikers not only on their citizenship, which often corresponded to their last place of residence, but also on their nativity. Only forty percent of Klondikers were revealed to be Americans, not sixty percent as initially reported in the NWMP census [Census of Canada, 1901, vol.1, Table VI, cited in Morrison (1968: 412-13)]. Results from the 1901 census also reveal a rich diversity in the nativity of non-North American Klondikers. Porsild states:

> *When I compared the ethnicity and place-of-origin figures for non-North Americans, the picture changed dramatically. The number of people born in the British Isles, Scandinavia, and Continental Europe was at least double that of people claiming citizenship in those places. Overall then, the figure for the non-North American born rose almost exactly in proportion to the drop in the American citizenship/origin figure. (Porsild, 1998: 202)*

The international miscellany included Klondikers native to the British Isles, Europe, Australia, New Zealand, Mexico, South and Central America, Africa, Palestine, and Asia.

The occupations that Klondikers had so hastily abandoned to scramble northward were equally as amazing. The Klondike attracted commercial and professional workers, in addition to other skilled or unskilled individuals. The occupations seem endless – newspaper editors, lawyers, doctors, bankers,

teachers, architects, photographers, veterinarians, clergy, traders, merchants, managers, carpenters, butchers, tailors, blacksmiths, farmers, trappers and barbers; to cooks, dancers, laundry workers, peddlers, and prostitutes. What a potpourri of occupations, ethnicities, and nationalities to pour onto the trail! What an array of sights, sounds, and languages to splash along a rapidly denuding valley bottom, among alpine rocks and around upland lakes. What a hive of resolution and incompetence, ingenuity and incomprehension to inflict upon the timeless route. And what a contrast with today's traveller, the well-informed, well-equipped, fast-paced, and usually relatively well-off visitor for whom the trail is finite personal fulfillment rather than personal endurance on the road to uncertainty. Nature alone remains constant across the centuries, rarely benign and always demanding respect.

## Dangers of the Chilkoot Pass

Henry De Windt in the *Klondike: Chicago Record's Book for Gold-Seekers* had sobering advice to Klondike prospectors concerning the difficulty of travelling through the Chilkoot Pass in the fall, winter, and spring. His words of wisdom, garnered from the excruciating stampede experience of 1897–98, were instructive but already destined for the recycle bin of historic documentation as the gold rush disintegrated and the White Pass & Yukon Route railway presented an alternate and less demanding route inland.

*The journey to the Alaskan gold fields is a hard one for the well-equipped explorer, who travels in light marching order. The gold prospector, on the other hand, must carry a winter's supplies, dearly purchased at Juneau to be transported at ruinous prices over the Chilkoot pass.... No one should think of leaving Seattle for the Klondike later than September, and even at that date he would require to have his whole outfit packed over the*

*mountain. From Dyea to Lake Lindeman, the round trip requires three days, and it takes a good, husky man to pack 100 pounds over either route. As the necessary outfit for a man will weigh fully 1,000 pounds, you can easily see that it would take him thirty-six days to pack his outfit unaided over either of the passes alone.... The distance from Dyea over the Chilkoot pass to the head of Lindeman is twenty-four miles. A horse cannot go the full distance over the Chilkoot pass.... Now, anybody who thinks of leaving for the Klondike late in the season should be warned of the great peril he will encounter. If he should be frozen in at any point between the pass and Dawson he would be there till spring. I can easily demonstrate just how that would be. He has with him 1,000 pounds of dead weight. To move this in winter is almost impossible. The snow is dry and frosty, and a sleigh pulls very hard over it. The best a man could hope to do would be to haul 200 pounds, and with this he could make about fifteen miles a day. Say he starts from a given point, takes 200 pounds of his freight for seven and a half miles, and then comes back after his other stuff thus making his round trip for the day fifteen miles. You can see that it would take him five days to make seven and a half miles. The total distance from Dyea or Skagway to Dawson City is 578 miles. If a person should have the misfortune to be frozen in, my advice to him is to go ashore at once, build a small cabin, and prospect any small creek in the vicinity. This, of course, is on the supposition that he is not alone, but is a member of a party of several. (Chicago Record, 1898: 168-69; 174-75)*

There were moments of levity to offset the ever-present harsh realities of making Chilkoot Pass. One participant on March 17, 1898, described the challenge and adventure of a climb to and an optional form of descent from the summit in the spring snow:

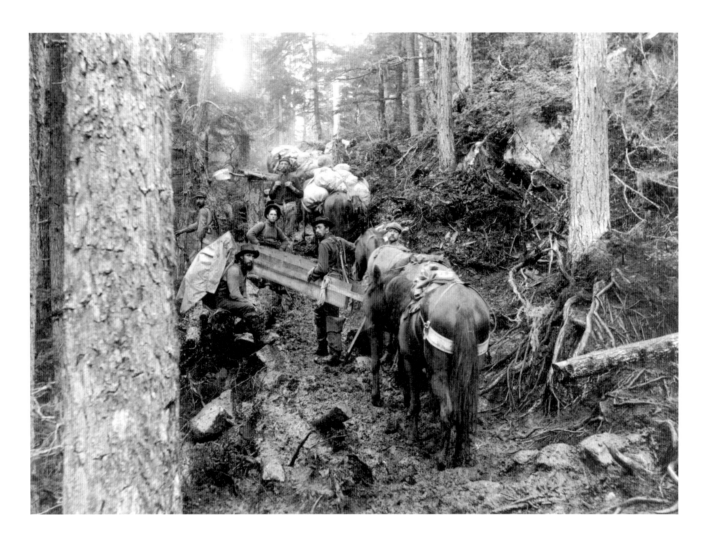

The summer Chilkoot Trail, a particular set

of challenges for humans and horses alike.

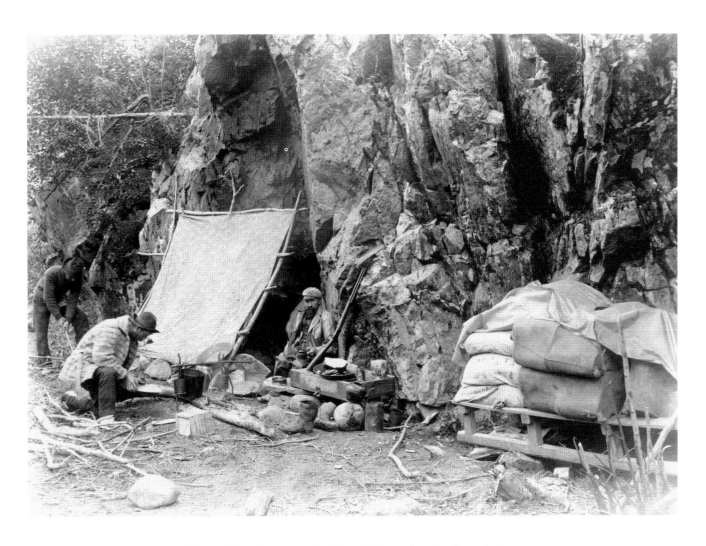

The gold rush spawned a river of humanity distributed along
the length of Chilkoot Trail.

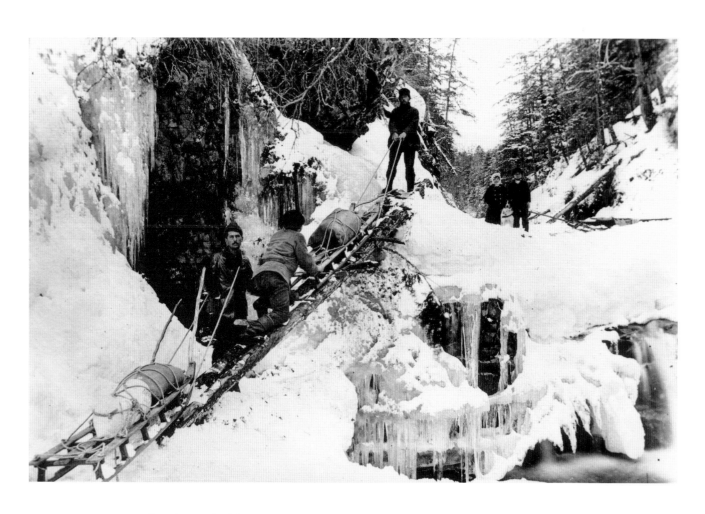

In winter, the Taiya River canyon presented a new set of travel challenges.

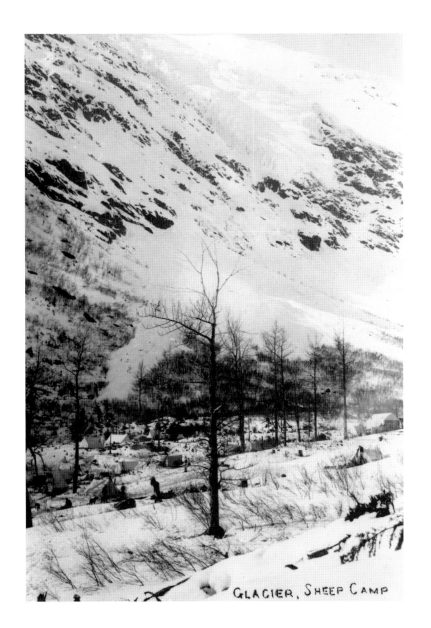

GLACIER, SHEEP CAMP

Encroaching mountains and valley slopes dominated Sheep Camp in 1897-98.

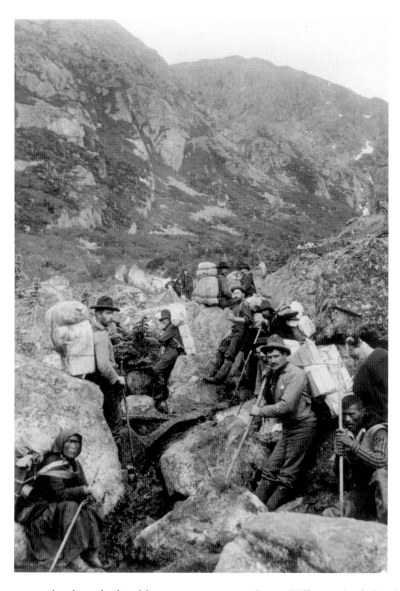

Enormous loads and a boulder-strewn route on Long Hill exercised the skills
and patience of aboriginal packers and stampeders alike – men, women, and children.

*I went to the summit of Chilkoot Pass. From Canyon City, six miles north of Dyea, it is seven miles to what is called the foot of the pass and it seems like forty when you walk it; but after so much has been accomplished, one's troubles have just begun. The ascent is say 500 feet almost straight up. It would be impossible to make the climb but for the snow, which is, on an average, 40 feet deep; this provides a footing and it required more than an hour for me to make the first summit, before the second climb, much steeper, was made, which landed me on the real summit of Chilkoot Pass.... When ready to leave, and it was not long the Indian guide said "do as I do" and proceeded to tuck his clothes under him, seated himself in the snow on the edge of the slope, and away he went down the side of the mountain. I followed. The experience was exciting and after crossing the level plateau, took another slide reaching the bottom in less than a minute, while it had required more than an hour to mount. In watching a man descend it looks for all the world like a cloud of snow shooting down the mountain, and the victim lands at your feet; such is the Chilkoot Pass. (Robertson, 1940: 134-37)*

Within a month, other "clouds of snow" and other "victims" cast an entirely different perspective on the late winter landscape. The April 3 Palm Sunday avalanche between Sheep Camp and the Scales took about seventy lives. It is recorded as the most deadly gold rush occurrence on Chilkoot Trail, one of a number of avalanche and flood conditions to take more than 100 lives during the stampede.

*A blinding snowstorm was raging all day upon the summit, and as a consequence many of those in the vicinity were making no attempt to travel. Thousands of people were encamped in the vicinity of the accident at the time, and were soon upon the scene rendering*

*such assistance as possible. Upon receipt of the news, points below Dyea telephoned up to know if assistance was required, and received an answer to the effect that 5,000 people were at work on clearing the debris and were only in each other's way. Thirty-one bodies in all have been recovered. The horror of the Dyea trail is growing in magnitude hourly. As the work of rescue proceeds it becomes more apparent that many more lives were lost than at first thought possible. It is now believed that between 50 and 100 men and women were killed by the misadventure. Many bodies will not be recovered until the summer sun melts the tons of snow and ice that now bury them from sight.... Two or three thousand men are working in relays of as many as can stand side by side, shoveling away the debris in search of the dead and dying. Twenty-two bodies have been recovered and identified, and 25 have been taken out alive. Seventeen employees of the Chilkoot Railway and Tram Company who went up to the summit on the morning of the slide to work are missing, and it is feared that they are among the lost. It is estimated that 10,000 tons of outfits are buried under the snow and ice.*

*There were several smaller slides before the death dealing avalanche was started. About 2 o'clock in the morning a small slide occurred, which buried several cabins. The alarm was spread, and many people were endeavoring to work back to Sheep Camp when the big one came. The snowstorm was blinding, and crowds were coming down by the aid of a rope when overtaken.*

*The exact location of the slide is given at two and a half miles above Sheep Camp, and one hundred yards above the Oregon Improvement Company's power house. Here an im-*

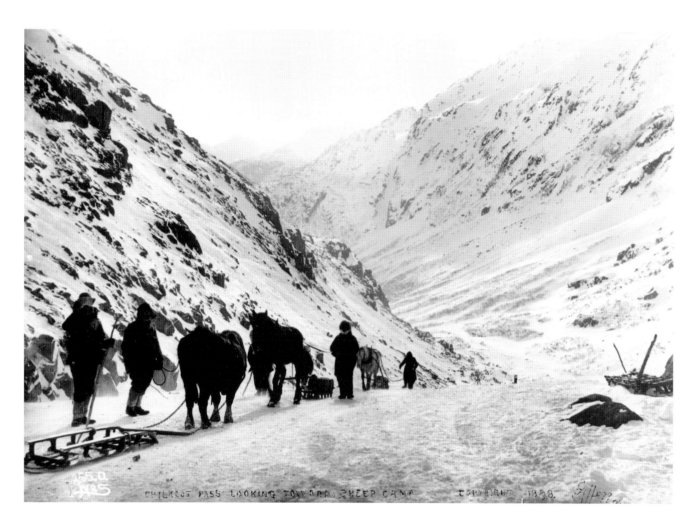

Winter on Long Hill dramatically altered both the land surface

and transportation options.

*mense gorge rises at a very steep incline into the hills, and it was down this the avalanche came. The telephone office here has been thronged all day and night with people anxious to get some word of the disaster. Many people have gone from this city and Dyea to Sheep Camp to aid in the work of rescue. It is believed that when the full returns are in the dead will number nearer 150. (Robertson, 1940: 134-135)*

Mr. J.A. Raines of Maine, a fortunate avalanche survivor, described his ordeal as follows:

*All of a sudden I heard a loud report, and instantly felt myself going swiftly down the hill. Looking around I saw many others buried, some with their feet out and head buried out of sight, and others vice versa. When I struck the bottom I tried to run, but the snow caught me and I was instantly buried beneath thirty feet of snow and rock, being on the verge of death by suffocation when I was reached by rescuers. I think the slide occurred about 11 a.m. I am thankful to be alive today. Many I presume, were saved by taking hold of a rope for hauling freight up to the summit. By this means forty or fifty were pulled out, battered and bruised more or less, but glad to be alive at any discount. I never want to nor expect to experience such an awful half hour again as long as I live.*

*The awful snow slide starts in a blue smoke of snow far up the mountain side, and acres of earth, rock and forest all come down in a fierce sweep of its mighty current. There has probably been a snow slide in the Chilkoot Pass twice a year for centuries, but now at last there are people in front of the slides, and the northern land will not cease to write sad records of death from this cause. (qtd. in Robertson, 1940: 136-37)*

The commentary was apt. Aboriginal packers drawing on acquired knowledge of weather and landscape refused to pack above Sheep Camp on Palm Sunday. Experience gained from earlier winter travels to and from the interior was invaluable in this instance. Likely, however, First Nations also had known similar loss in previous times in their trade routes and were without benefit of the rescuers who have materialized in more recent times.

Such likely was the fate of Kwaday Dan Sinchi (Long Ago Person Found) whose remains were discovered in 1999 at the foot of a melting glacier in Tatshenshini – Alsek Provincial Park near the British Columbia–Yukon border. This is the traditional territory of the Champagne and Aishihik First Nation, and the remains were those of a seemingly young and healthy hunter in his late teens or early twenties who probably died of exposure in a snowstorm. His weapons and items of clothing were found nearby. What is remarkable about Kwaday Dan Sinchi, an individual about whom science will tell us more in the near future, is that he died approximately 550 years ago. From the perspective of our Chilkoot Trail story, he is further testimony to the widespread and long-term use that First Nations of the Pacific Northwest made of their mountain environments. Other melting snowfields doubtless will reveal still more evidence of such use.

## The Tidewater Communities

Left behind by the Klondikers on tidewater at the head of Lynn Canal were the two staging points which had introduced them to the rigours of the northern environment. Dyea and Skagway epitomized all frontier towns across the landscape of nineteenth-century gold rushes. Instant townscapes, frenetic, lawless, awash in rumours, deals, and despair, they were magnets to a constantly changing cast of shrewd entrepreneurs, scoundrels, and those trying by whatever means to simply get by. The two communities disembarked the masses from the south, provided temporary succor, and sent people

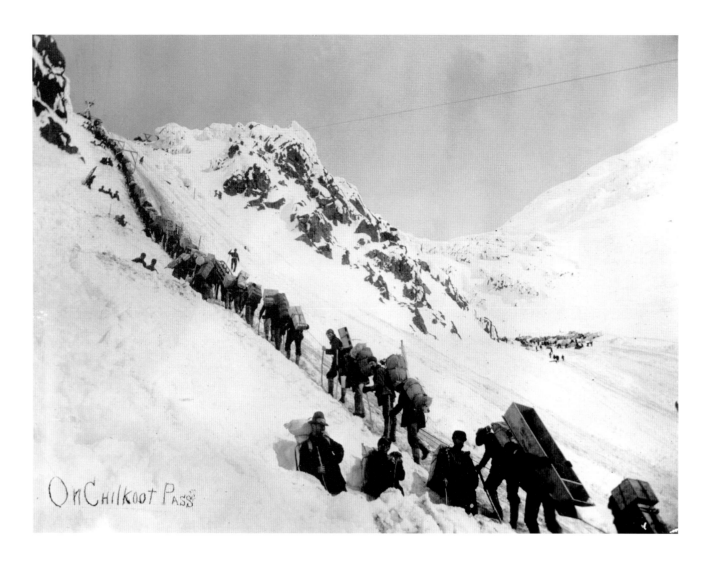

On Chilkoot Pass

The Golden Stairs, fabled gateway to the upper Yukon River basin

and the distant gold fields.

on their way to whatever future would befall them. The fate of each community would mirror the fortunes of the respective routes to which it provided entry.

Dyea at the mouth of Taiya River was the stampeders introduction to the Chilkoot Trail. Originally a personal hunting and fishing camp, then a settlement of native packers and a trading post from 1885, the community witnessed passage of a small number of mining and government exploring parties in the twenty years preceding the Klondike Gold Rush. From a village of perhaps less than 1,000 souls in the summer of 1897, Dyea exploded with a transient population fluctuating between eight and ten thousand during the next several months. More than 150 businesses were established in Dyea, including several breweries, hotels, restaurants, a postal service, and provision supply houses.

Today, Dyea is a ghost town. The town structures are long gone, its contemporary fame vested in the cemetery in which lie the gold seekers killed by avalanches in the spring of 1898. Dyea's demise was as sudden as its rise. By July, 1899, passage by rail from Skagway to Bennett seemed infinitely more practical and safe than the hazards posed by the Chilkoot route. There was no reason for the town to continue. Ships now docked exclusively at Skagway and no road would reach Dyea for another forty years. Backpackers today spend little time about the place. Dyea, it seems, was destined to be a transition point, a fleeting memory.

Skagway has survived. Gateway to trail, then railway and road across White Pass, it revels in and remains alive on the strength of its historic association with facts and legends of the northern gold rushes. It has become a sanitized re-creation of its original self, host to fleets of cruise ships disgorging at its piers ever more international populations eager to sample the ambience of 1898. The symbiosis is itself historic. Once breached, the mountain passes remarkably quickly became the means for tourists to follow in the wake of the gold seekers. Atlin, Whitehorse, and Dawson became exotic locales to absorb in leisure what had so recently passed into history. Skagway and its entrepreneurs, who faced

an uncertain future once the gold rush passed, were able to capitalize on our continuing fascination with the gold rush. The presence of the White Pass & Yukon Route railway, a gradually improving northern road network, and ultimately the Chilkoot Trail would facilitate access to that experience.

Today, registration requirements make Skagway the formal entry point to the Chilkoot Trail. We found the summer chaos of the town's streets to be strangely at odds with the several days of relative solitude and silence we were to experience on the nearby trail. The contrast also brought sharply into focus that it is possible to juxtapose high-density facilities-based tourism and low-impact ecotourism. Of course, the conditions for these facets of modern tourism had long since been established in the rugged landscape of the region and historical sequence of human responses to the mountain barrier and paucity of valleys and passes permitting entry from Pacific coast to northern interior. When combined with judicious planning and management for sustainable tourism, the end effect is to demonstrate that intense recreational development and ecotourism can be successfully integrated for benefit of both ecotourism and human community.

## Whose Trail Anyway?

Today the status of the Chilkoot as an international trail seems to be accepted at face value by visitors. To the casual eye, it derives from the not-unusual practice of using crests of mountain ranges to identify boundary lines. What we did not fully appreciate before our own journey was that the Chilkoot was included in a long-drawn-out political process involving American, British, Canadian, and Russian interests and dating from the Russian–American Treaty of 1824 and Anglo-Russian Treaty of 1825 to the Alaskan Boundary Tribunal of 1903. The Chilkoot Trail would play a role in that process, both in regard to which territory the trail occupied and the role of gold strikes (Cassiar, Forty Mile, Klondike) in international boundary decision-making. The presence of the North-West

Mounted Police at Chilkoot summit to enforce Canadian sovereignty during the gold rush reflected upon the long-standing issue of territory and a boundary agreement yet to be formalized. The area in dispute is shown on figure 10. So rancorous was the international dispute that publicly in England and the United States there was speculation that war would erupt over the imperial designs of the major powers. The situation was complicated by Canadian aspirations regarding nationhood and ongoing disputes with the United States in the matters of economic protectionism and economic expansionism. These momentous historic events combined with imprecise knowledge of its geography to make the Alaska Panhandle boundary an international flashpoint.

The origin of the boundary dispute lay initially in eighteenth-century explorations of the northern Pacific region by the Russians and British – and later the Americans – and territorial claims and trading activities of the Russians. By edict, in 1799, Emperor Paul of Russia granted the Russian-American Company a trading monopoly centred on furs, across the Pacific Ocean from Asia to America, north of latitude 55°. Later, as the Russian hold on trade became more tenuous a further edict extended Russian-American Company privileges to 51° in North America, thereby extending the company's exclusive trading, whaling, and economic privileges. Foreign ships could not approach American and Asian coasts closer than 100 Italian miles (1 Italian mile = 6,085.2 feet or 1,854.8 m).

The Russian position denied the doctrine of freedom of the seas, a position particularly unacceptable to British and American interests as these increasingly turned to boundary-making in the Pacific Northwest. International negotiations followed. The Russian–American Treaty of 1824 divided Russian and American spheres of influence at 54° 40′ latitude; Russia gave up its maritime exclusion and granted American navigation, trading, and fishing privileges on the coast. The Anglo-Russian Treaty followed in 1825 with essentially the same provisions. Britain demanded, however, that 141° W longitude rather than the 139° desired by Russia divide land from the Pacific to the Arctic Ocean and

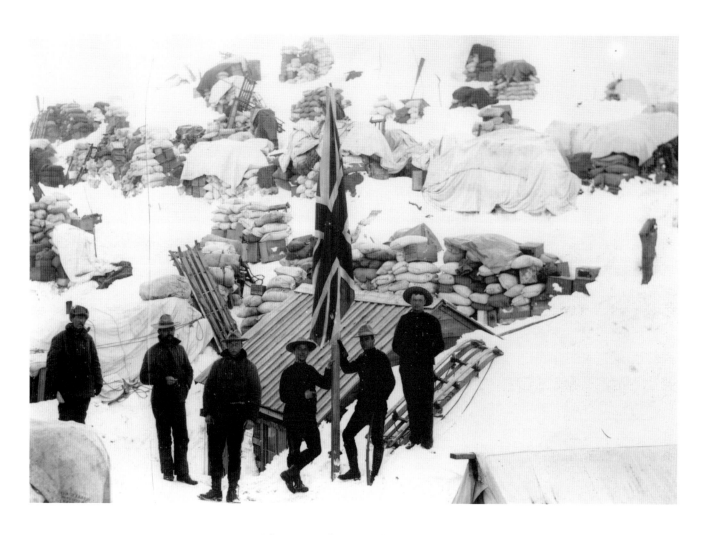

With customs house and Maxim gun,
Canada's North-West Mounted Police succeeded the Tlingit as masters of Chilkoot Pass.

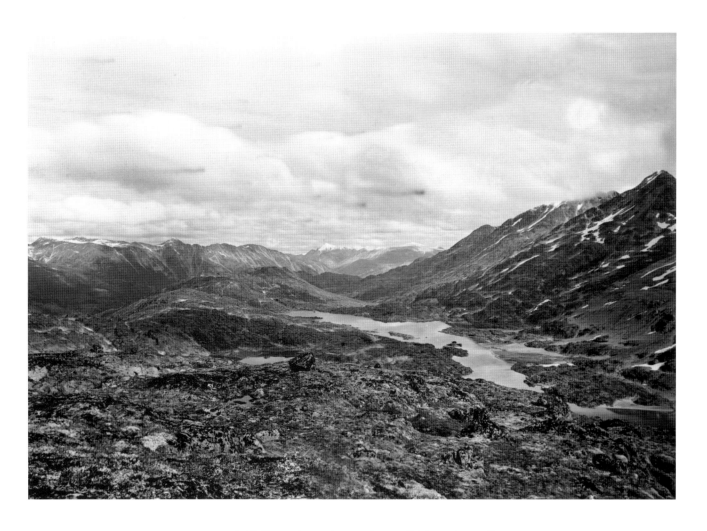

Beyond Chilkoot Pass, the confines of Taiya River valley
were replaced by endless horizons of the vast interior plateau.

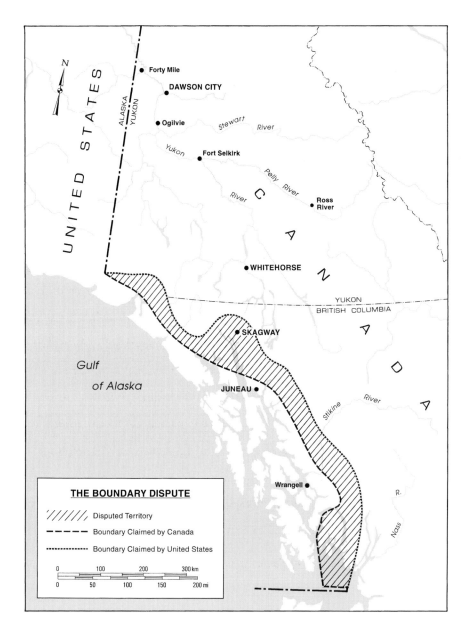

Fig. 10. The Boundary Dispute (after Minter, 1987).

"Canada received the Klondike as a result of that concession" (Penlington, 1972: 10). The adjustment arose apparently because Russia was to receive all of Prince of Wales Island.

The Treaty of 1825 addressed the boundary to be established in the Alaska Panhandle and is worthy of full quotation because of its later implications for a final boundary delineation in 1903 and the effect of denying British and later Canadian territorial access to the sea. Articles III and IV of the Treaty state:

*The line of demarcation between the Possessions of the High Contracting Parties, upon the Coast of the Continent, and the Islands of America to the North-West, shall be drawn in the manner following:*

*Commencing from the Southernmost Point of the Island called Prince of Wales Island which Point lies in the parallel of 54 degrees 40 minutes North latitude, and between 131st and 133rd degrees of West longitude (Meridian of Greenwich), the said line shall ascend to the North along the channel called Portland Channel, as far as the Point of the Continent where it strikes the 56th degree of North latitude; from this last-mentioned Point, the line of demarcation shall follow the summit of the mountains situated parallel to the coast, as far as the point of intersection of the 141st degree of West longitude (of the same Meridian); and, finally, from the said point of intersection, the said Meridian Line of the 141st degree, in its prolongation as far as the Frozen Ocean, shall form the limit between Russian and British Possessions on the Continent of America to the North-West.*

*IV. With reference to the line of demarcation laid down in the preceding Article, it is understood:*

*1st. That the Island called Prince of Wales Island shall belong wholly to Russia.*

*2nd. That wherever the summit of the mountains which extend in a direction parallel to*

*the Coast, from the 56th degree of North latitude to the point of intersection of the 141st*

*degree of West longitude, shall prove to be at the distance of more than ten marine leagues*

*from the Ocean, the limit between the British Possessions and the line of Coast which is to*

*belong to Russia, as above mentioned, shall be formed by a line parallel to the windings of*

*the Coast, and which shall never exceed the distance of ten marine leagues therefrom.*

Russia chose to cartographically represent the boundary on the basis of ten leagues – approximately thirty miles (48 km) – distance from the coast (fig. 11), an action unprotested by Britain and a boundary line accepted by the United States when it purchased Alaska in 1867 (fig. 12). "Once Britain had acquiesced in the Russian interpretation of the Treaty of the 1825," states Penlington, "sixty years of map precedents unanimously fortified the interpretation" (Penlington, 1972: 14).

The Alaska purchase added strength to the need for formal boundary fixing as issues of state sovereignty gained momentum over the activities of trading companies such as the Hudson's Bay Company. The actual push for boundary settlement arose in part from the gold rushes. A gold rush to the Cassiar Mountains of British Columbia and identification of the coastal range at fifteen to nineteen miles (24 to 30.4 km) from the coast brought the first American acknowledgement that an alternative could exist to the ten league map line. From British Columbian and Canadian perspectives, between 1884 and 1903 various maps produced by the respective governments identified their growing claims in Alaska (see fig. 13). These claims universally had the Chilkoot Trail wholly within Canada in concert with a diminished American territory on the mainland of the Alaska Panhandle.

Americans saw the situation quite differently. "The United States interpreted the 1825 treaty to claim territory extending 16 to 19 km (10 to 12 mi.) inland of the Chilkoot and White Pass summits. Canada, however, felt that the treaty gave them sovereignty over Skagway, Dyea, the entire length of

both trails, and most of the territory between Skagway and Juneau" (Neufeld and Norris, 1996: 129). Adding to the frustration for Canadians in the Northwest was the fact that, while Canada considered the end of Lynn Canal to be disputed territory, the national government did not protest the "founding" of Dyea and Skagway in 1897. There were other actions to be taken regarding boundary claims and sovereignty, and perhaps it would be better to keep this issue in abeyance.

With the advent of the Klondike Gold Rush in 1897–98, Canada also was frustrated by the fact that most of the Klondike miners were reported to be American, the United States seemingly would persist in its position on the boundary of the Panhandle and was using its political power to facilitate entry of American miners into the Yukon. A first-class international crisis seemed to be in the making. Then:

> ... the United States exerted pressure apparently to force the making of a temporary boundary which Canada had first proposed. Early in April, 1898, the officer commanding troops at Dyea officially demanded, apparently on the authority of the Acting Secretary of War, that the Canadian police stop exercising jurisdiction at the summits of the Chilkoot and White Passes and at Lake Lindeman. Canada had proposed a temporary boundary at the Chilkoot summit. The United States agreed, and widened the proposal to include the summits of the White and Chilkat Passes. Canada concurred in the boundary on the summit of the White Pass but not on the Chilkat Pass because that pass exceeded ten leagues from the sea. It was not until October 20, 1899, that Britain and the United States officially agreed to a temporary boundary on all three passes. (Penlington, 1972: 38)

The reality on the ground was that a tense, confused, and potentially explosive situation had developed as each week of the gold rush passed. International efforts to date to resolve the whole Alaska

Fig. 11. Russian Imperial Map, 1827 (Penlington, 1972).

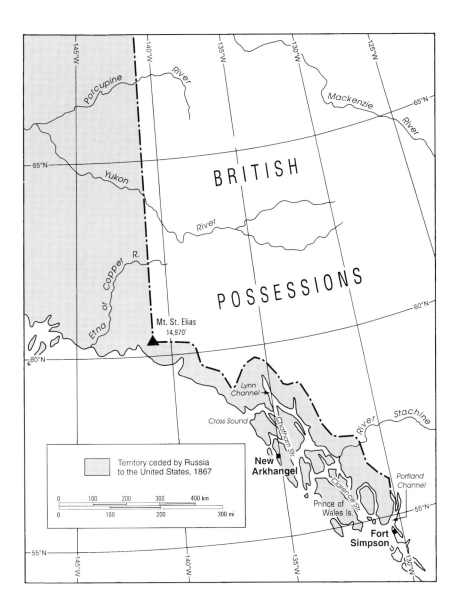

Fig. 12. Territory Ceded by Russia to the United States, 1867 (Penlington, 1972).

77

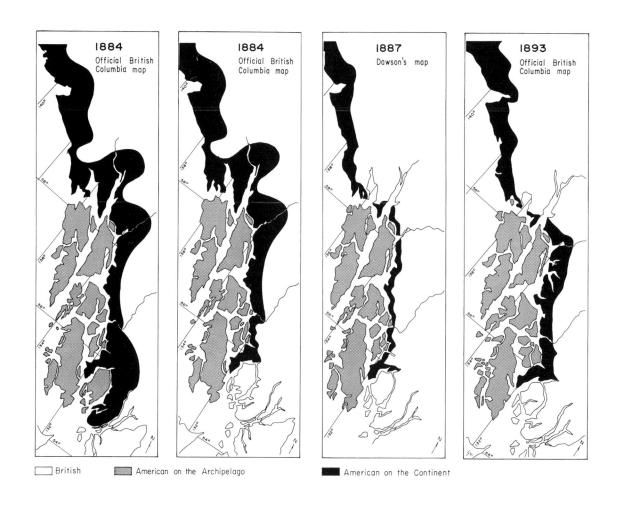

Fig. 13. British Columbian and Canadian Claims, 1884-1903 (Penlington, 1972).

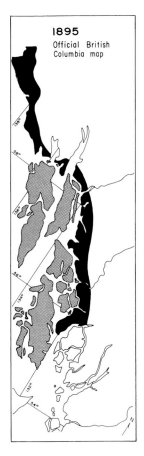

**1895**

Official British
Columbia map

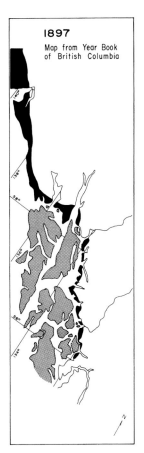

**1897**

Map from Year Book
of British Columbia

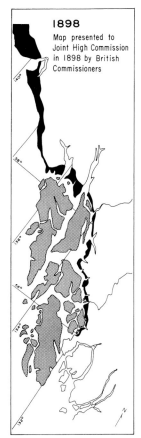

**1898**

Map presented to
Joint High Commission
in 1898 by British
Commissioners

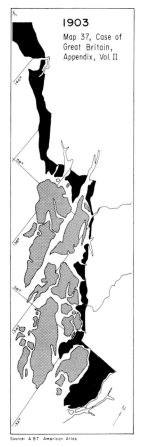

**1903**

Map 37, Case of
Great Britain,
Appendix, Vol. II

Source: A.B.T. American Atlas

boundary issue had not broken the deadlock, and, with each gold discovery, the relationship between boundary location, mining regulations, and customs duties became even more contentious. These issues had arisen in the Cassiar and Forty Mile strikes, in the latter instance resulting in the North-West Mounted Police's arrival in the Yukon in 1894 to impose mining regulations and collect customs duties. The issue of where the boundary was to be located was not only a matter of sovereignty, it carried with it potentially immense economic implications in a region where for most of the nine-teenth-century boundary-making had remained peripheral to more consuming world events.

*Those familiar with conditions in the Yukon basin were well aware that miners and prospectors needed almost a ton of food, clothing, and mining equipment to sustain them for a year. These supplies cost at least $500 per person. Considering the tens of thousands of stampeders who poured into the Yukon during the rush, the value of those outfits has been estimated at between $40 and $100 million. This amount is especially significant when compared to the 1900 Klondike peak gold production of about $25 million.*

*The country that collected customs duties stood to receive a huge financial windfall. Fur-thermore, customs duties were collected only on "foreign" goods, that is, goods not pur-chased in the country in question. This meant that the country collecting customs duties could influence miners to buy the vast mountain of needed supplies in their country's stores. There was no income tax in the 1890s; the bulk of government revenues in both Canada and the United States came from customs duties, excise taxes and licence fees. Therefore, the Klondike stampede was potentially a huge money-maker for governments as well as businesses. (Neufeld and Norris, 1996: 129)*

*What angered [Canadians] were the [presumed] economic advantages that resulted from the United States control of the Panhandle. Expensive mining outfits bought in Canada, for example, had to be transported across the Panhandle either in bond, which required payment of an accompanying convoy fee up to $9.00 per day or payment of American duties. American outfits of course had to pay Canadian duties. But after convoy or duty payments were added to the value of the Canadian outfits, Canadians received little economic advantage in selling Canadian mining outfits. (Penlington, 1972: 36)*

Once again, Americans saw the situation quite differently. Neufeld and Norris observe that, as early as 1896:

*Treasury officials noted miners heading into the Yukon no longer purchased supplies at Juneau, their usual jumping-off point. The high duties paid on American goods, and improved supplies in the Yukon, encouraged miners to purchase their outfits from Canadian suppliers.*

*With more than a score of Mounted Police already in the region, the Canadian government had a distinct advantage. However, the overwhelming number of Americans in the rush and the tenuous supply lines through American territory made the Mounties very aware of the weakness of their position. (Neufeld and Norris, 1996: 129-30)*

Both Canadian and American authorities engaged in a series of measures and counter-measures to bolster their sovereignty claims, but both had to contend with the tidal wave of people taking passage through the Alaska Panhandle and northwards into Canada's Yukon. For its part, the NWMP established posts at Tagish (September 1897), then southwards in Bennett (October, 1897), and then even farther south to the White and Chilkoot passes (February, 1898). The response from Americans from

late 1897 was to variously dispute payment of Canadian customs duties, to demand U.S. troops on the ground at Taiya Inlet, and, in the case of the Alaska government, to press boundary claims north of Chilkoot Pass through registering an official Lindeman town plan with the United States government. The prospect of violence from the stampeders and local officials was very real; common sense arrangements had to prevail on the part of both national governments to defuse the volatile situation.

By mid-December, 1897, "U.S. customs officials institute[d] a convoy system on Canadian goods travelling in bond through U.S. territory. The related costs equal[led] the duty charged on American goods at the Canadian boundary" (Neufeld and Norris, 1996: 131). Five months later, the convoy system ended; instead, American customs officials were at the summits to check bonded goods. The number of American troops at Skagway and Dyea was reduced. On behalf of Canada, the NWMP withdrew its detachments to Log Cabin and Lindeman, and the governments of both nations agreed to resolve the matter of the boundary by means of arbitration.

The Alaskan Boundary Tribunal rendered its decision exactly four years to the day after the temporary boundary had been established. The decision stands today. The boundary with some localized exceptions – including extending the line twenty miles inland beyond the temporary boundary in the Chilkat Pass area – was much as shown by the Russians several decades before. The boundary at Chilkoot summit was formalized. Canada remained without a port on tidewater and almost a century of sometimes furious political activity was brought to an uneasy conclusion (fig. 14).

When the boundary was formalized on October 20, 1903, it "set off one of the most concentrated expressions of resentment in twentieth-century Canadian history" (Penlington, 1972: 1), not least because the British representative cast the key vote that guaranteed victory for the United States position on where the boundary line should be drawn. The boundary decision demonstrated Canada still to be a youthful player on the world stage, unable as yet to find full voice in world political and

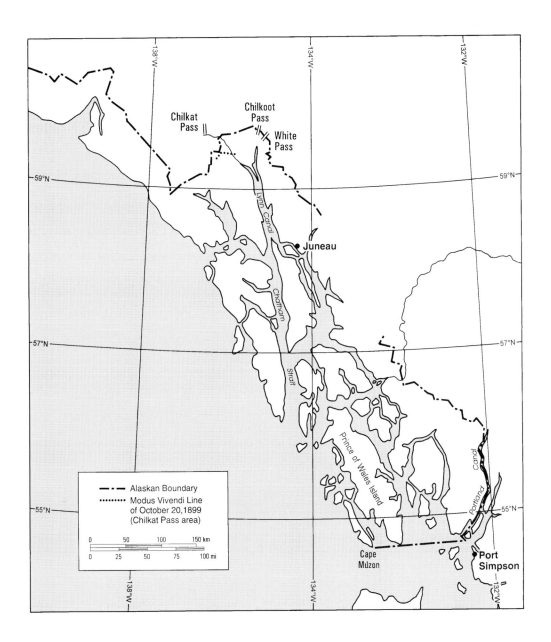

Fig. 14. Decision of the Alaskan Boundary Tribunal, 1903 (after Penlington, 1972).

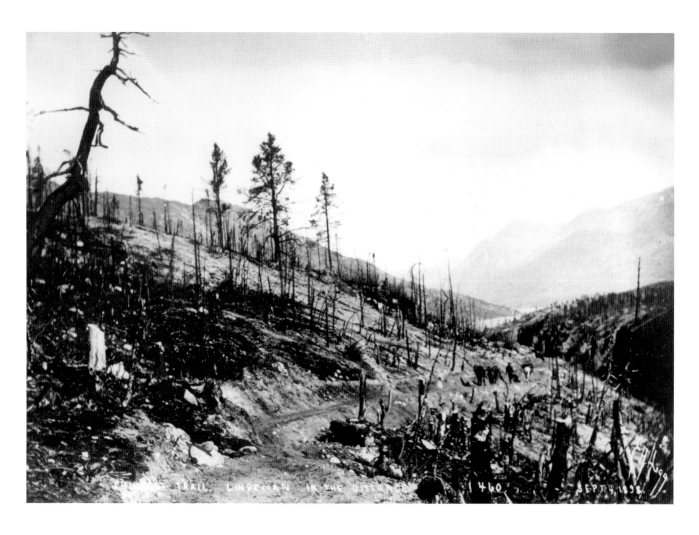

A frenzy of cutting denuded ancient forests,

in this instance where Chilkoot Trail approached Lake Lindeman.

84

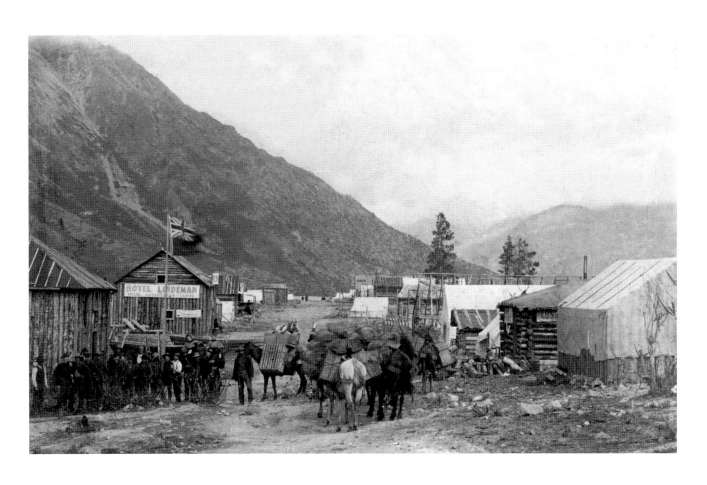

Lindman City epitomized the ephemeral gold rush communities of 1897–98.

economic debates. As hikers cross Chilkoot Pass, however, they should also understand that Canada acted with alacrity to defend its national interest in a hinterland suddenly transformed to the world stage. The boundary dispute, in retrospect, was an important contribution to Canada's nation-building, for the Americans a sounding bell as to their northern neighbour's tenacity, and for both countries an instructive experience in frontier bilateral relations. Today, it seems remarkable that, for a time, the NWMP mounted machine guns on Chilkoot Pass; it is even more remarkable that the international boundary does indeed lie along the summit.

## Tourism as History

Tourism develops, in part, to service our celebration of historic places. Occasionally, tourism itself becomes a seamless extension of that history. So it was for the Chilkoot Trail, for "Even as the last stragglers of the stampede moved on and the brush grew back over the ragged ruins of the trail communities, a few tourists and hikers began to explore the trail, reliving the excitement of the rush" (Neufeld and Norris, 1996: 147). These initial visits were sporadic, the trail being difficult of access and perambulation. As it became a generalized route more than a specific trail over the next six decades, the Chilkoot was passage to only occasional travellers until the advent of modern trail-building in the 1960s. First Nations people used it to walk between Carcross and Dyea or Skagway and "the occasional miner wishing to avoid the train fare still used it as well" (Greer, 1995: 80). The International Boundary Commission passed that way in 1906, and during the 1930s there began a series of adventurous expeditions by youth groups along the lost trail.

Finally removed from untold hundreds of years service as a travel and trade route, briefly in world headlines, its landscape battered and littered by the stampede of thousands, the route through the Taiya River valley and upper Yukon River watershed had time to salve or erase some of the Klondike's

worst impacts. This hiatus would prove invaluable to today's Chilkoot Trail. Tourism developments that would evolve into today's mass visitation through Skagway continued as the Chilkoot slumbered. By the time the Chilkoot Trail again opened up, it was possible to introduce a management system capable of supporting modern ecotourism.

Tourism was made possible in the Chilkoot area by the very vehicle that had robbed the trail of its utility – the White Pass & Yukon Route railway. When combined with Pacific coast sea travel and the presence of Skagway as an established community, the transportation thread was there to lure tourists farther afield – even to Dawson City – with vessels such as the *M.V. Tarahne* (on Atlin Lake), the *S.S. Klondike* (on Yukon River), the *Gleaner* and the *Tutshi* (on the southern lakes), and more exotic modes such as a tramway on the Graham Inlet of Tagish Lake. Construction of the Alaska Highway and subsequent northern roads would only add to Skagway's role as a tidewater node. Astonishingly, perhaps, in the light of the frontier or wilderness imagery attached to the Klondike Gold Rush, Alaska's Inside Passage route had begun to draw excursion ships in the decade *before* the gold rush.

> *When the gold rush exploded, these vessels merely added an extra day to their itinerary to visit the new town. Skagway's first tourist steamer arrived in July, 1898. Visitors joined local residents to celebrate the inaugural train on a newly-completed section of the railway. The following year, the chamber of commerce was urging local residents to prepare for the upcoming tourist season, and the first Skagway Clean-up Day was scheduled to beautify the streets and yards. (Neufeld and Norris, 1996: 144)*

What a contrast to the popular imagery of Skagway as wild frontier, controlled by the ruthless "Soapy" Smith gang, which was destroyed in the very month the first tourist arrived! And seemingly, what conformity by civic leaders with those of all tourist centres where tourism likewise was life-blood!

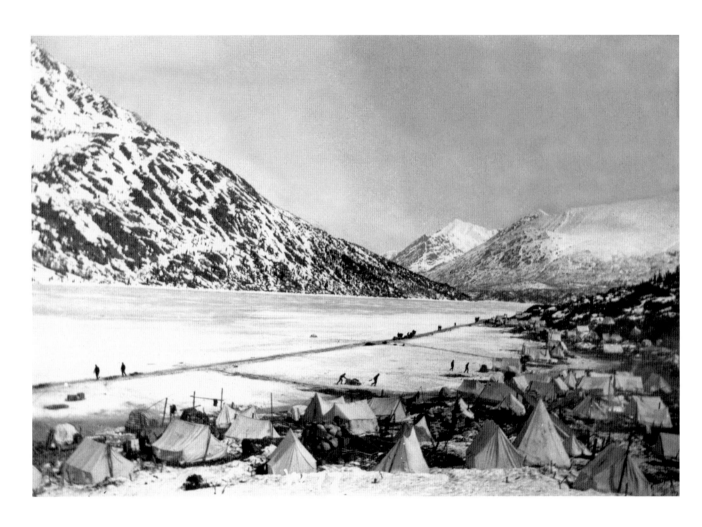

Winter ice on Lake Lindeman, convenient for local travel but an impediment

to extended travel on the Yukon River system.

The only direct ongoing contact between the Chilkoot Trail and regional tourism development until the 1970s happened at Bennett. The railway was built to the lakeside community by July, 1899, and onwards to its terminal point at Whitehorse in 1900. The driving of the last spike at Carcross took place on July 29 of that year. Gazing upon the slowly disintegrating remains of a gold rush community condemned through completion of the White Pass route, train passengers could eat lunch and contemplate history. Bennett railway station – "the eating house" as it was delightfully known to locals – became part and parcel of the daily livelihood of the Johnson family, who lived at Bennett between the 1920s and the 1970s.

> *As the local Indian family, the Johnsons were an important attraction. The Johnson children and grandchildren recalled having their pictures taken by passengers during the train stop at Bennett. The visitors photographed the children, their dog team, and the family's winter fur harvest. The family popularity with photographers led Mrs. Johnson to have her own postcards manufactured for sale. (Greer, 1995: 115)*

Mrs. Winnie Atlin, the last surviving member of the family of Martha and Billy Johnson, recalled that "In the summer, my mom and us kids we used to get together and do a lot of beadwork. There's lots of tourists there then. We'd have 500 or 600 tourists every day" (qtd. in Greer, 1995: 114). The beadwork and sewn garments of First Nations were and remain exquisite – gloves, moccasins, and other items, especially those made of white (non-smoked) goat skin.

> *[Goat skin] Yeah, it works really nice. It makes a good trimming. The hair doesn't fall off like rabbit fur. Rabbit hair falls off, goat doesn't. I like sewing with goat and beaver. Beaver hair doesn't fall off either.*

*Like for the big skin, the big goat she [mother] would take the hair and flesh off and make the skin. Use the skin for mitts, moccasins and stuff like that. If they got a little goat she would leave the hair on and flesh it, tan it, and leave the fur on. She would use that for trimming. That is what she trimmed her slippers with and mitts and all that stuff.*

*My mom used to look after her tools. She had things for everything. Like skinning gophers … it's made out of moose bone too. They say caribou bone was better than moose…. (qtd. in Greer, 1995: 107)*

The family links with the Chilkoot Trail were intimate as both parents packed on the trail. Billy had been a regular member of Skookum Jim's packing crew working the trail in the 1880s and 1890s. He was there to recover bodies from the Easter avalanche of 1898, and he helped build the White Pass railway. Later, he would prospect with the famous man in Kluane, Teslin, and Atlin. In one intriguing closure to Bennett's gold rush days, Billy was one of the Carcross group who in 1899 rafted supplies from Bennett to the new railway point for construction of Skookum Jim's house, the first frame house in the village. Billy originally was from the Juneau area; Martha's roots were there too, and the Taku River area. Their first three children were born in the Atlin area, the others around Carcross. The Johnson's travels across a large region are indicative of just how much First Nations people moved about the land, hunting, fishing, and berry-picking for country foods, trapping for fur, and working at various jobs brought about as mining, transportation, and tourism activities penetrated the Northwest.

The Johnsons also epitomize the role that Carcross/Tagish people have played in tourism for a century, as the area moved into a new economy fuelled increasingly by tourism-related activities. First Nations people provided country foods to the railroad – moose or caribou stew was for long a staple on the Bennett lunch menu – to the vessels plying the lakes to the 1950s ["Annie and I used to fish for

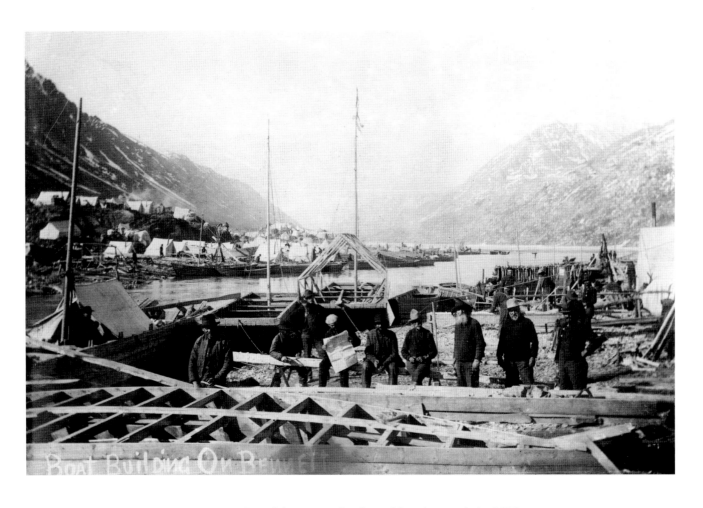

Bennett, point of departure for the gold rush armada in 1898,

point of convergence for Chilkoot Trail and the WP & YR railway in 1899.

the steamboats, the *Tutshi* and others in the summer. We'd catch and sell 200-300 pounds of fish to the tourist boats. We had 13 nets to supply the *Tutshi* (John Good, qtd. in Greer, 1995: 114)], and to businesses in Atlin, Carcross, and Whitehorse. Berries, one of the most important country foods, also were sold in these communities. There would be blueberries, raspberries, mossberries, blackberries, and high-bush cranberries.

> *The exciting time up there in Bennett is August, when there's a lot of people come up, picking berries. There's mostly women, all the women go berry picking. They go all the way up to Fraser. Most of them take the train from Bennett. They go by boat from Carcross to Bennett, and then they take the train. The younger people walk with dogs. We always had dogs for protection, because there's a lot of bears. A lot of bears after the berries. (Mrs. Winnie Atlin, qtd. in Greer, 1995: 90)*

High Bridge (South of Bennett), Log Cabin, Fraser, and the King River valley were among the favoured berry-picking locations.

The railway's links with the Chilkoot would be suspended for most of the 1980s (1982–88) when rail operations closed down because of financial difficulties associated with collapse of the base metal market and closure of Yukon mines. Now, tourists can again cross White Pass and visit Bennett, the railway not only providing a spectacular introduction to the mountainous environment of the Chilkoot, but also a welcome means for backpackers to return to Skagway after their trail experience.

With establishment of the Chilkoot as an international trail, a new dimension has been added to the relationship between First Nations people and tourism. It is a role appropriate both to native ties with the route that extend over hundreds of years and a mantra of ecotourism that local people appropriately benefit from the presence of visitors to their homeplace.

*Some Carcross-Tagish people also work for the Chilkoot Trail National Historic Site. Visitors should stop and ask a warden or trail crew member to tell them the stories they heard as they were growing up, about the trading and packing on the Chilkoot Trail, or about their famous ancestors. Carcross-Tagish people might also share some stories about how they and their family members continue to harvest the region's country foods, and what this land means to them. (Greer, 1995: 118)*

## Heritage International

First Nations have not severed their associations with homeplace, even as it has been manipulated and remodelled by more powerful economic orders. In the century since the Klondike, however, they have witnessed a remarkable transmogrification in attitudes and actions towards the region among others. Few who equated the nineteenth-century Chilkoot as wilderness to conquer – or wild country to sample in the case of early tourists – could have imagined the kaleidoscope of protected landscapes a century hence. Neither in the climate of contentious boundary-making could they have visualized the remarkable fusion of national and bilateral actions to create this situation. It is true that, elsewhere, Canada and the United States were responding to the loss of wildscapes and species through remarkable systems of public parks (and John Muir in 1879 was espousing the wonders of Glacier Bay); but in the panhandle country the confusion of boundary lines and international discord hardly seemed fertile soil for choices of wild mountains and rivers over mines and logged forests. Yet this is what has happened. Today's Chilkoot Trail forms part of a jigsaw of transfrontier heritage places in Alaska, British Columbia, and Yukon arguably without equal around the world (fig. 15). Even in instances when the boundary itself has continued to raise hackles in the century since the Alaskan Boundary Tribunal decision, environment has been the indirect beneficiary. For example, for a time in

the early 1950s, it seemed all the Yukon and British Columbia lakes from Marsh Lake in the north to Lindeman in the south would become a massive storage reservoir for an aluminum smelter plant to be built at Dyea. The lake surfaces would be raised and a tunnel driven under Chilkoot Pass to carry water to the powerhouses. Canadian support for the project withered when competitive projects in Canada were commenced and the American project was declared to present no economic benefit to Canada.

The sequence of protective actions began when Glacier Bay was protected as a national monument in February, 1925, about the time the Historic Sites and Monuments Board of Canada was casting commemorative eyes upon Chilkoot Trail. Glacier Bay, which had been visited by John Muir in October, 1879, to study glaciers at the height of a controversy over the role of glaciers in forming Yosemite's landscape, would be enlarged and upgraded to national park status in 1980. In the same year, Alaska's Wrangell-St. Elias National Park was established. Kluane National Park Reserve in Yukon would be created contiguous to Wrangell-St. Elias in 1972. Separating the two complexes of protected lands was the wild country of the Tatshenshini and Alsek rivers, which remained unprotected until the 1990s. Here, the prospect of an open-pit copper mine atop Windy Craggy Mountain in British Columbia and between the two rivers "had the makings for a transboundary environmental disaster on a monumental scale, one that could result in a major international environmental conflict between Canada and the United States. After all, major American interests were at risk: Alaska's Glacier Bay National Park, the livelihood of the Yakutat and Chilkat peoples, and a commercial salmon fishing worth $50 million each year" (Careless, 1997: 171).

History haunted Geddes Resources, proponent of the mine. Boundary-making had denied Canada direct access to the sea and for ore to be transported from Windy Craggy, the mining company would have to access a U.S. port. There was another intriguing consideration that those without an eye on conservation history likely missed. Regional manifestations of continent-wide conflicts between resource

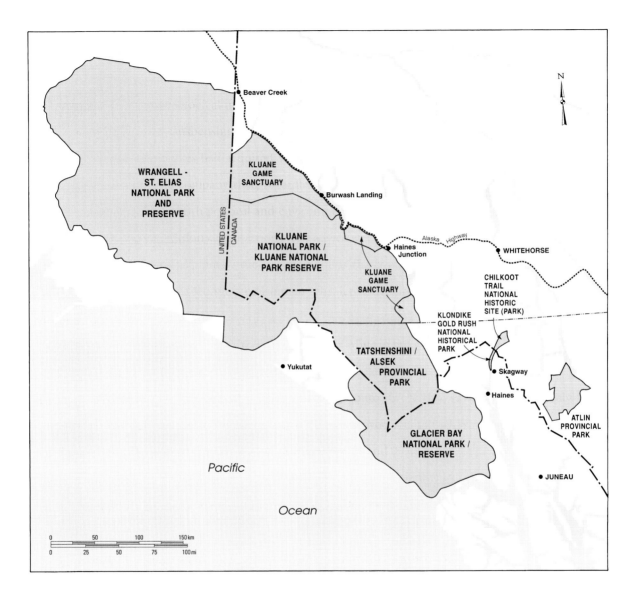

Fig. 15. Heritage International.

developers and landscape conservationists ultimately concluded with decisions largely in favour of protection. This was the case, for example, in Glacier Bay National Park. When Glacier Bay was still classified as a national monument, Congress had permitted mining in 1936, despite a chorus of opposition from conservation organizations (Ise, 1961: 435-36). Mining was terminated there in the 1970s, as was to be the case in Kluane National Park Reserve.

Ric Careless and other environmental activists embarked on a remarkable campaign in 1989 to protect the Tatshenshini:

> *Winning at Tatshenshini would entail pressuring not just British Columbia legislators but also the government of the United States. Assuming we could make Tatshenshini an issue in Washington, a binational strategy offered the best means of success. This international approach would also require lobbying the Canadian federal government as well as those in Yukon and Alaska. With so many fronts to work on, a large and complex effort would be required. Indeed, Tatshenshini would become the first continent-wide wilderness campaign. (Careless, 1997: 180)*

In 1991, fifty organizations with a combined North American membership of ten million people came together as Tatshenshini International (TI). Following a vigorous campaign conducted at the highest political levels by TI in which Tatshenshini became one of North America's "Ten Most Endangered Rivers," the British Columbia government in June, 1993, declared Tatshenshini-Alsek would become a 958,000 ha (2.4 million acre) provincial park. Designation took effect on October 15. The action effectively terminated prospects for the Windy Craggy mine. In the following year, Tatshenshini-Alsek was added to a vast World Heritage Site, which also included Kluane National Park/Wrangell-

St. Elias National Park and Preserve, and Glacier Bay National Park. Altogether, these designations conclude a century of efforts by conservationists across North America that have resulted in protection of a vast unbroken ecological unit today covering 97,000 square kilometres (37,452 sq. mi.).

For Bob Scace, the Tatshenshini-Alsek designations were something of a personal vindication. Soon after Geddes Resources had acquired Windy Craggy from its previous owner, Bob repeatedly warned a principal of the company that, regardless of economic considerations, the location of the mine was untenable from both political and environmental perspectives and likely would be targeted internationally by conservation organizations. His advice went unheard for many years – that is until Geddes Resources contacted him at the last moment as the company sought to garner support to dissuade the Word Heritage Committee from an affirmative decision regarding the World Heritage Site. Bob declined the opportunity.

More recently, a plan to re-open the Tulsequah Chief Mine in the British Columbia portion of the Taku River watershed with a 160-kilometre access road from Atlin has been opposed by both the United States and Alaska governments and by others (Toronto, *Globe and Mail,* June 13, 30; July 4, 2000). The project was approved by the British Columbia government in 1998, and the decision was supported by the Canadian government. American concerns and those of the Taku River Tlingit First Nation and several environmental organizations relate principally to potential damage to one of the major sockeye salmon spawning grounds in the Northwest and despoliation of a wild, unprotected 1.8 million hectare (4.45 million acre) river basin that drains into the Pacific near Juneau, Alaska. American authorities have stated unilateral referral of the matter to the International Joint Commission is possible, as there may be violations of bilateral agreements between the two nations. In June, 2000, the British Columbia Supreme Court quashed provincial approval of the project, citing inadequate consultation with the Tlingits in the environmental review process under the province's

Environmental Assessment Act and possible infringement on aboriginal rights. Coincidentally the Taku River was recognized by the Outdoor Recreation Council of British Columbia to be one of the "most endangered rivers" of the province. The Council views the mine to be unacceptable because acid and heavy metal leakage already is reported from the previous Tulsequah mine, and improved access would expose the watershed to logging, increased hunting and fishing activity, in addition to mining.

The story of the Chilkoot and its region is an amazing one. Over centuries, it has been and remains homeplace to its aboriginal people. Two centuries of penetration from outside climaxed with an International Stampede in pursuit of mining riches. Today, the theme has become Heritage International, synonymous with collaborative efforts among many governments and stakeholder groups to protect and to conserve the spectacular natural and cultural heritage of the region.

In addition to the Chilkoot Trail Unit, the U.S. Klondike Gold Rush National Historical Park includes the Seattle Unit centred on Pioneer Square, the Skagway Historic District and the White Pass Trail Unit. In Canada, in addition to Chilkoot Trail National Historic Site, heritage recognition has been extended to the *S.S. Klondike* and the *S.S. Keno*, Thirty Mile Heritage River (a reach of the Yukon River), the Dawson Historic Complex, and nearby Dredge No 4. Designation of the Klondike Gold Rush International Historical Park is the formal recognition of remarkable historic events in an international setting. It is also vindication for those supporters in both countries who for the past several decades have envisioned the Chilkoot Trail as a collaborative international effort.

This is the legacy of the Chilkoot Trail in history, a history still in the making with each footstep we were about to place on the trail.

*Part Three*

# ALONG
# THE CHILKOOT TRAIL

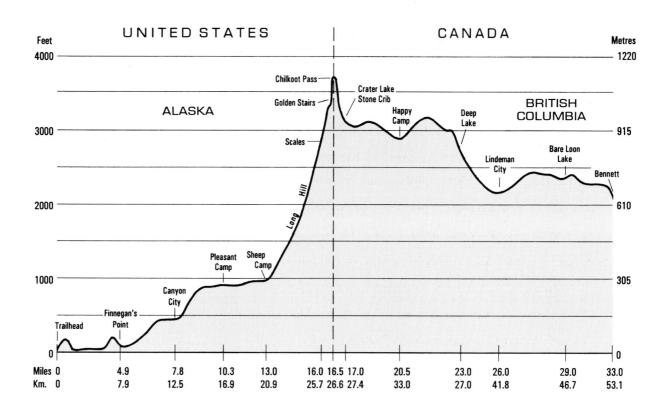

Fig. 16. Chilkoot Trail Profile.

# ALONG
# THE CHILKOOT TRAIL

Now it is time to set out on the Chilkoot Trail ourselves, time to absorb the route through our own senses. Experience tells us each will respond in different ways to landscape, weather, trail conditions, the physical challenge, and other people we encounter in the next few days. Most likely, we all share but refuse to acknowledge the gut flutter of anticipation that sets in at the trailhead. All the planning and preparation cannot preclude the tingle that comes with final commitment to a backpacking trip. Were wise decisions made on physical conditioning and backpack contents? Are we compatible with our trail companions? Will the weather hold for us throughout the hike? Do we really understand the demands upon us during Day Two or Three – the arduous slog up Long Hill, cherry-picking a route up the bouldery rubble of the Golden Stairs, persevering on the relatively short but seemingly endless final leg to Happy Camp? Will we lift our heads and look about us at the wonderful landscapes of forest, mountain, stream and lake, and, yes, sand dune, and with the aid of trailside artifacts, imagine what scenes greeted our predecessors?

We've come a long way to hike this trail: will it be all it is hyped up to be in the book accounts or as effortless as some of our acquaintances would have it be in their understated way ("Yeah, it was a neat trip, you'll enjoy it")? Best to remember that ultimately such a journey will be a testament to our own capabilities, interests, and expectations, set against the prevailing realities of the Chilkoot on the days we move along the trail.

When standing at the trailhead, one cannot but wonder about those who have passed this way; the astonishing, carefully planned yearly trading journeys of the Tlingit, the unfathomable maelstrom of humanity that was the gold rush, the locals who have honoured their heritage by travelling the route "many, many times," and now recreationists like ourselves. There are also the rangers and wardens, ever vigilant about our safety and interpreting the world about us; and what about those seemingly daft moderns who made mad competitive dashes to Dawson by foot and canoe to celebrate the centennial?

There is mystery too. Take the prospector George Holt in 1878, for instance, whom Pierre Berton describes as a "vague and shadowy figure, scarcely more than a name in the early annals of Alaska ... the first white man to penetrate the massive wall of scalloped peaks that seals off the Yukon Valley from the Northern Pacific Ocean" (Berton, 1987: 8). Did he actually set eyes on Chilkoot Pass? How did he do it? Did he slip past the Chilkoot Indians who "guarded it with a jealousy bordering on fanaticism" (Berton, 1987: 8)? Or did he cross the White Pass, "accompanied by several Indians" (McClellan, 1975: 6), likely native guards? If his immortality was assured by crossing whichever of the passes, his mortality suffered somewhat, for Holt:

> *Having breached one barrier, moved west to wilder land and tried to add to his exploits by invading the copper country of the Chettyna. The Indians there had three murders to their credit when Holt tried to slip through. Poor Holt made the fourth. (Berton, 1987: 9)*

The Chilkoot, then, is about history, and it is about history in the making. By stepping out, we too were about to become part of that magic.

# A Diverse Landscape:
# From Salt Water to Barren Scree

A fine rain fell as we made last minute preparations. We had stayed overnight at the nearby campground, a short distance from both tidewater and trailhead. Now, we had made the short walk to the latter as the Taiya River rushed by, milky and cold. Droplets fell from the trees; we were surrounded by a damp forest. Casting a glance upvalley, it was possible through misty conditions to see mountains enfolding the route, containing it, and hinting that beyond the abundant tree canopy was the prospect of an open landscape, of short tufted grass and then slabs of raw rock. Nowhere else on the continent can one so readily hike from sea level and temperate coastal rain forest with a rainfall at Dyea in the order of 1,270 to 1,520 millimetres (50 to 60 inches), upwards to the frigid climes of the alpine where snow depths of five to ten metres (16 to 33 feet) are commonplace, and into the welcoming sun and shelter of the boreal forest where precipitation is reduced to 380 to 760 millimetres (15 to 30 inches). Here about us were wet stands of alder, cottonwood, aspen, western hemlock, and Sitka spruce; below the trees grew a phalanx of understory plants – lady-fern, devil's club, and bunchberry among them. Up there somewhere in the mist was a transitional zone, a subalpine environment, fleetingly represented on the Pacific slope but outstanding in the drier Canadian boreal forest with its open stands of subalpine fir, black and white spruce, alpine fir, and lodgepole pine. Higher still would be the alpine with its lichens, mosses, dwarf shrubs, and low-growing willows, all rapidly surrendering to that awesome image in our minds of rock face and immense talus slope. And scattered throughout the zones would be the artifacts and the memories.

Let us now take you on that journey by way of our photographs of the Chilkoot Trail. We have divided the trail into a number of sections, to show how conditions change along the route from Dyea to Bennett.

1. The trailhead near Dyea, Alaska; rainforest beginnings on an international route

to Bennett, British Columbia.

# Trailhead to Finnegan's Point
## Mile 0 (km 0) to mile 4.9 (km 7.9)

Near the trailhead and surrounded by Pacific alder trees, a sign erected by the National Park Service reminds hikers that the Alaska section of the trail is in Klondike Gold Rush National Historical Park (Photograph 1). Some may not realize that the United States and Canada have commemorated the gold rush by designating sites (or "units") as far apart as Seattle and Dawson City itself. Most backpackers choose to hike northwards, thereby emulating the Klondike gold seekers. What may not be so readily apparent to them is that it is easier in wet weather to ascend the talus boulders on Chilkoot Pass rather than slipping and likely falling downslope coming from the trailhead at Bennett.

The modern Chilkoot Trail begins on the east bank of the Taiya River. Salmon (pink, chum) and eulachon upon which the Tlingit so much depended continue to migrate along the river. During the winter months of the gold rush, the partially frozen Taiya River was used to drag supplies on hand-pulled or horse-drawn sleds. During the summer, Tlingit and gold seekers alike paddled, polled, or dragged loaded canoes upstream to a landing beyond Finnegan's Point. From there, the supplies were carried on foot, horseback and oxen, and hand cart and freight wagon farther up the trail.

The trail to Finnegan's Point in due course follows a 1950s logging road, but not before one completes a sharp uphill hike immediately after leaving the trailhead. For those of us who had not looked closely at the trail profile, this early sweat was an unexpected surprise. A surprise too in that we knew the historic trail from Dyea initially followed level ground along the *west* bank of the Taiya River; so why were we getting an early workout on the *east* bank? The answer only adds to Chilkoot Trail folklore.

When the state of Alaska set about re-opening the trail in 1961, state officials flagged the proposed route along the east bank from Dyea to Sheep Camp. A local resident accompanying the trailblazers advised that the old wagon road west of the river from Dyea to Canyon City really was the

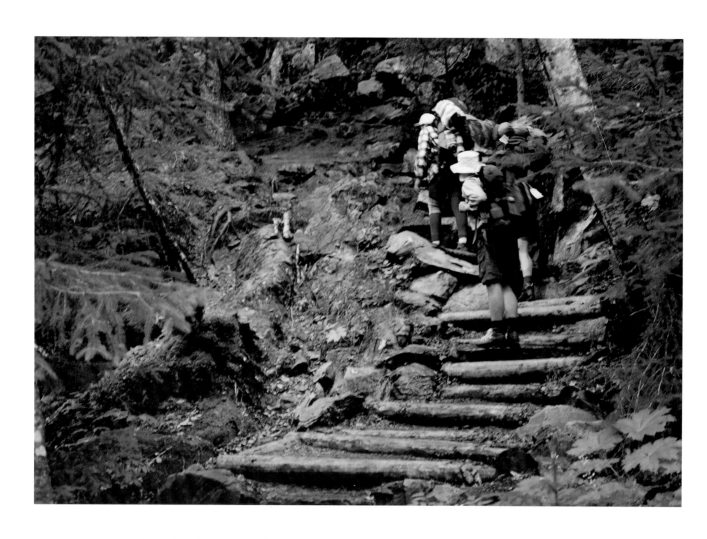

2. Backpackers on the first steep ascent taking them high above the Taiya River.

3. A poisonous fungus fly agaric (*Amanita muscaria*) in the Alaskan rainforest.

4. Trailside bushes with colourful berries include the pin or fire cherry (*Prunus pennsylvanica*).

gold rush route. Regardless, when work crews arrived, they steadfastly followed the flags! "The route they pioneered that summer is, with minor exceptions, the same one still used today" (Norris, 1996). Later thoughts by the National Park Service to restore the trail to its historical right-of-way were abandoned because so many artifacts had been removed during the 1960s and a return to the historic trail could only exacerbate the problem.

Log steps have been constructed here and there to assist hikers and backpackers along the trail. Those shown in Photograph 2 are surrounded by maple and spruce trees. We met both day hikers who were travelling only part of the trail and backpackers prepared to complete the route to Bennett. Especially impressive was the family who had hiked to the summit, the mother with a baby in her backpack, the father keeping an eye on a son not yet into his teens. The dominant greenery of the forest was periodically interrupted where ample moisture has encouraged the growth of fungi such as the fly agaric (*Amanita muscaria*) in Photograph 3. This is a deadly poisonous fungus that can be identified by its white warts or sections on the reddish orange top. Fly agaric is often two to seven inches wide with a stem three to seven inches tall. The fungus may be confused with edible species. During the first three-mile (4.8-km) section of the trail, we observed remnants of an old saw mill from the 1950s and the occasional rotting log cabin.

The lush rain forest provided welcome shade along the trail. Our misty start had been transformed into a sunny day, and in time we were sweating profusely while continuing to adjust our heavy packs and get into the rhythm of the hike. There was a plethora of trees and shrubs along the trail. We were particularly attracted to the red berry of the pin or fire cherry (*Prunus pennsylvanica*) seen in Photograph 4. We also observed a variety of mosses, ferns – and toads! In this densely forested section of the trail, it is a good idea to be particularly on the lookout for black bears (*Ursus americanus Pallas*) and grizzly bears (*Ursus arctos horribilis Ord*). At the designated campsites along the trail, such as Finnegan's Point, Canyon

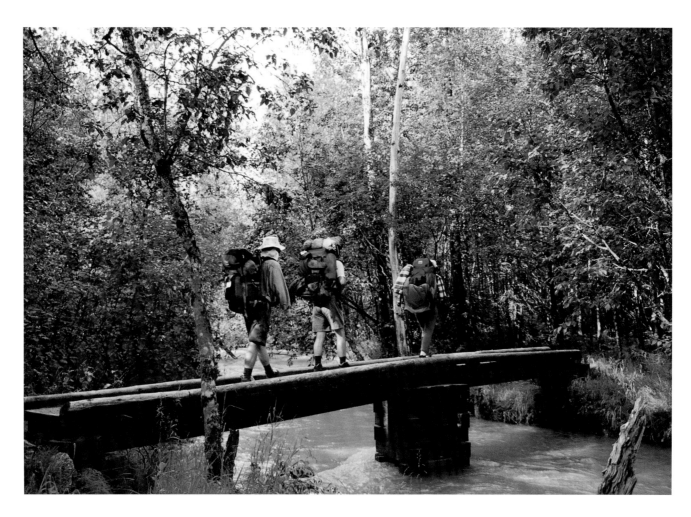

5. A sturdy wooden footbridge keeps feet dry on this stream crossing.

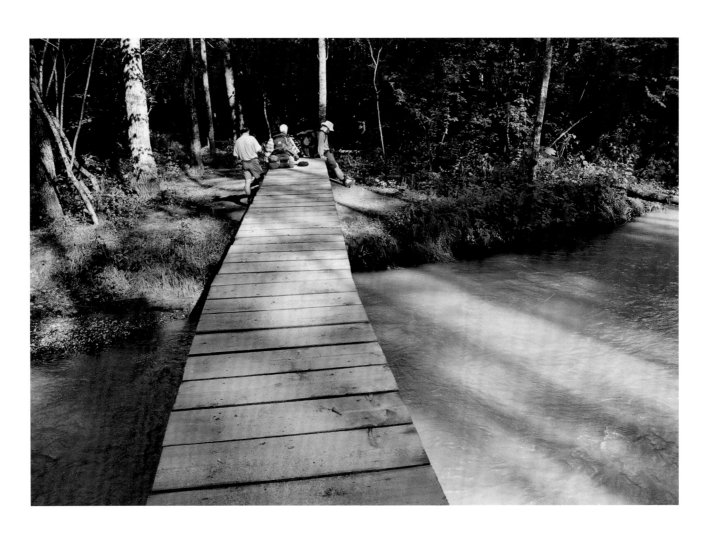

6. Another stream crossed and a short rest beside ice-cold water.

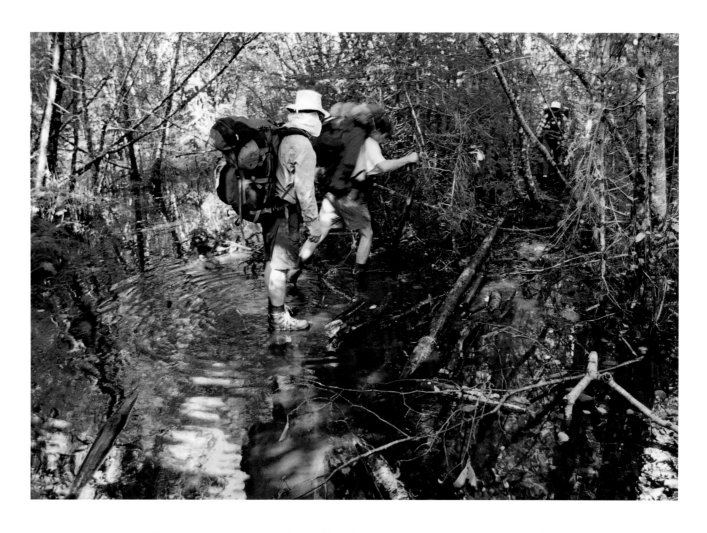

7. Beaver dams may flood the trail in places, requiring some minor scrambling.

City, Sheep Camp, and Lindeman City, park authorities have erected poles on which to hoist your food above the reach of bears and away from your tent. Every group setting out on the trail must remember that, to make use of these hangs, they will be required to carry with them a rope and sturdy rainproof bag in which to keep their food while resident in the campsites. Watching others trying to chuck their ropes over the pole hangs is a never-ending source of casual campsite entertainment.

The trail surface and stream crossings along the lower Taiya River valley pose little challenge. There are quite a number of helpful structures along the way. One of our groups (see Photograph 5) approached a strongly built footbridge crossing one of the many silt-laden creeks flowing to the Taiya. The backpackers in Photograph 6 are resting beside another sturdy footbridge. There are still opportunities to get your boots wet, however, as Photograph 7, taken on a muddy section of the trail, attests. Here, eager beavers were the cause of flooding. The National Park Service has placed split logs along these submerged areas to assist hikers and backpackers. Caution should be exercised when using these logs as their smooth surfaces can be slippery. A few miles into the hike, one of us slipped on a just such a smoothly inclined log, instantly indulging in a mud bath in the puddled water. The memory serves to remind us that waterproof boots and clothing are a must on the Chilkoot, to avoid blisters certainly, but more importantly, to remain warm. Canvas-topped shelters (between Finnegan's Point and Sheep Camp) may be used in an emergency, but there are no cabins to sleep in and tents must be erected in designated campsites.

The first campsite along the trail is near Finnegan's Point (Photograph 8). It has taken us about three hours to reach the point. The shelter here (Photograph 9) and others along the trail are a welcome sight for travellers who need to dry clothes in the frequently rainy weather. So too are the tent platforms when it is wet and miserable (Photograph 10). Soon after the gold rush began, Pat Finnegan and his two sons constructed a toll road to Finnegan's Point. The enterprising family members improved a wet section of the Chilkoot Trail by constructing a corduroy road which wound

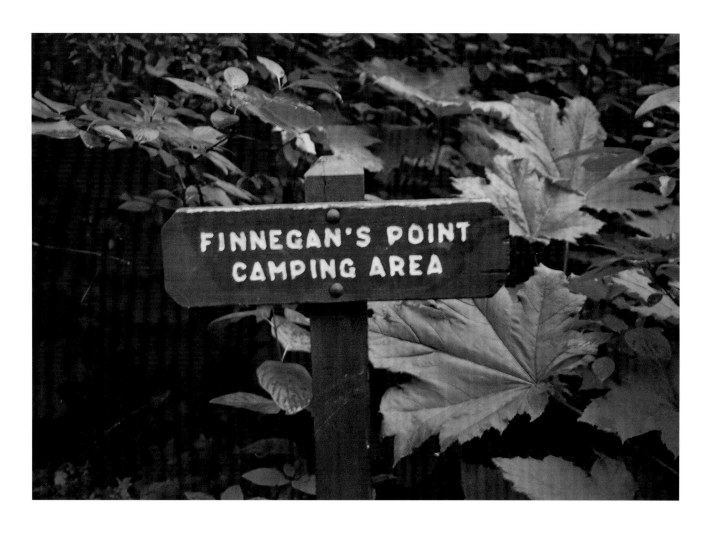

8. Finnegan's Point campsite, an opportunity to conclude an easy first day's hike.

9. The canvas-topped shelter at Finnegan's Point, a place to dry out, cook, eat, and socialize.

10. Tent platforms at Finnegan's Point campsite lie midst dense shrubbery vegetation.

along through a bog from Dyea's Trail Street. They also constructed a rickety bridge across the Taiya River and for a time charged one dollar a person to cross the bridge. Among the first to capitalize on the ground from the advent of the gold rush, the Finnegan's were equally among the early casualties. They were literally overwhelmed by the swarming stampeders; yet the site that carries Finnegan's name and was something of a community in the autumn of 1897 was deserted less than a year later. A century of growth in the rain forest has obliterated the buildings and covered the artifacts.

# Finnegan's Point to Canyon City
## Mile 4.9 (km 7.9) to mile 7.8 (km 12.5)

As we continued on the trail from Finnegan's, we left the logging road and moved towards what had been the "head of navigation" on the Taiya River according to the *Seattle Post-Intelligencer*'s 1897 map of the Chilkoot and White Pass trails; "head of polling" would have been a more apt description! Across the river, retreating Irene Glacier was visible (Photograph 11). The glacier's effect was quite startling; the reflection from snow, ice, and rock was caught above the evergreen forest. As we proceeded towards Canyon City, there were more streams to bridge (Photograph 12) and more moss covered logs to rest against during our breaks (Photograph 13). We delighted in the clusters of the honey mushroom (*Armillariella mellea*) and moss clothing the rotten logs (Photograph 14). The mosquitoes with whom we interacted during these breaks were less welcome. Insect repellant came in handy for the less hardy souls until we climbed above the forest. As usual, the mosquitoes' preference was for our heads, with legs an acceptable alternate for those of us sporting shorts and bare legs.

Gradually, the mountains were taking on a more prominent appearance. The forest would open up and there would be a mountain slope, beckoning us (Photograph 15). But just as quickly the forest again would become a tangle, picturesque as a backdrop (Photograph 16), but difficult to penetrate

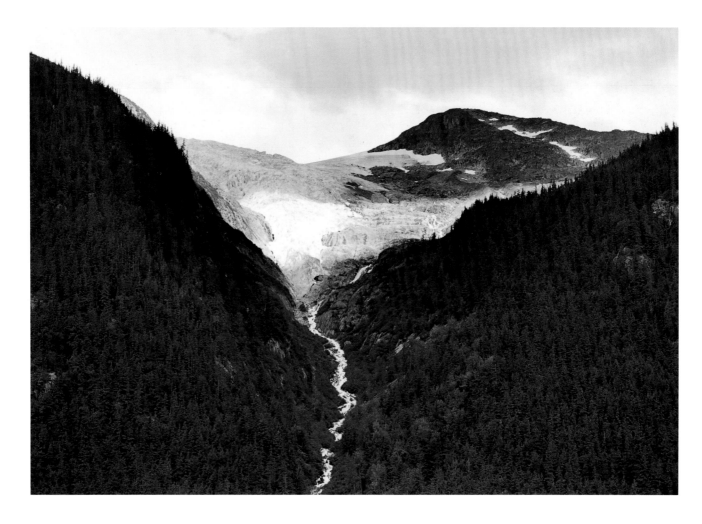

11. A peek at Irene Glacier across the Taiya River valley from Finnegan's Point.

12. Tributary streams periodically cross the trail between Finnegan's Point and Canyon City.

13. The forested trail invites contemplation and perhaps a quick snack.

Mosquitoes appreciate such opportunities.

14. Clusters of the honey mushroom (*Armillariella mellea*) and moss encrust a rotten cedar log.

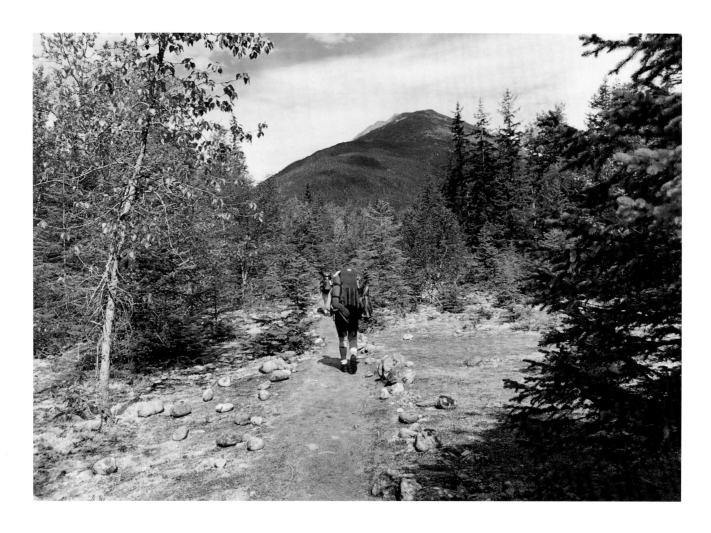

15. A clearing along the well-marked trail through poplar and spruce forest.

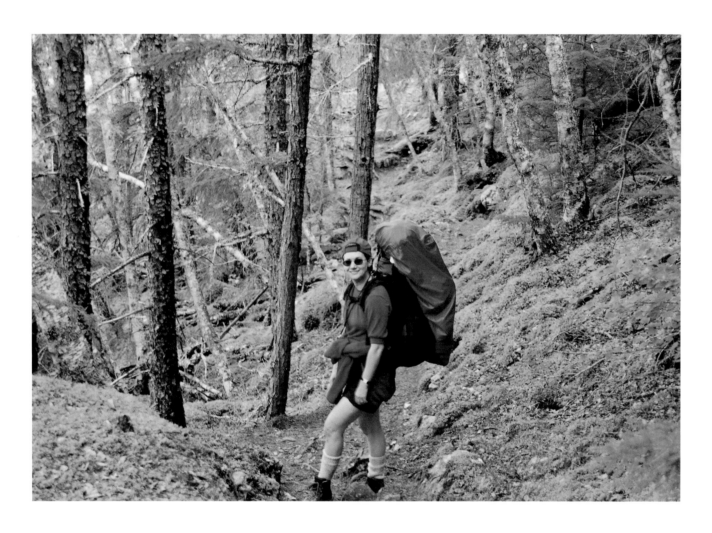

16. Debbie pauses in the forest with a thirty-pound pack and rainproof pack cover.

17. Backpackers are swallowed in the dense bush along the trail beyond Finnegan's Point.

without benefit of the trail. Periodically our backpacking colleagues would be swallowed by the dense bush (Photograph 17). This rainforest vegetation results from the considerable rainfall generated by prevailing westerly winds, which bring moisture sweeping in from the Pacific Ocean. The air cools as it rises and loses its ability to carry the moisture. The excess vapour falls as rain or as snow.

Along the trail, we were surprised to meet a European hiker carrying a sausage and a bag of cookies outside his pack. This, of course, is an excellent way to attract bears. Hikers wishing to avoid bears should be more careful with food and periodically make noises while hiking to minimize the chance of surprising *Ursus*, particularly in the densely forested sections of the trail. There are signs on the trail reminding backpackers not to leave packs unattended as bears are known to have dragged off packs containing food. We carried bear spray and bear bangers, and we were careful not to emulate the hiker we criticized. We also made sure we packed our garbage bag inside our backpacks. (We always assure the designated garbage packer that he or she is doing something noble, an accolade usually poorly received as the bag continues to grow with each day's passing!)

At mile 7.8 (km 12.5), a swinging bridge gave access from the Chilkoot Trail to the former townsite of Canyon City (Photograph 18). Here was our first real opportunity to examine and photograph a variety of gold rush artifacts. Canyon City, a short distance from the main trail, is located at the mouth of the Taiya River canyon; it is the terminus of the broad river valley and a natural camping site for both Tlingit and early prospectors who preceded the Klondike Gold Rush. This was our first crossing of the Taiya River and highlighted the difference in location between the modern trail and the route recorded a century ago. The famous *Seattle Post-Intelligencer* map has the nineteenth-century Chilkoot Trail crossing the Taiya no less than seven times, though, on the final crossing high on the Long Hill and approaching the Scales, the river is but a small stream. It was on Long Hill that we too would make our official route crossing of the Taiya.

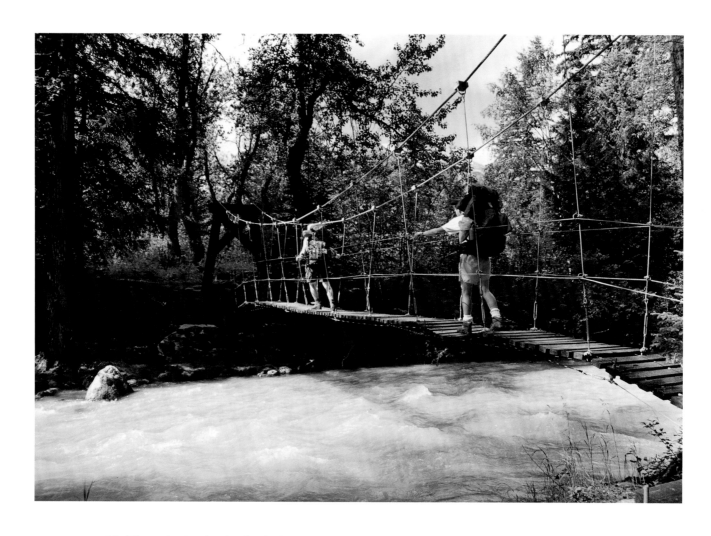

18. The swinging bridge leads the inquisitive across the Taiya River to historic Canyon City,

a short detour from today's trail.

Canyon City was a resting place, a transition point, a freight transfer station. In the early part of 1898, it was a prosperous town with electrical power. There were more than 1,500 residents. Historic accounts tell us there were over twenty-four businesses including hotels, restaurants, taverns, barber shops, outfitting stores, a real estate office, a doctor, and a post office. A year later, the settlement was deserted. Hidden among the trees today are saws, stoves, tin cans, wheels, cooking utensils, and the remnants of log buildings, mute evidence of abbreviated human occupancy.

One of the larger artifacts at Canyon City is a tramway boiler introduced there by the Dyea-Klondike Transportation Company (Photograph 19). You will note a blue tarp erected by Alaska archaeologists who were working when we visited the site. The boiler is an intriguing reminder that, not only was the concept of the tramway the most intriguing technology introduced to the Chilkoot Trail, in its application it gave rise to vigourous competition during the stampede. Farther up the trail, we would come across endless loops of cable, wooden footings, and other tramway artifacts once rushed to the valley, only to be as hastily abandoned. These tramway remnants were also left behind by WP & YR crews who had been directed to remove tramway infrastructure after the railroad bought out the tramway.

The tramway era had begun with a horse-powered facility from the Scales to the summit in late 1897. Three competitors quickly appeared to replace the first operation, which lasted only a few months – the aforementioned company, the Chilkoot Railroad and Transportation Company and the Alaska Railroad and Transportation Company. Eventually, goods could be conveyed from Canyon City as far as Stone Crib above Crater Lake, a distance of approximately nine miles (15 km) farther along the trail. The tramway was a significant engineering achievement in 1898, with its forty-five miles (72 km) of metal cable, but proved too expensive a method of transportation for most Klondike gold seekers.

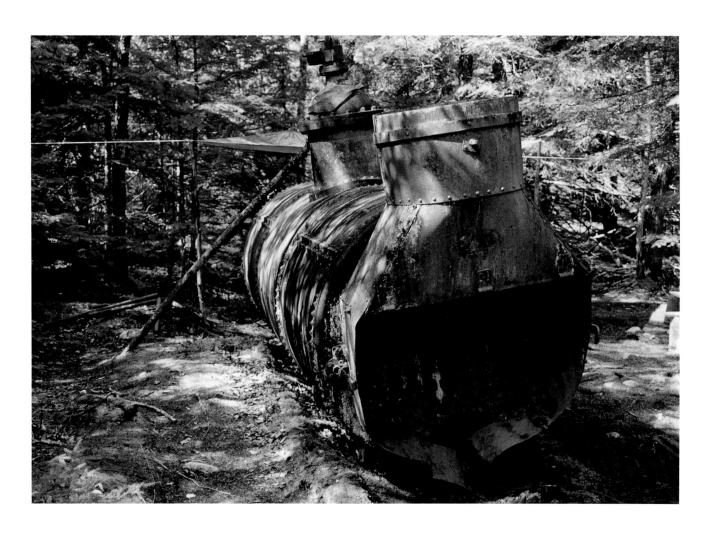

19. A tramway boiler of the Dyea-Klondike Transportation Company,

a large artifact rusting in the second growth forest.

The Dyea-Klondike Transportation Company had been founded in September, 1897, by a trio of Alaska investors with the hope of transporting freight from the wharf in Dyea all the way to Lindeman Lake. This was to be an electrically powered system and so a boiler and electric dynamo for the tramway were installed at Canyon City. In reality, only a modest two-bucket tramway running from the Scales to the summit of Chilkoot Pass was built by this company, opening on March 14, 1898. In due course, all competitors joined forces with the Chilkoot Railroad and Transportation Company, the only organization actually to operate from Canyon City across Chilkoot Pass to the vicinity of Crater Lake.

## Canyon City to Pleasant Camp
### Mile 7.8 (km 12.5) to mile 10.5 (km 16.9)

The trail continues to wind through the forest and is for the most part level near Canyon City. Along part of the way, the trail lies in shade close to the Taiya River (Photographs 20 and 21). However, at mile 8.3 (km 13.4), there is a steep incline that requires some scrambling on hands and knees. There are several hundred metres of difficult trail, but there are pleasant sights to ease one's concentration, as indicated in Photograph 22. Tree roots can snag an unwary backpacker's boots, especially on the slippery sections of the trail. Martha Black who hiked the trail in 1898 commented:

> *In my memory it will ever remain a hideous nightmare. The trail led through a scrub pine forest where we tripped over bare roots of trees that curled over and around rocks and boulders like great devilfishes. Rocks! Rocks! Rocks! Tearing boots to pieces. Hands bleeding with scratches. (Wilson, 1997)*

We are not so ill-served by the trail, but on steep pitches en route to Pleasant Camp we were conscious of trail wear. The thinking ecotourist will do his or her level best to stay on the designated trail or established route, but it is always a challenge to do so where steepness of slope and prior erosion make footing difficult – or snow and bare rock intermingle to camouflage the trail surface. Prior to tackling the Chilkoot, we had read Archie Satterfield's book on Chilkoot, the first modern guide, published in 1973. It was encouraging to read in a later edition that, when Satterfield revisited the trail in 1991 "for the first time in 19 years," he was surprised "how little the Chilkoot Trail had changed." This was a pleasant discovery because he "liked the Chilkoot the way it was when [he] first hiked it in 1972." Our own observations reaffirmed Satterfield's opinion that the trail had held up remarkably well in the modern era. Climate and humans can be brutal on trails, however, and it will take constant trail maintenance (at no little cost) and excellent use behaviour on the part of all hikers on the trail to sustain appropriate trail conditions. From what we saw on our respective trips, there is a high level of ecotourist respect for Chilkoot Trail – although doubtless rangers and wardens have their own tales! – and we saw little in the way of landscape abuse, littering, and so on.

Pleasant Camp is located at mile 10.5 (km 16.9) by the river's edge. There is much to commend this location. The level open ground, proximity to the river, and views afforded of glaciers and water-falls make the place aptly named. The park authorities' *Hiker's Guide* speaks to tents "more or less solid" from here upslope to Sheep Camp in early 1898. In truth, such a level of human activity pretty much consumed the entire route from Dyea to Bennett. The movement of people, animals, machines and goods, constant erection and disassembly of tents and lean-tos, the building of albeit temporary communities, and the provision of a range of services all combined to extend the ant-like imagery far beyond that recorded for posterity on the Golden Stairs.

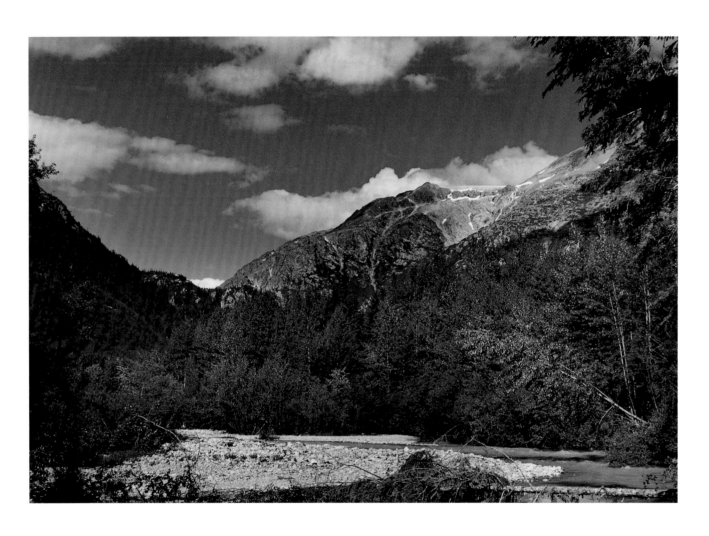

20. Dense forest cover edges the Taiya River between Canyon City and Pleasant Camp.

21. The Chilkoot Trail lies close to the Taiya River en route to Pleasant Camp.

22. Water tumbles noisily beside the trail.

# Pleasant Camp to Sheep Camp
## Mile 10.5 (km 16.9) to mile 13.0 (km 20.9)

The hill from Pleasant Camp to Sheep Camp is an easy 2.5 mile affair. Upon arriving at Sheep Camp it can be disconcerting to check the cross-section chart and realize that after thirteen miles (20.9 km) of up-and-down hiking you are still only at 1,000 feet (305 m) above sea-level. By way of contrast, you will soon climb over 2,500 feet (762 m) in 3.5 miles (5.64 km)! There is no more emphatic way to bring home the reality of what lies ahead between Sheep Camp and Chilkoot Pass.

Sheep Camp is something of a Holy Grail for today's hiker and occupies a role curiously similar to the community that housed between 6,000 and 8,000 transient residents during the gold rush. Many – perhaps most – backpackers are bent on making Sheep Camp on the first day with the idea of tackling Chilkoot Pass on Day 2. This is where Allan and Debbie first made camp. Mike and Bob and their groups took two nights to get there. How long one spends on the trail is very much a function of personal or group circumstances. There is much to be said in favour of evenly splitting the trip on either side of the pass, in part to more gradually assimilate the nuances of the trail, but also not to be consumed by thoughts of the trail as predominantly "gold rush" and "Chilkoot Pass." In Part One, we have shown how Chilkoot Trail is very much a "complete experience" for most ecotourists, so think carefully about all of the route's attributes before you set out. Spacing out overnight stops also is beneficial from a route-management perspective, especially if foul weather creates a bunch-up at Sheep Camp. Weather conditions between Sheep and Happy camps are notorious, of course, and little satisfaction can be gained in making it to the toe of the Long Hill on Day 1 and spending the next in rain, snow, wind, or fog with Happy Camp a distant but very attractive magnet, some 7.5 miles away on the far side of Chilkoot Pass.

23. The trail announces Pleasant Camp, which boasted a toll bridge and restaurant in 1897.

"The bread that is baked in some camps would kill a mule" (E. Hazard Wells, 1897).

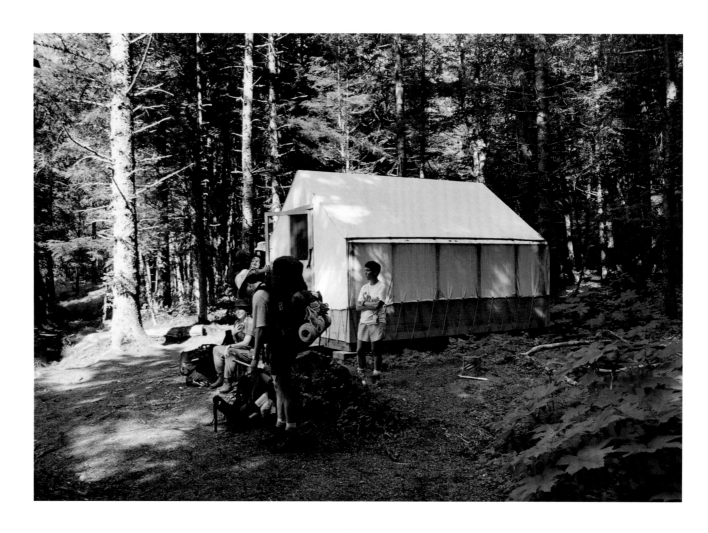

24. Pleasant Camp provides a level camping spot and continued shelter in the forest.

The atmosphere at Sheep Camp is a delicious mix of anticipation and apprehension. So much will have been read, heard, and imagined by each traveller about the Long Hill, the Scales, the Golden Stairs, and lakes beyond the summit that some sober thought is desirable about the day to follow. The National Park Service does yeoman service each evening through a judicious talk on preparations for what is to come and informative accounts of the area's natural and cultural environments. We were pleased to learn that the trail has been relatively free of bear incidents in the modern era. This is good news, an indicator of excellent food and garbage management along the trail. Bears are readily habituated, and, to maintain a record relatively free of human-bear encounters, parks authorities will have to constantly monitor trail conditions and the trail users. The latter had better know the rules – and abide by them. When there are human-wildlife "interactions," invariably it is the wildlife that makes the ultimate sacrifice.

Sheep Camp lived and died by the gold rush. Neufeld and Norris (1996: 68) provide a useful site diagram of the more than sixty businesses that briefly flourished, as they also do for Dyea, Bennett, and Log Cabin. Among the establishments were sixteen hotels, fourteen restaurants, thirteen supply depots, three saloons, two dance halls, two laundries, five doctors and pharmacists, one hospital, a bath house, a lumber yard, and a post office. There had to be a Golden Gate Restaurant, of course, and we have since wondered humourously just how many "Golden something" eating establishments are distributed across North America! By May, 1898, most of the stampeders had packed over the pass, and the population of Sheep Camp dwindled. There is little evidence of a town today, mostly ruins across the river from the campsite.

Along the trail near Sheep Camp, we picked berries, photographed one of the artifacts – a tram sprocket lying on forest floor (Photograph 25) – and admired the surrounding wild flowers (Photograph 26). A bright red porcelain-like berry shaped like a nectarine, called the baneberry (*Actaea*

*rubra*), is one of the few poisonous berries growing along the trail. We tasted salmonberries (*Rubus spectabilis*), currants (members of the Saxifrage family), and blueberries (*Vaccinium alaskanum*), some of which were wormy. In addition to her comments about the local fauna and flora during the evening presentation, the knowledgeable Park Ranger at Sheep Camp provided excellent advice to that day's crop of backpackers about their next day on the trail: "When the weather forecast is for a clear sunny day such as tomorrow, start your climb to the Chilkoot summit as early as possible." All of us did just that. We did not regret the decision.

A ritual in one of our groups is to listen to campfire tales read from a volume appropriate to our surroundings. At Sheep Camp, it seemed timely to bring forth Robert Service, though the campfire had to be imagined. As the sun set and shadows lengthened, renditions of "The Shooting of Dan McGrew" and "The Cremation of Sam McGee" soon had all within earshot listening attentively. But it was "The Trail of Ninety-Eight" that really grabbed us, heightening our imaginations for the morrow.

*We landed in wind-swept Skagway.*
*we joined the weltering mass,*
*Clamoring over their outfits,*
*waiting to climb the Pass.*
*We tightened our girths and our pack-straps;*
*we linked on the Human Chain,*
*Struggling up to the summit,*
*where every step was a pain.*
*Gone was the joy of our faces,*
*grim and haggard and pale;*

*The heedless mirth of the shipboard*

    *was changed to the care of the trail.*

*We flung ourselves in the struggle,*

    *packing our grub in relays,*

*Step by step to the summit*

    *in the bale of the winter days.*

*Floundering deep in the sump-holes,*

    *stumbling out again;*

*Crying with cold and weakness,*

    *crazy with fear and pain.*

*Then from the depths of our travail,*

    *ere our spirits were broke,*

*Grim, tenacious and savage,*

    *the lust of the trail awoke.*

We would inscribe our campfire volume once we reached our own trail's end at Bennett: "Enjoyed by the undernoted as they followed The Trail of '98, one hundred years later, from Dyea, Alaska on August 7, 1998 to Bennett, Canada on August 11, 1998."

25. A tramway sprocket from the Klondike Gold Rush, one of the many artifacts
hidden in the forest near Sheep Camp.

26. Colourful wildflowers abound along the trail.

# Sheep Camp to the Chilkoot Summit
## Mile 13.0 (km 20.9) to mile 16.5 (km 26.6)

Consistent with our theme for the book, the BIG DAY on the Chilkoot must be visualized as a triptych. Each part presents its own challenges, landscapes, and rewards; as a whole, the experience is a rich harvest for future memories. First, there is the long, long haul up aptly named Long Hill, gradually emerging from the shielding forest and ever more exposed with each step to dramatic mountainous elements. Between Sheep Camp and the Scales you will ascend about 1,650 feet (503 m) over three miles (4.6 km). Shortly after the Scales, the Long Hill becomes the Golden Stairs, demanding you climb 900 feet ( 274 m) through 4,300 horizontal feet (1,311 m), of which the final 450 vertical feet ( 137 m) are climbed through 1,650 horizontal feet (503 m). The huge boulder talus field adds significantly to the challenge of upward movement. The third part is the journey from the summit to Happy Camp (though some hikers will continue on to Deep Lake, even Lindeman Lake). Happy Camp lies four miles (6.4 km) from the summit, the trail dropping about 450 feet (137 m) to Crater Lake, to about the same elevation as at Happy Camp, which is reached after some reasonably level trail walking.

One cardinal rule for us before we left Sheep Camp, apart from the obvious early start, was to carefully balance our backpacks. Poorly organized packs will pull you backwards when you tackle the Golden Stairs. Any hint of this problem while still on Long Hill is reason enough to take time to repack at the Scales. A second rule is to not underestimate variability in diurnal weather conditions. We had been told that Sheep Camp frequently marks the onset of cold, windy, and rainy weather. We experienced just such a change in the weather on both days in which our groups climbed up to and beyond the pass. It was hot, sunny, and very pleasant in the morning, but just after we reached the summit, we experienced strong winds and freezing drizzle on our backs all the way to Happy Camp.

Shortly after we left our campsite at Sheep Camp, we passed by the Ranger Station (Photograph 27) and nearby trailside cabin (Photographs 28 and 29) and also noticed a wooden grave marker next to the trail. The faded board reminded us of the unfortunate Klondike prospectors who died on the trail. The sight elicited some morbid humour among us about the possible disposition of our own remains in the event the Chilkoot made further claims. As we climbed north from Sheep Camp toward timberline, side-streams became noticeably smaller (Photograph 30) and the rising sun revealed spectacular alpine slopes (Photograph 31). Colourful flowers such as purple monkshood (*Aconitum delphinifolium*), and the pink fireweed (*Epilobium angustifolium*) were about us. At the end of July, the northern geranium (*Geranium erianthum*) (Photograph 32) with its five violet petals in clusters is in bloom. The first half mile after leaving Sheep Camp is easy, but the Long Hill soon requires concentration through difficult underfoot conditions (Photograph 33). As you approach the Scales, large boulders and patches of snow increasingly are in evidence.

The Scales are marked with interpretive signs at mile sixteen (km 26.7). Artifacts are strewn amongst the boulders along this section of the trail. It was at the Scales that the stampeders bargained with packers and the tramway operators for the best price to transport their tons of goods to Chilkoot Pass. Loads were reweighed as higher rates were charged for the final climb. After viewing the pass from the Scales, many discouraged gold seekers discarded their equipment and turned back. Those who thus witnessed the Golden Stairs in winter with their 1,500 precut ice steps and orderly human procession might have been even more disheartened by the rocky jungle that greets the summer traveller. During the Klondike Gold Rush, there were six restaurants and coffee houses, two hotels, a saloon, and the offices and tramway warehouses at the Scales. Remnants of the old tramway systems can be seen today. Photographs 38 through 41 feature artifacts scattered among the rocks, including tramway cables, machinery, nails, dishes, frying pans, boot soles, gold pans, broken dishes, stoves, pots and pans, picks

and shovels, nails, harnesses, lamps, and strewn bones.

Henry De Windt, a *London Times* correspondent, provided dramatic emphasis when describing his journey through Chilkoot Pass during the Klondike Gold Rush.

> *Endurance, nerve and perseverance are required of the adventurer who sets out to make his fortune in the El Dorado of the north. The Chilkoot pass is difficult, even dangerous, to those not possessed of steady nerves. Toward the summit there is a sheer ascent of 1,000 feet, where a slip would certainly be fatal. (Klondike: The Chicago Record's Book for Gold-Seekers, 168)*

Stampeders paid a toll for use of the steps carved into the snow on the Golden Stairs. A single trip could take from one to six hours. Many people could endure only one trip per day. Frequently, thirty trips across the pass were required to carry all the necessary supplies. The North-West Mounted Police required that each Klondike prospector carry adequate supplies into Canada to survive for one year – at least one thousand pounds. Such an amount had to be divided into manageable loads. Men regularly carried packs in excess of one-hundred pounds (45 kg) and young boys carried from forty to fifty pounds. There were the women packers too who impressed with their ability to manoeuvre heavy, awkward loads.

This state of affairs was not lost upon far away officialdom, even though sovereignty, boundary placement, and customs duties clearly were all-consuming matters. Clifford Sifton, the Dominion's minister of the interior, for instance, clearly recognized the agonies experienced by prospectors trudging through snowdrifts and between avalanche slopes with a ton of supplies during the winter and early spring: "The inhumanity which this trail has been witness to, the heartbreak and suffering which so many have undergone, cannot be imagined."

27. The Sheep Camp Ranger Station.

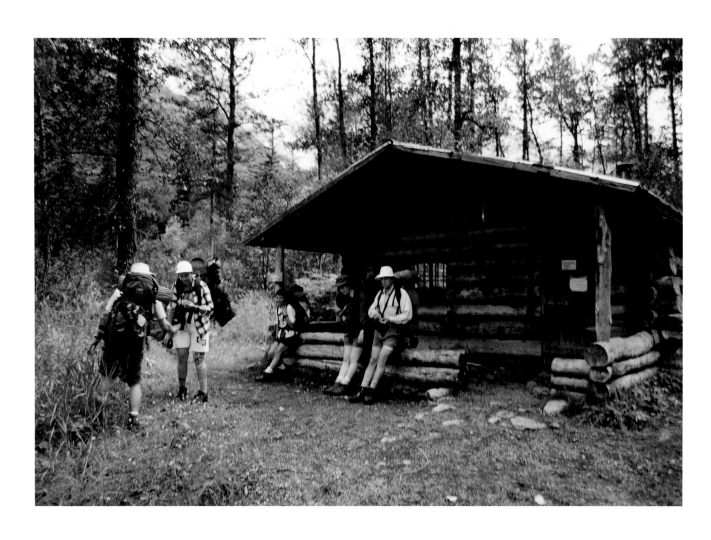

28. A sturdy cabin by the trail lies just beyond Sheep Camp.

29. Inside the cabin.

30. Bouldered creeks fed by rain, snow, and ice assume a more rugged appearance at higher elevations.

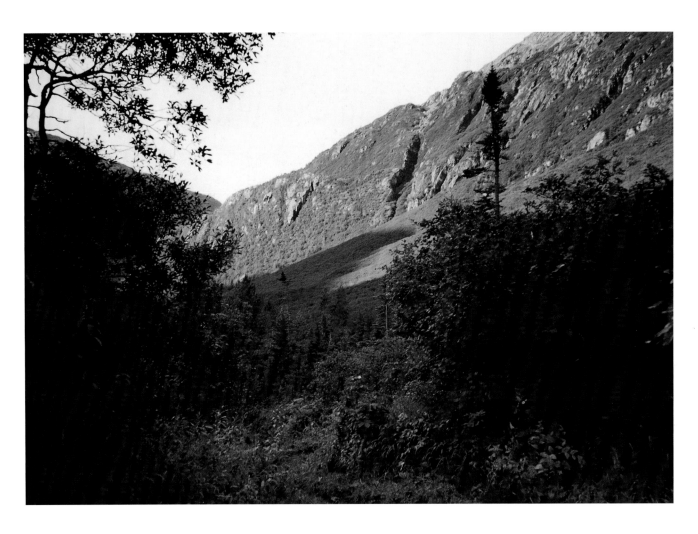

31. The ascent from Sheep Camp in the shade of early morning gives promise
of spectacular mountain landscapes.

32. The northern geranium (*Geranium erianthum*) in bloom along the trail.

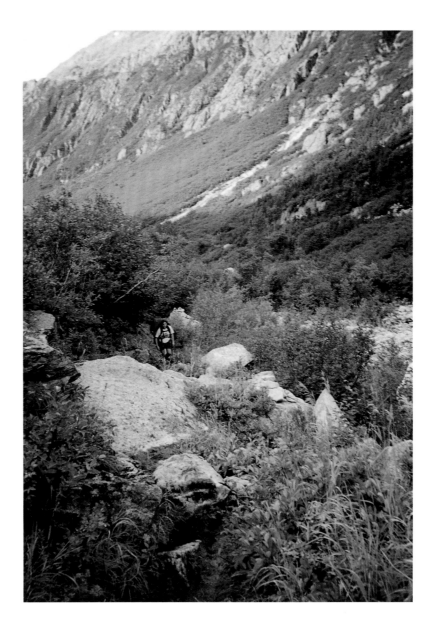

33. The reality of the Long Hill as both long and steep sets in as the forest cover recedes.

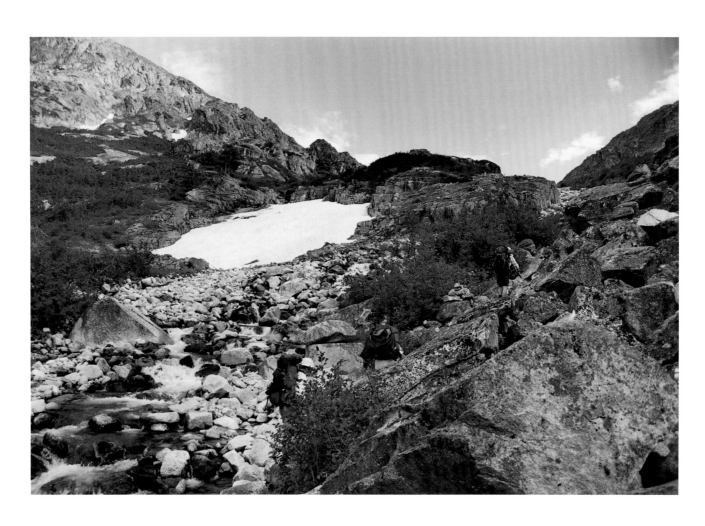

34. An encounter with the first snow patch along the trail in early August.

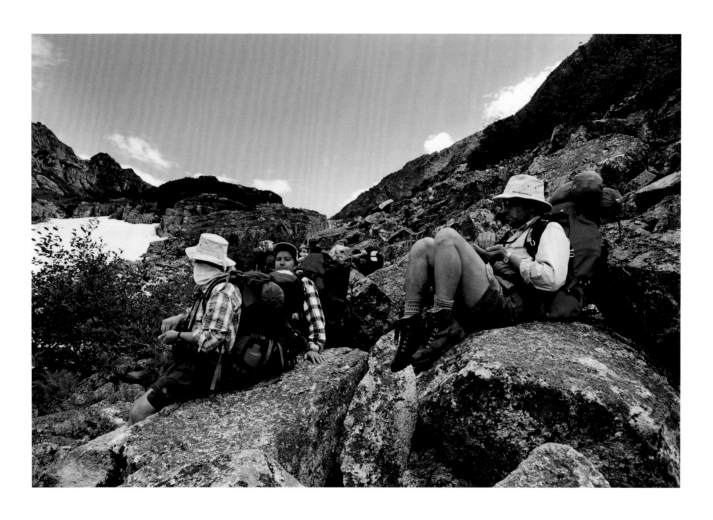

35. Trailside boulders and attentive mosquitoes provide contrasting challenges
en route to the Scales.

36. Water tumbles from a rugged cliff face on the Long Hill.

37. A lone backpacker, a rugged landscape; soul food beneath a spectacular sky.

38. Interpretive signs at the Scales stand among their subject matter – scattered artifacts of the gold rush.

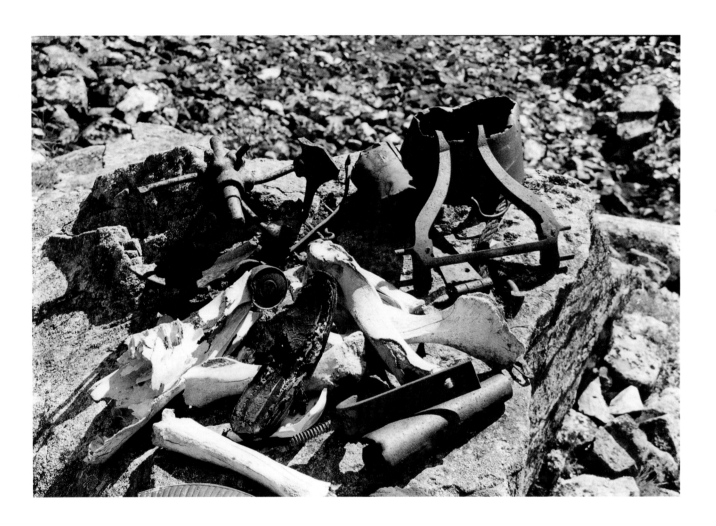

39. Boot soles and bones, mute legacy from an incredible moment in the history of the North.

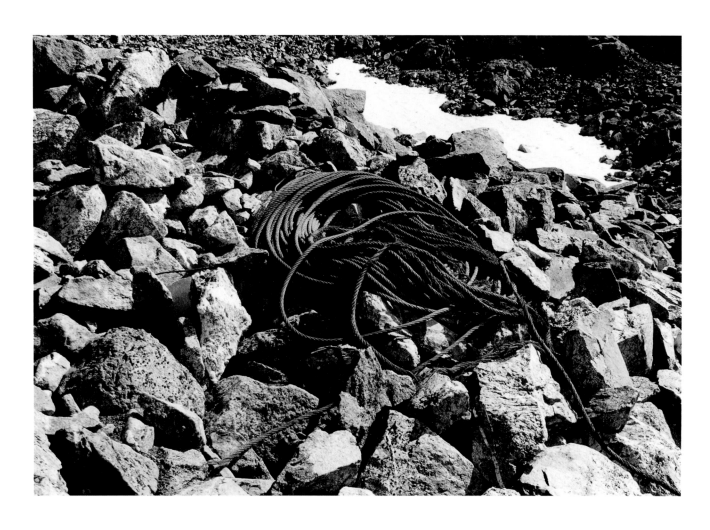

40. Steel cable at the Scales tells of the tramway's role in conveying goods over Chilkoot Pass.

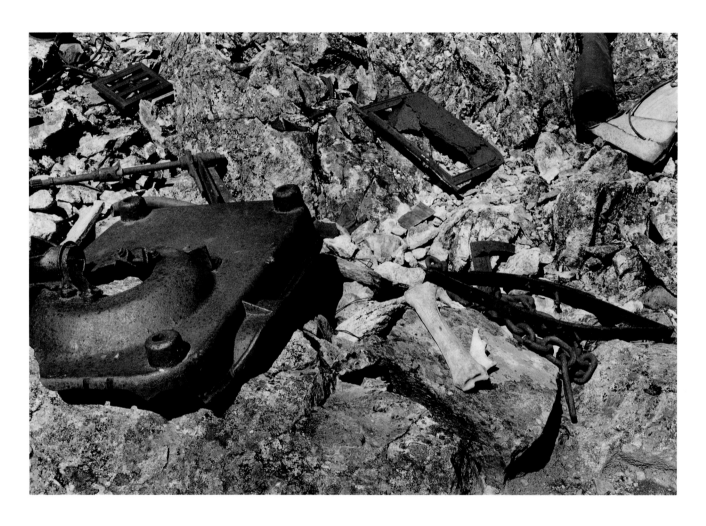

41. Fragments of machinery add to the miscellany of gold rush artifacts on the talus slope.

At the height of the Klondike Gold Rush, the summit was jam-packed with huge piles of freight awaiting Canadian customs inspection. These supplies were regularly buried in the constantly falling snow. Horses, dog teams, oxen, sleds, and carts were used to haul supplies. Live chickens, fresh eggs, fresh vegetables, kegs of liquor, books, and musical instruments were carried over the summit. (Mike likes to remind us that a namesake – Mahoney with an 'e' – supposedly carried a piano over the pass. We gently remind our Mike that "Klondike Mike" also claimed to have actually witnessed "The Shooting of Dan McGrew" and perhaps our Mike should be more conservative in espousing kinship with his northern namesake!)

The Mounties provided information to prospectors, supervised the border post, and collected custom duties. Their small damp hut held only two bunks and a small counter. Significant amounts of money were stored in a kit bag under one of the bunks. Near the summit, there were tent hotels, restaurants, and custom brokers to provide services. Communications with the outside world were achieved by means of a telephone connection to Dyea and a regular mail service. For the gold seekers, then, it was indeed a superhuman effort to complete passage over Chilkoot Pass so early in their trek to Dawson. After reaching the Chilkoot summit, they would still have to face the daunting challenge of travelling another six hundred miles to reach the Yukon gold fields.

From the Scales, Debbie looked ahead at a tiny red speck far above her. That speck was another backpacker, climbing over and around boulders several times her size, slowly approaching the top. The boulders made it more difficult to climb the steep slope, especially with forty-odd pounds of equipment on our backs. Photographs 42 through 45 illustrate this section of the trail but really do not do justice to steepness of slope or the difficulty of rock navigation. Debbie had one additional challenge, a fear of heights! She shot to the summit like the proverbial bullet. Not looking back, she focussed on counting her steps to keep her mind busy. The scramble made apparent why most hikers

climb up from Alaska rather than down the slope from British Columbia. It is so steep, a climb down would be far more awkward and dangerous, especially in wet weather. At some spots, we were forced to climb over the boulders on our knees. Orange plastic pipe wands placed at intervals among the rocks to guide hikers during the frequent foggy weather and high winds were strangely comforting, even on this fine morning. Upon reaching the summit, backpackers may discover the scrambling has given them sore feet. Even with today's lighter packs, it remains a physical challenge to reach Chilkoot Pass.

On the day we reached the Chilkoot summit, we had a spectacular view. Looking back down the valley beyond the rock monument dedicated to the stampeders by Alaska's Governor Walter Hickel in 1965 (Photograph 46), the glaciers and waterfalls on the mountainsides were breathtaking. We were truly awed by the scenery. For the first time, we could place the hike along the Taiya River valley in some perspective and wonder at the thoughts of native people as they too in small groups once made annual passage through this place. As for the stampeders, we doubted their sentiments were much given to the beauty captured in the view from this place. Exhaustion, cold and privation do not beget spiritual and aesthetic thoughts.

We turned our attention to the immediate landscape of the summit. Here, in contrast, was the residue of human hopes. Artifacts scattered on the rocks near the summit include wood-framed canvas boats (Photograph 47), rusted machinery, buckets, utensils, pans, dishes, and cables. The strange parade of more than a hundred folding boats originally were among "232 nonpareil canvas compartment boats, together with oars, rowlocks and other material for the aforesaid boats" documented in the brochure of Flowers, Smith & Company (qtd. in Satterfield, 1978: 189). It was as well that these craft went no farther. National Park Service archaeologists removed one boat to Skagway to serve as a model for a new framework and canvas. "It was then assembled and found to be unstable and weak in construction. The frame would have needed architectural bracing to survive moderate use" (Satterfield, 1978: 189).

Today, the summit is quiet except for the ceaseless wind of eons, the trickle of melting snow over rusting artifacts, the periodic whoop of achievement emanating from yet another backpacking group celebrating its arrival. After conquering the summit on that warm August day, we finally had some appreciation of the challenge faced by Klondike stampeders. We all agreed that our single summer climb with much lighter equipment paled in comparison with the winter stampede of a century ago and the journeys of First Nations people. Imagine carrying a heavy stove on your back across avalanche slopes, wearing wool instead of fleece and gortex. Imagine making the journey, not once, but many, many times! Winter seemingly offered only one advantage to the Klondike prospectors. Snow packed hard by thousands of feet on stairs carved from the Scales to the summit must have been easier to traverse than a summer grind over and around huge talus boulders.

It was at the summit that we encountered the only storm during our trek. The sunshine and blue sky disappeared. Clouds moved in quickly from the Pacific. Wind gusts pelted our backs with hail and rain. The balance of the day's hike to Happy Camp would seem to take forever, but the wind pushed us along, and we were now embarked on the downhill portion of our journey. Although we all wore sturdy leather hiking boots with two pairs of socks, our feet would be tender by day's end. We had no blisters, but the thought of a foot massage seemed entirely reasonable on a trail of boats that wouldn't float, where the rich had strolled and the poor struggled, where ignorance and invention were bedfellows in '98, and where today, park wardens not police patrols arbitrate entry to Canada.

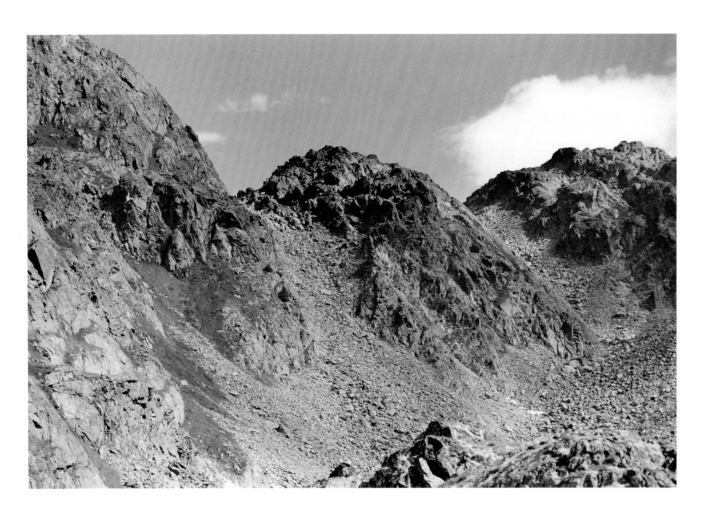

42. The Golden Stairs to Chilkoot Pass, with Peterson's Pass at right; ascent over boulders, made worse in fog, wind, rain, and rotting snow.

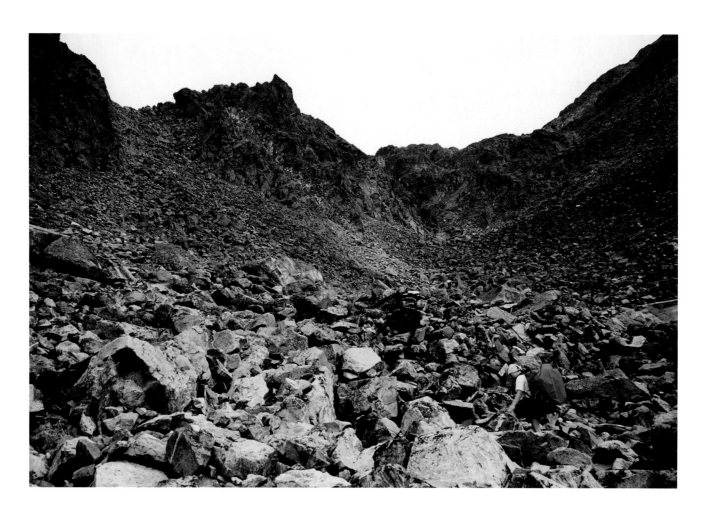

43. Higher on the talus slope; picking your own route to Chilkoot Pass
is an intensely personal experience.

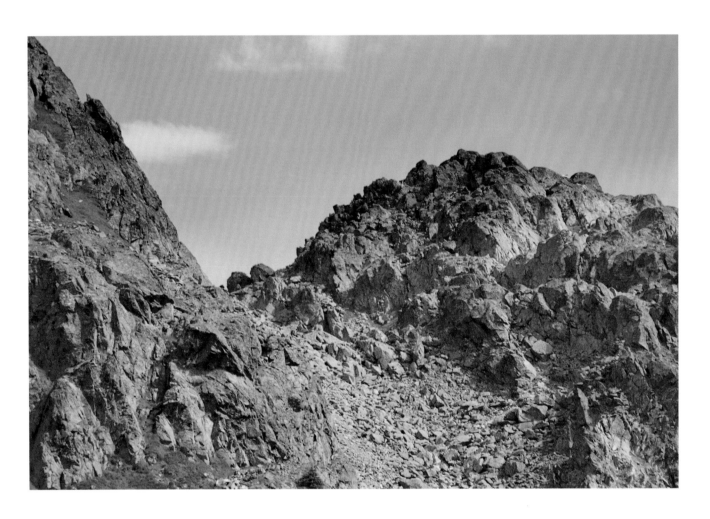

44. Nearing the summit and the international boundary.

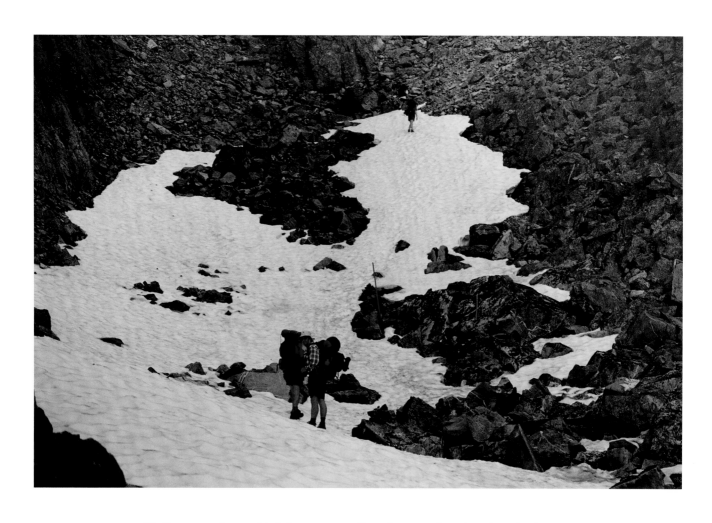

45. Snow patches and bright orange trail markers on the talus slope in August;
reminders of constant weather hazards near Chilkoot Pass.

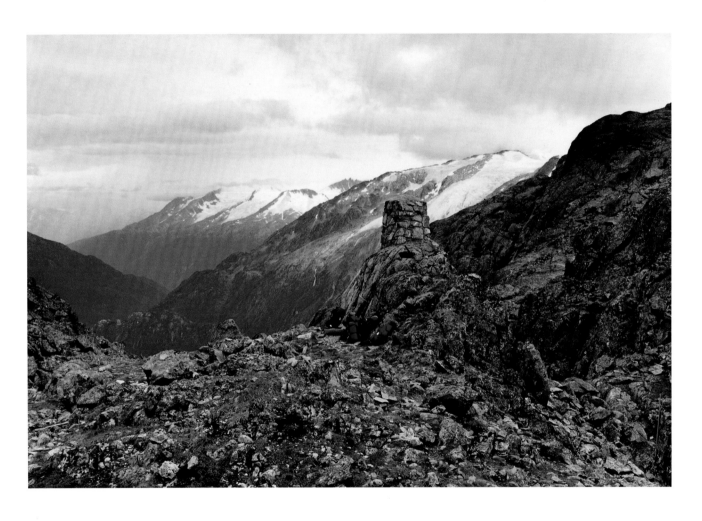

46. Rock monument at the summit and a spectacular view into Alaska
across the upper Taiya River valley.

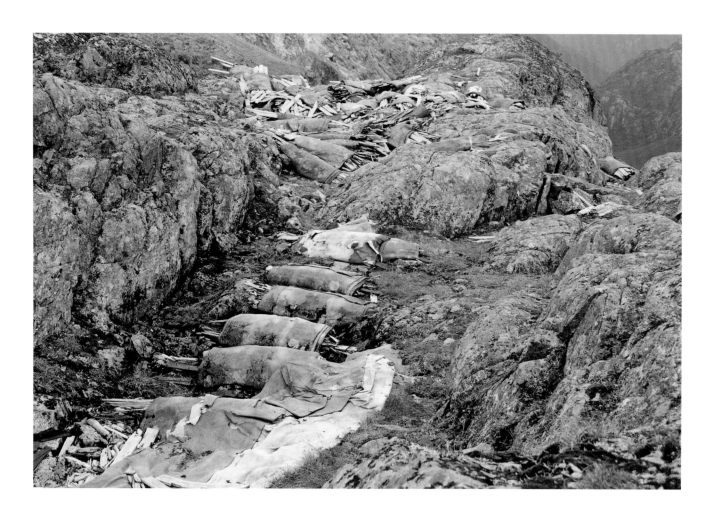

47. The remains of canvas and wood boats near the summit abandoned a century ago by a Klondike entrepreneur.

# Chilkoot Summit to Happy Camp
## Mile 16.5 (km 26.6) to mile 20.5 (km 33.01)

Beyond the summit, the warden station is an incongruously welcoming sight, hitting the imagination like a surprise survivor in a devastated rocky wasteland (Photograph 48). The cabin looks out upon a glaciated landscape in vivid contrast to the scalloped depths of the Taiya Valley (Photographs 49 and 50). The foreground Crater Lake, the trail wandering off towards an endless horizon of ridges and mountain tops – perfect imagery for a vast interior wilderness where access and egress was so jealously guarded and for so long by the Tlingit. Is there some catharsis engendered by this sight – relief in making Chilkoot Pass and witnessing a canvas seemingly so easy to traverse after the (now hidden) rigours of Long Hill and the Golden Stairs? Our group behaviour suggested so, perhaps in the expectation that Happy Camp was but around the far ridge line, a short trudge on legs readjusting to fairly level walking on thin soil, small rocks, and snow patches once the steep drop to Crater Lake was completed.

The first site of significant historic interest en route to Happy Camp is the Stone Crib. The crib is a tramway terminus. In Photograph 51, the collapsed timbers from the structure are evident above the waters of Crater Lake.

During the gold rush summer season, wagons were used to haul supplies beyond here. At least 150 horses and mules owned by the commercial packers were stabled in a meadow beside Crater Lake. At the north end of the lake, supplies were transferred to colourfully painted wagons or sleighs and transported to Long Lake. From there, boats carried freight across Long Lake to a wharf near the Deep Lake campsite. Over one hundred buildings and tents were located near Long Lake landing during the summers of 1898 and 1899.

This section of the trail is in the open alpine tundra as it follows along the east side of Crater and

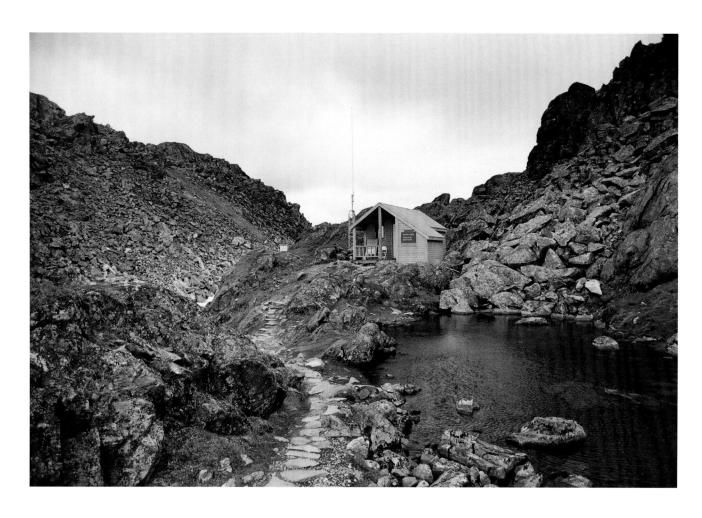

48. The Parks Canada warden station lies just beyond the summit,

a welcome sight in an emergency.

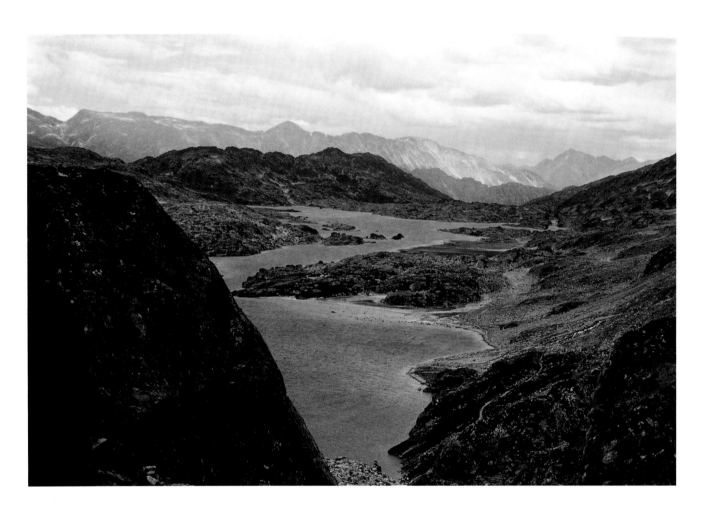

49. Northwards from Chilkoot Pass, British Columbia presents a watery
and rocky face as the trail wanders beside Crater Lake.

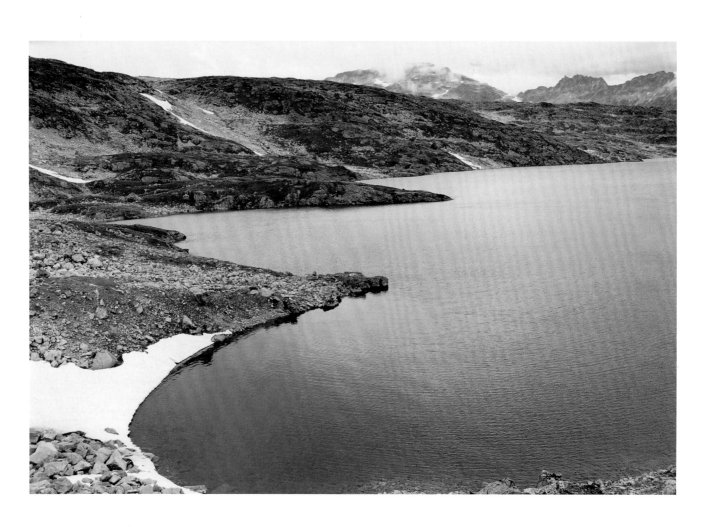

50. Crater Lake, British Columbia.

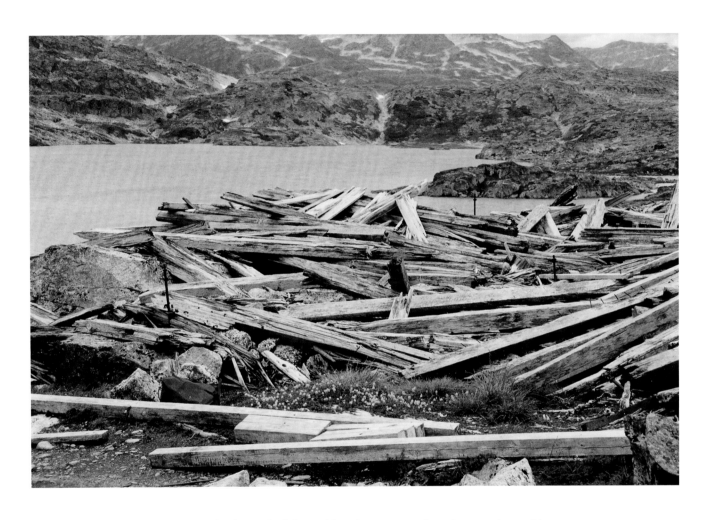

51. Stone Crib, the end of the gold rush tramway; from here mules and horses carried supplies downslope to Crater Lake.

Morrow lakes. These alpine lakes were formed when mountainside glaciers melted. The vegetation consists largely of moss and lichen on the glaciated boulders. Dwarf shrubs and willows are common along the trail. Occasionally, the trail passes through areas of shattered rock (Photograph 52). In no time, the scene will change to an uncontained stream untidily spewing across a section of trail (Photograph 53). Granite boulders along the trail originated in a batholith, a large reservoir of molten magma that invaded the earth's crust from considerable depth and then slowly cooled. Granite is exposed when overlying materials are eroded away. The process of mountain building in this area likely took place during the last fifteen million years. The arc of the mountains stretches from southern Alaska through the St. Elias Range of Kluane National Park to merge with the northern coast mountains of British Columbia. Nowhere else in North America can you hike along a trail from a coastal rain forest to a subarctic interior and encounter a granite plateau, relatively unchanged since the last ice age.

In the open, rocky alpine environment, it is possible to catch sight of the local wildlife. We saw willow ptarmigan (*Lagopus lagopus*), ground squirrels, and marmots near the trail. One ptarmigan perched quietly on a boulder unfazed by our proximity (Photograph 54). Large beds of the bright pink dwarf fireweed (*Epilobium angustifolium*) were in bloom and provided a vivid contrast to the grayish tones of rock that continued to dominate the landscape hues.

Most backpackers we spoke to at Happy Camp said they were very tired or exhausted by the day's effort. Many arrive at the campsite in a dampened condition, and the small shelter (Photograph 55) exhales the odours of wet clothes and food as successive parties crowd into the limited space. Prospectors crossing into Canada once rested and relaxed here. Many male Klondikers were made "happy" from the availability of a bed, warm meals, and "female companionship."

Happy Camp has two distinguishing features to benefit today's backpackers. There is a closet at the back of the shelter to store food away from the tents rather than the more usual food pole. Happy

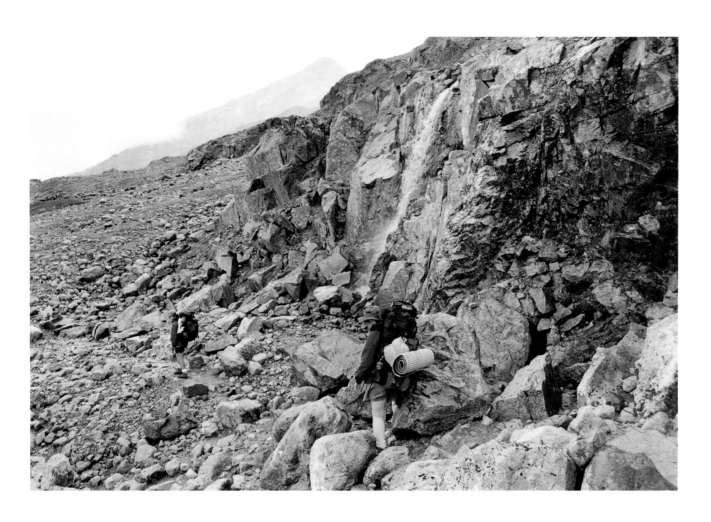

52. Spray from a waterfall refreshes backpackers as the trail edges past Crater Lake.

53. Watercourses that splay across the trail test the waterproofing of hiking boots.

54. A ptarmigan sits camouflaged among the rocks,

testament to the alpine environment as wildlife habitat.

55. Sight of the Happy Camp shelter convinces today's backpackers

that the resting place was aptly named by stampeders.

Camp also features a unique outhouse on wheels (Photograph 56). When we had checked it out, we acknowledged the establishment to be a very fine affair, worthy of the constant attention it was receiving. Each year, Parks Canada flies out the contents of the outhouse by helicopter. The vegetation at Happy Camp is sparse (Photograph 57), and, as we had near the start of the trip, we again found a perfect specimen of the deadly poisonous fungus fly agaric (*Amanita muscaria*) surrounded by Alaskan mountain heather (*Cassiope stelleriana*) and other alpine flowers scattered among the boulders (Photograph 58).

56. Happy Camp's unique outhouse on wheels adds to the iconography

and mystique of the trail biffy.

57. Low growth spruce provides a modicum of shelter for tenters at Happy Camp.

58. The poisonous fungus fly agaric (*Amanita muscaria*), surrounded by mountain heather, reappears along the trail (compare with Photograph 3).

# Happy Camp to Lindeman City
## Mile 20.5 (km 33.0) to mile 26.0 (km 41.8)

During the winter and spring of 1897–98, the Klondike prospectors continued their trek from Happy Camp over frozen lakes and creeks. The trail from Happy Camp soon follows a series of switchbacks to attain Long Lake Ridge, but thereafter the trail is on gentle grades and is easy to walk on. The trail follows the east side of Long Lake before crossing to the north side of Deep Lake. Various artifacts lie along the way (Photographs 59-62). The descent from the ridge to Deep Lake campsite where the forest appears is particularly pleasurable. A wooden footbridge crosses the creek joining the two lakes at mile 23.0 (km 37.0) (Photograph 63). On the trail beyond the campsite, an arresting and obviously much examined sight, are the remains of a sled and the skeleton of a boat (Photograph 64). Moose Creek flows from Deep Lake creating rapids in an imposing canyon (Photographs 65 and 66). The boreal forest hints that it may shelter us all the way from Deep Lake campsite to Lindeman City, but the promise is fulfilled only when we reach the gentle arc of trail that parallels Moose Creek. As Deep Lake fades behind us, the mountain shoulder and a forest of pine, fir, hemlock, and other trees form a wind break, and the underfoot trail becomes a mixture of pine needles and earth, the hardened surface behind us now forgotten. Trail vigilance has to be maintained, however. Pine needles muffle footsteps, a lesson reinforced as we came upon a black bear near Lindeman.

Lindeman City lies on the shore of Lake Lindeman at mile 26 (km 41.8) and 1,000 feet lower in elevation than Happy Camp. Lake Lindeman is a beautiful alpine lake more than ten miles long (Photographs 67 and 68). The Lindeman area was used by prospectors and British Columbia and Yukon travellers for at least a decade before the stampede. Most likely, it long had been a campsite for aboriginal people, similar to sites that have been recorded between this lake and Bennett Lake. Lake Lindeman was named for Dr. Lindeman, a German botanist. He was one of six men sent to Alaska to

59. A pick and shovel left behind by a Klondike gold seeker on the trail between Happy Camp and Deep Lake.

60. A horseshoe lies rusting along the trail.

61. A frying pan and boot soles discarded along the trail near Deep Lake.

62. These skids are skeletal reminders of a Klondike sled used to transport supplies.

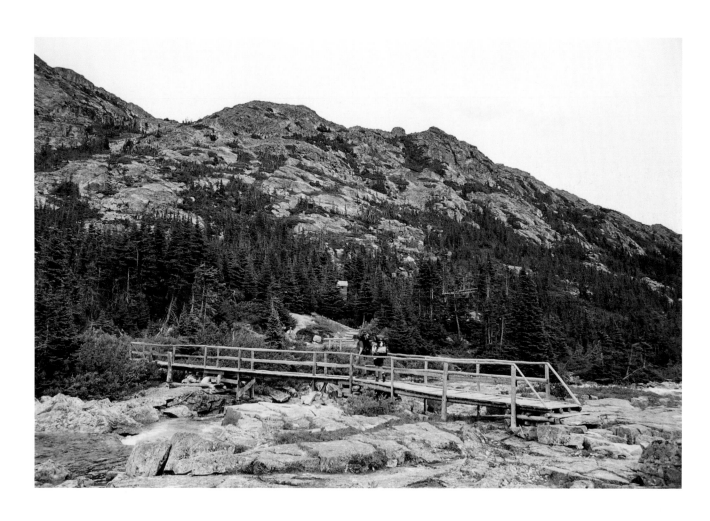

63. The creek bridge crossing between Long Lake and Deep Lake

marks the trail's re-entry to a tree-covered landscape, the boreal forest.

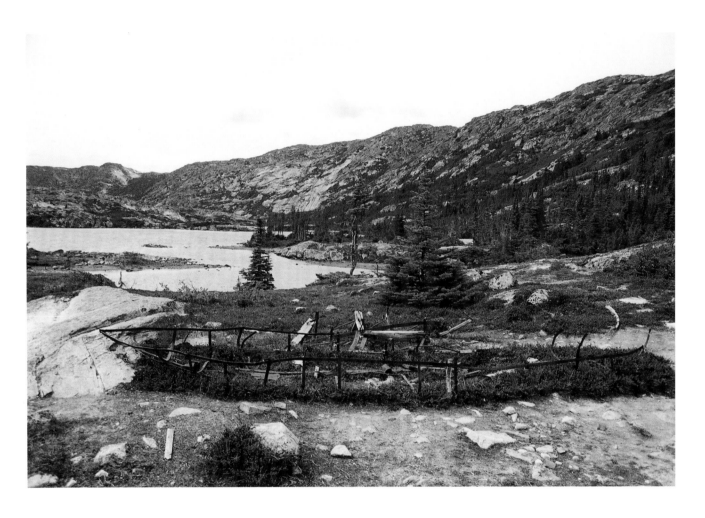

64. The remains of Klondike boat hull and sled, abandoned beside the trail on the north side of Deep Lake. The steel ribs were bolted together and the craft was covered with canvas.

65. Rapids lead to a gorge as mountain waters tumble and roil towards Lake Lindeman.

66. Between Deep Lake and Lindeman City, the landscape canvas provided by Moose Creek
becomes close and intimate, but no less enthralling.

ascertain the number, character, and disposition of the aboriginal people, their relations with each other, their feelings toward the Russian government and their attitude toward the United States. He was to study the natives, their lifestyle, and their method of communicating between regions. He was also to report on the type of weapons used by the natives and where and how they secured them.

During the gold rush, travellers camped at Lindeman and built boats or rafts while waiting for the ice to melt in the spring. The ephemeral stampede canvas tent city of Lindeman was located on a point of land reaching into the lake. It was the first good campsite beyond the summit. Early in September, 1897, 200 tents were scattered through the trees along the upper lakeshore. More than 400 men and women sawed wood for boat timbers. By freeze-up, 1,000 people camped at Lindeman, and the number grew through the winter. In the spring of 1898, Lindeman was a noisy community of 4,000 people. A steady stream of stampeders and horses packed freight along the main street between the canvas walls of hotels, bakeries, and saloons. By late May, 1898, the North-West Mounted Police counted 778 boats under construction.

The Lindeman area was more heavily timbered than near Bennett. Many trees were cut along the lake and from valley slopes, then converted into boats, shelters, or firewood. Businesses serving the population included sawmills, hotels, boat builders, eating establishments, and a bakery. The only full-time residents of Lindeman City were members of the North-West Mounted Police, the families of packers, and some business people. During the summer, a small steamer and several barges carried freight and passengers across the lake. In the winter, the frozen lake provided a sled highway to Bennett. After the stampeders passed, there was no reason for Lindeman City to continue, and, by the fall of 1899, the site was deserted. The landscape will take longer to recover. Though today's forest may seem quite dense in contrast to the barren heights, many decades will pass before it is restored to the maturity and appearance of pre-stampede days.

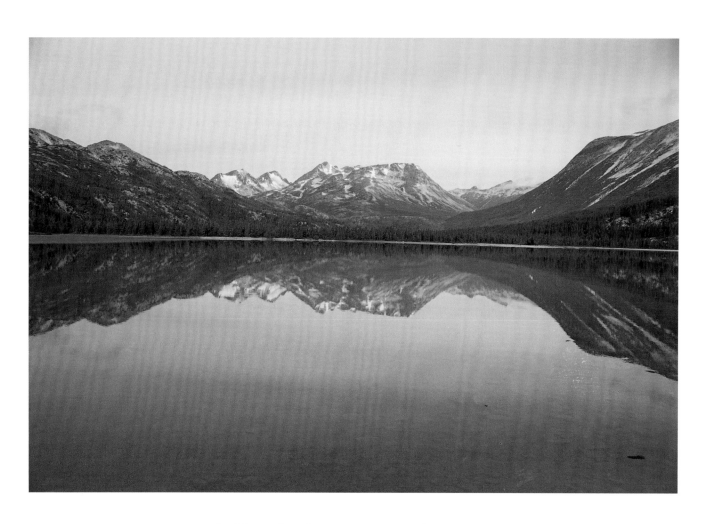

67. Mountain reflections on upper Lake Lindeman.

68. The beach on Lake Lindeman at Lindeman City campsite.

69. Parks Canada warden station at Lindeman City. This designated camping area with its sandy beaches and picnic tables is one of the most pleasant camping spots along the trail.

70. A Parks Canada's Interpretive Exhibit on the Klondike Gold Rush
is presented in a canvas-topped shelter at Lindeman City.

71. Debbie was happy to soak her sore feet in the cool water of Lake Lindeman.

72. Sawing firewood next to one of the warming shelters at Lindeman City.

73. More outhouse iconography – the log establishment at Lindeman City.

74. Many of the gold seekers did not reach Dawson; the graveyard at Lindeman City

is the final resting place for some stampeders.

Today Lindeman is the location of a Parks Canada warden station (Photograph 69) and a Chilkoot Trail Gold Rush interpretive tent exhibit (Photograph 70). Full marks to Parks Canada for locating the exhibit here. At Lindeman, we were relaxed and more responsive to details about the route, now that we, too, had almost completed it. Moreover, Lindeman is one of the most comfortable campsites along the trail, with beaches to soak your feet, log cabin cooking shelters, and yet more variety in outhouse architecture (Photographs 71 to 73). During our visit, bears were seen near the campsite. Artifacts, a nearby graveyard, log cabins, and stumps scattered through the woods and along the trail attest to a once bustling community (Photograph 74).

## Lindeman City to Bennett
### Mile 26.0 (km 41.8) to mile 33.0 (km 53.1)

A bridge over Moose Creek led us onward to the east side of Lindeman Lake (Photograph 75). We looked back on the campsite (Photograph 76) and for a moment in the complex of white canvas tents we could visualize the site as it was a century before. Before us were a variety of trail conditions, from bare earth (Photograph 77) to hard rock (Photograph 78). An important landmark along the trail is Bare Loon Lake (Photograph 79). Just north of the lake is the cut-off trail to the White Pass & Yukon Route railroad tracks for those who do not wish to finish the hike at Bennett but instead hike out to Log Cabin. We continued past a trapper's cabin towards Bennett (Photograph 80). Our final steps to Bennett were through what can only be described as a sand dune forest (Photograph 81), adding one final dimension to the range of walking surfaces. The stampeders also had found a challenge in this area. The nearby rapids of One Mile River (Lindeman Creek) between Lindeman and Bennett lakes were serious obstacles. Despite instream improvements and the construction of a portage tramway, most travellers preferred to start their river journey from Bennett.

75. Building the Chilkoot Trail has produced sturdy and sometimes intriguing bridge structures.

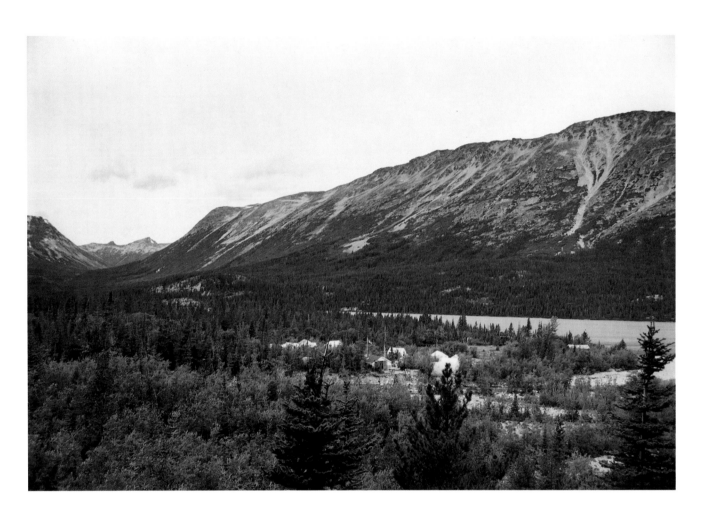

76. Looking back to Lindeman City, the modest canvas covers are a reminder that once the site was yet another historic tent city.

77. In places, compositions of trail features and their immediate environment become local landscape masterpieces.

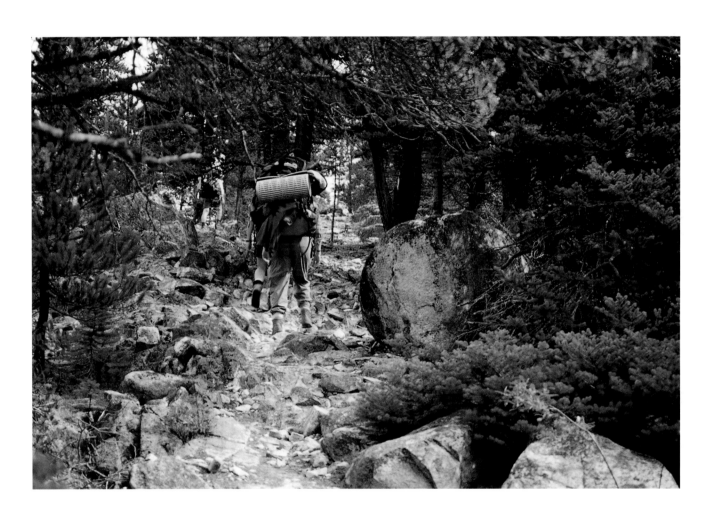

78. The trail east of Lake Lindeman moves over extensive rock surfaces;
small cairns serve as useful trail markers.

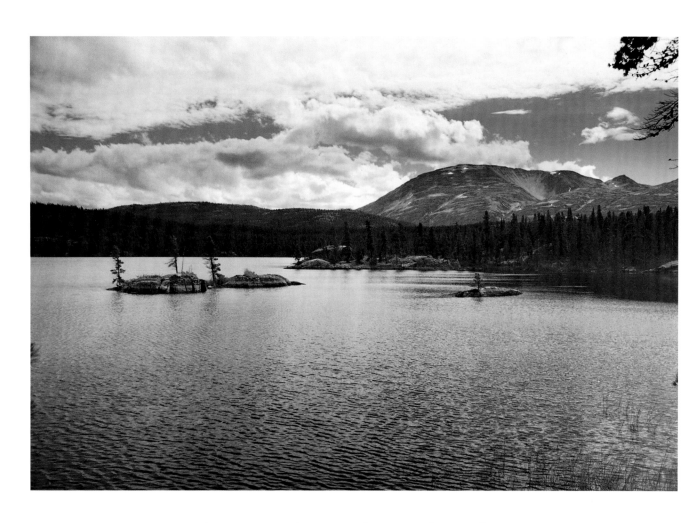

79. Bare Loon Lake, a tranquil spot near the cut-off trail
to the railway corridor and Log Cabin.

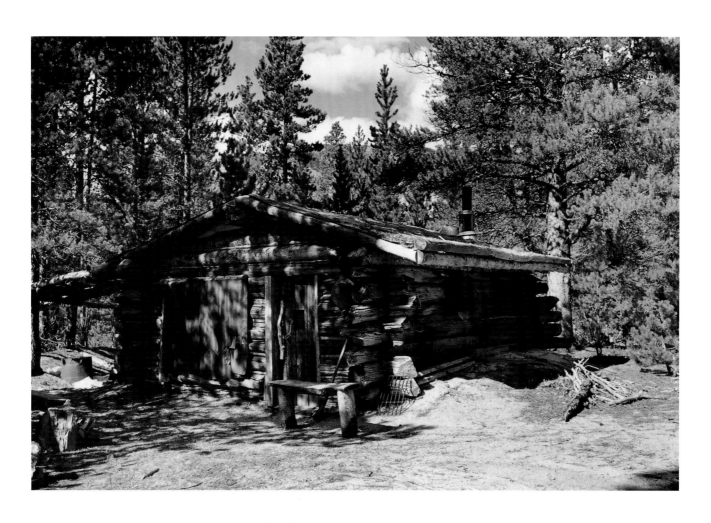

80. A trapper's cabin on the trail.

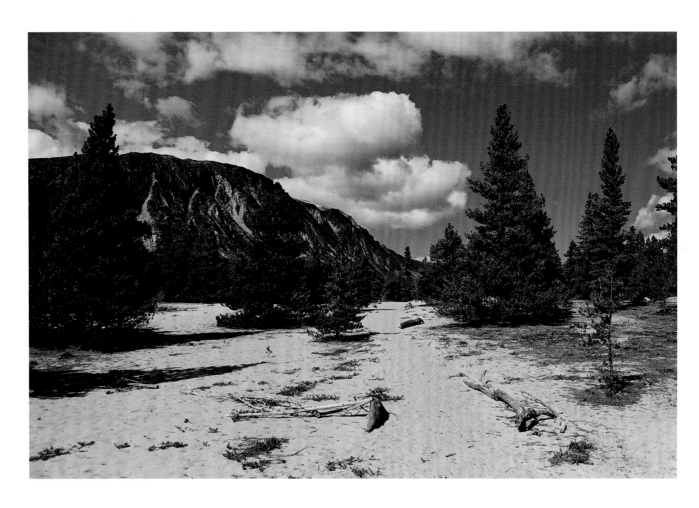

81. Extensive sand dunes between Lake Lindeman and Lake Bennett
create yet another fascinating trail landscape.

# Bennett: The End of the Trail
## Mile 33.0 (km 53.1)

Finally, we reached Bennett. This is a glorious location, a fitting conclusion to hiking the Chilkoot Trail (Photographs 82 and 83). Ironically, perhaps, in light of past boundary disputes, the place was named after James Gordon Bennett of the *New York Herald*. Bennett was a focal point for Klondike stampeders along both the Chilkoot and White Pass trails. The town's population mushroomed to 20,000 as prospectors built their boats and waited for the ice to melt. Shortly after the ice broke on May 29, 1898, seven thousand vessels sailed for Dawson, their crews bound largely for disappointment and more than a few disasters. Unlike the other trail communities, which died in 1898, Bennett continued briefly as a large, bustling town. Hotels, stores, and shipping offices were built near the docks (Photograph 84). A pattern of streets emerged. Contributions from the public and volunteer labour helped build the St. Andrew's Presbyterian Church (Photograph 85), the only gold rush building still standing in Bennett today. The town continued to thrive in 1899 with arrival of the railway from Skagway. Large amounts of Klondike freight were transferred from the railroad cars to boats at the Bennett docks. In the following year, when the railway line was completed to Whitehorse, the town lost its reason to exist and quickly withered, other than at Bennett Station.

The campsite is located amidst the sandy surrounds of old Bennett (Photograph 86). It is a grand place to have the final evening's meal (Photograph 87), to hoist the food bags and the garbage one more time (Photograph 88), and, in that final surrender, to snooze before the glories of Bennett Lake (Photograph 89). For those of us on the trail in 1998, the Chilkoot Sourdough Bakery was a centennial bonus (Photograph 90). But there was no train on that particular day, and so loading up on pancakes and coffee seemed an appropriate indulgence prior to tackling 6.8 miles (11 km) of railroad ties that would take us out to Log Cabin.

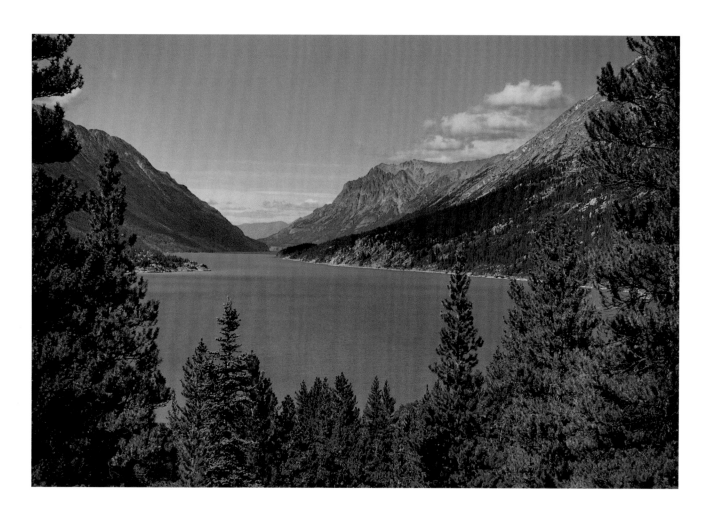

82. Lake Bennett surely is one of the most beautiful water bodies in northwestern North America.

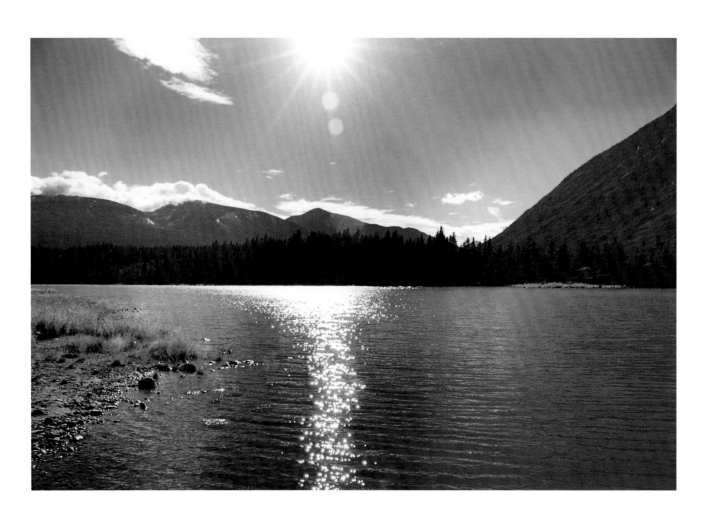

83. The sun's reflection on Lake Bennett.

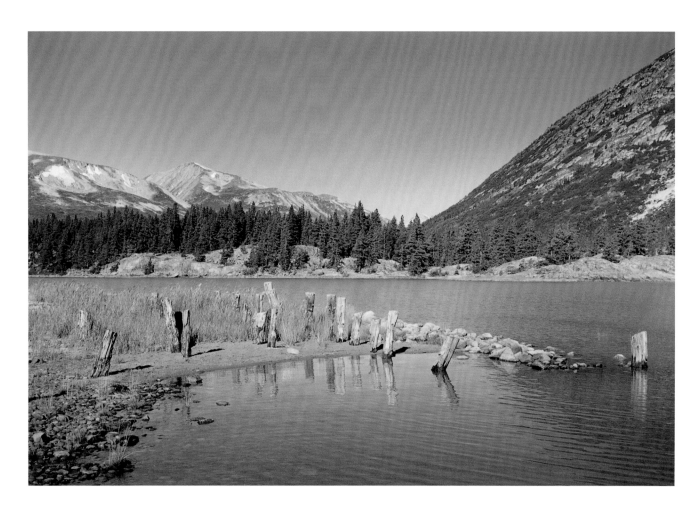

84. An old wharf on Lake Bennett at the site of Bennett City.

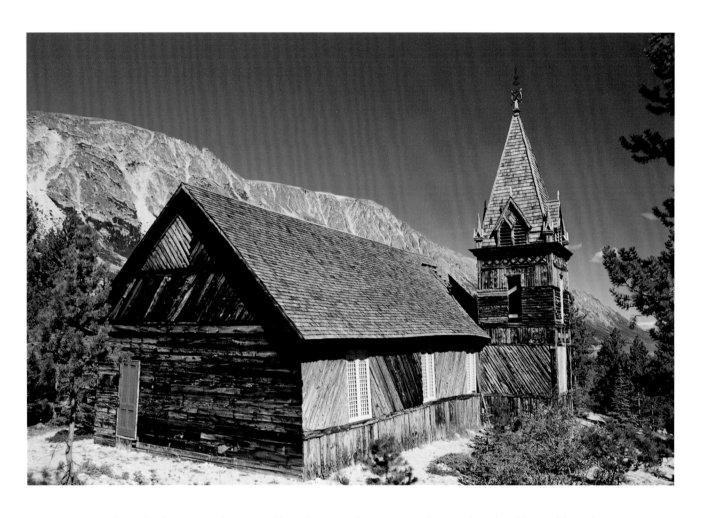

85. St. Andrew's Presbyterian Church, erected at Bennett during the Klondike Gold Rush.

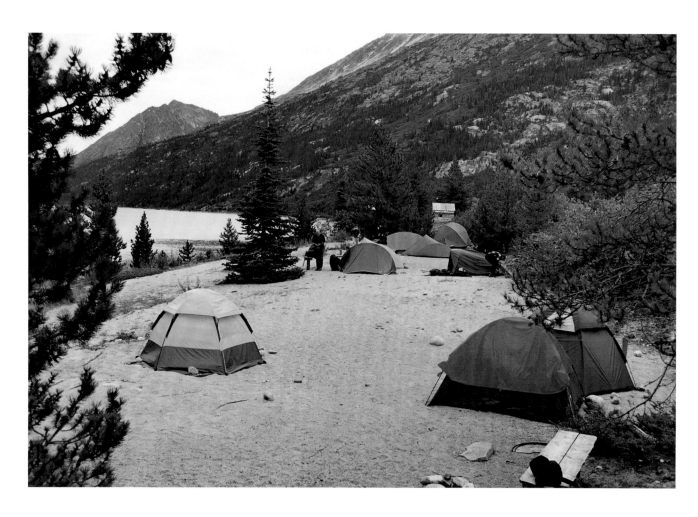

86. The designated campsite on the south shore of Lake Bennett.

87. The final meal on the trail is a poignant affair: an exotic mix of leftovers or a cherished treat accompanied by the omnipresent garbage bag and food cache hoist rope.

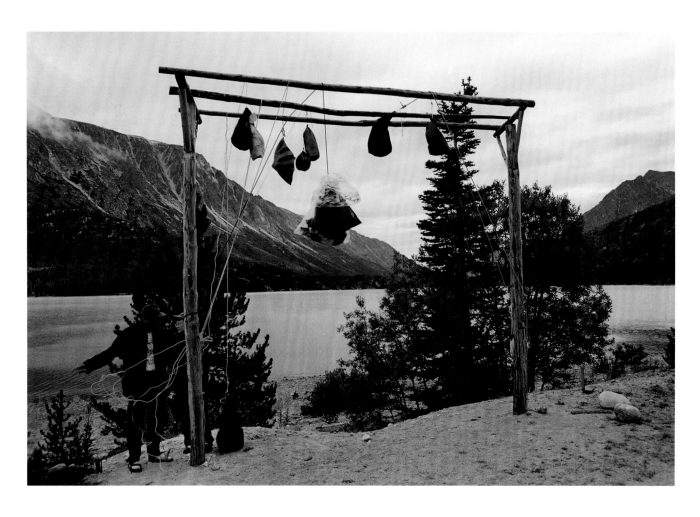

88. A food cache at the Bennett campsite – an essential daily ritual to discourage bears from campsite habituation.

89. Trail companions caught in a moment of profound reflection; more likely they are asleep.

90. The centennial Chilkoot Sourdough Bakery at Bennett in 1998; great pancakes and coffee, with an electric fence to discourage bear diners.

# Leaving the Trail:
## Bennett to Skagway/Whitehorse

There are three options available to exit the Chilkoot at Bennett – by foot, by boat, and by train (Photographs 91-99). From Bennett Station, the WP & YR railway will return hikers to Skagway during the summer hiking season. The daily service, begun in 2000, the railway's own centennial year, has replaced the previous periodic weekly service, and the trip is an intriguing way to complete one's appreciation of the turn-of-century development of routes through the two mountain passes. The White Pass route remains as spectacular as when first built. The journey makes abundantly clear why the Chilkoot Pass was so rapidly abandoned by 1900. There is a small but delightful twist on the transportation history of the area in that the railway company has adapted an open baggage car to transport the backpacks of those who have crossed Chilkoot Pass back across White Pass to Skagway. Regular train passengers given to delicate senses doubtless appreciate similar arrangements for the more rustically inclined owners of these same backpacks! The latter are assigned their very own railcar!

An alternative arrangement is to continue the route of the stampeders by water taxi to Carcross, Yukon. This means of departure from Bennett has merit in that this lake was but the start of a long float along the Yukon River system to Dawson and imparts a sense of the continuing adventures of the stampeders. Time spent at Carcross can only add to appreciation of the life and times of that era.

For those who want to or must, the Chilkoot Trail can be exited by foot. This entails a continuous uphill hike along the route of the WP & YR to Log Cabin on the Klondike Highway. Some of us followed this route. The experience in itself is not particularly rewarding – unless one has a thing for railroad ties on a narrow gauge railway – but there are some attractive distance views to the head of Lindeman Lake. The cold beers awaiting us in our vehicle at the Log Cabin parking lot were a welcome promise of more to come in Skagway. Log Cabin had the typically abbreviated history of regional

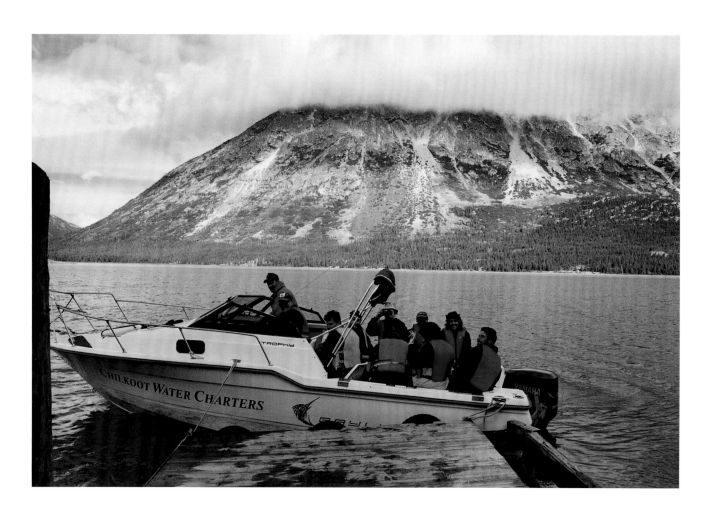

91. A water taxi transports backpackers along Lake Bennett to a vehicle transfer site
at Carcross, en route to Skagway or Whitehorse.

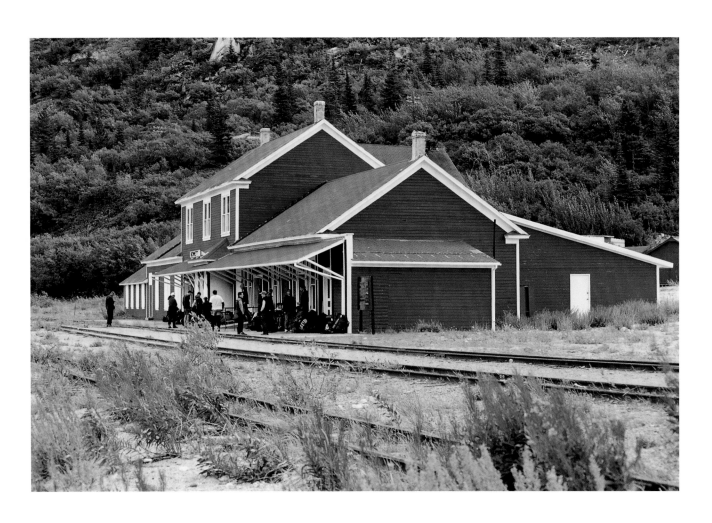

92. The train station at Bennett.

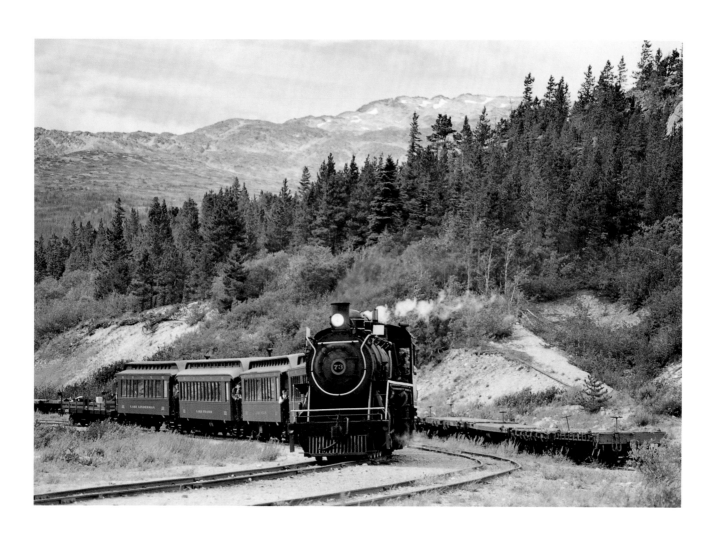

93. The White Pass & Yukon Route train arrives at Bennett Station.

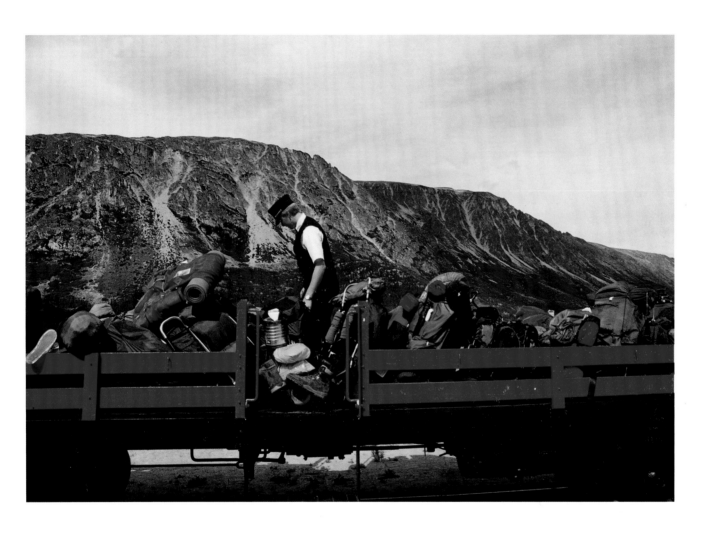

94. The conductor loads backpacks for a forty-one-mile (66-km) ride
back to Skagway, Alaska, via the White Pass route.

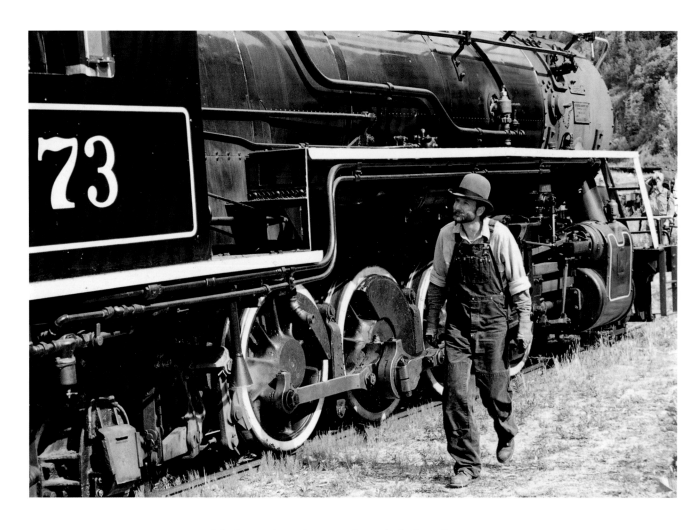

95. An engineer inspects the train before departure.

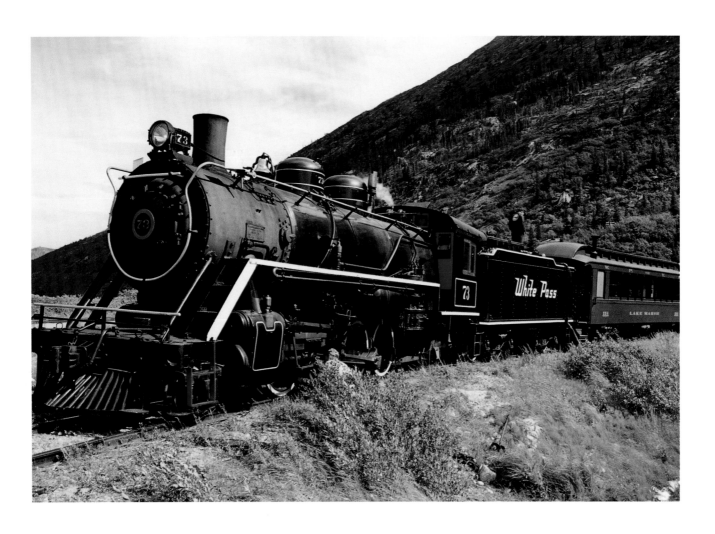

96. The locomotive, ready for departure, adds to the Chilkoot experience on "the single most spectacular one-day railway journey in Canada" (Berton, in Minter, 1988).

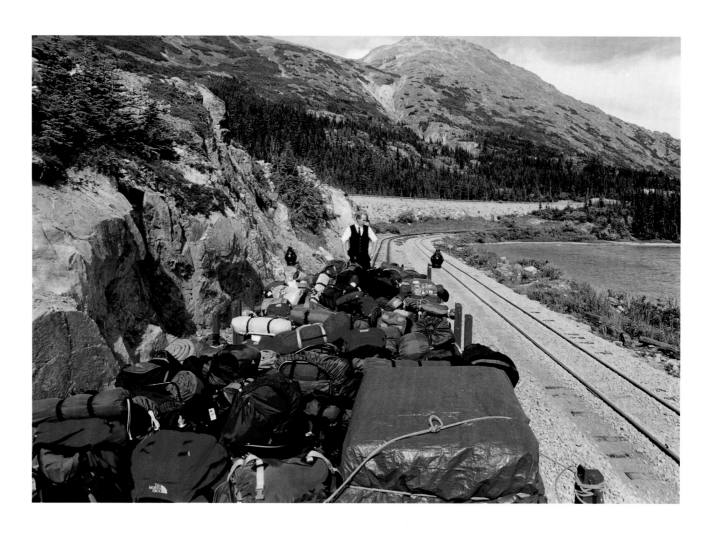

97. An impressive array of backpacks on the train: these modern accoutrements remind us
that packing is a centuries-old tradition on the Chilkoot Trail.

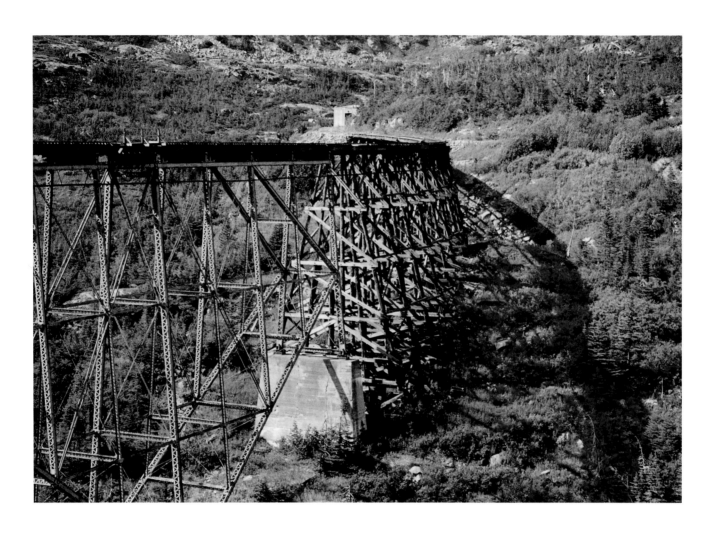

98. The historic Dead Horse Gulch.

99. The White Pass "Trail of 98."

gold rush communities now very familiar to us. It was the last staging point on the White Pass trail before reaching Bennett and, in the eyes of one traveller, seemed the "dirtiest place on earth" (Sinclair, 1978: 92). Tree stumps are all that remain of a community whose unsavoury reputation was exacerbated through having been sited on swampy ground. Only when freeze-up and snow came did conditions improve on both the White Pass trail and at Log Cabin. It was here that the NWMP post played a boundary role similar to that on Chilkoot Pass, though the boundary was some distance away. Regardless of the police presence, the community held a reputation as gruesome as any associated with the gold rush. Here, in a final sobering commentary, romantic thoughts about the gold rush could be dashed in a dose of reality from Reverend John A. Sinclair. It was he who "preached the funeral sermon at the grave of Soapy Smith and then for Frank Reid, the man who, as the head of a vigilante posse of citizens, duelled with the outlaw, Soapy, in the lawless Alaskan seaport town of Skagway" (Sinclair, 1978: n.p.), and who then planned and with volunteer help, built St. Andrew's Church in Bennett.

> *Such a filthy hole I never have seen as that group of shacks and tents at 'Log Cabin'. Loathsome-looking dogs slunk around the tents. They were red-eyed and diseased-looking through gorging themselves on decayed horse-flesh. Greasy and slatternly women, begrimed and ragged children and rough, shifty-eyed men wallowed in a sea of mud and filth. All this, plus the terrible stench of dead horses, more noticeable in the warmer temperature, spurred us on and fired us with renewed energy to get away from there with all haste.*
> *(Sinclair, 1978: 93)*

Upon our return to Skagway, we soaked our feet in an antique bathtub at the Golden North Hotel (Photograph 100). Then it was time for a cold beer at the Red Onion. Later, we joined crowds

229

thronging the town's wonderfully maintained historic district, which forms part of the Klondike Gold Rush International Historical Park. Most visitors were from cruise ships docked nearby (Photograph 101), an international population dropping upon an Alaskan shore and buying souvenirs where once others, equally constrained by time, had outfitted for the trail. The scene for us completed the imagery we had been building up over several days of past landscapes and societies. It was confirmation that recognition of Chilkoot Trail as ecotourism icon was justified. The occasion was also one to express appreciation for Canadian and American parks authorities and local communities whose efforts sustain the commemorative integrity of Chilkoot Trail, and travellers on the route in whose hands its future welfare lies.

100. Skagway's Golden North Hotel dates from 1897: quality accommodation in a historic hotel with a hot bath to soak sore feet, and time to enjoy a cold beer and hearty meal.

101. Cruise ship at Skagway; reminiscent of the gold rush armada of a century ago,

these vessels debouch thousands to Skagway's adjacent streets, stores,

and transportation modes in a seamless display of mass tourism.

# *Appendix*

# Planning to Visit, Planning to Hike?

The Chilkoot Trail entered the world's imagination through imagery of the impacts of rugged terrain, extreme weather patterns and melt water, muddy trails, icy snowfields, and deadly avalanches upon unprepared gold seekers. Reasons for perambulating the trail may have changed greatly since then, but the difficult natural conditions are still with us. The trail, as Parks Canada succinctly points out, is isolated, strenuous, physically challenging, and potentially hazardous. By the same token, it is extremely rewarding, providing spectacular scenery, transformations in landscape, and an incredible cultural heritage setting. Acquisition of up-to-date information, careful planning, physical conditioning, and carrying the correct equipment are therefore crucial to a memorable and safe trip. Accidents do happen each year, some requiring helicopter-assisted evacuation, and even on good days in summer considerable common sense and caution must be exercised.

We have provided below some information that should be helpful to anyone planning to visit the Chilkoot. The information should be used in conjunction with up-to-date information available from the national park services and other local authorities. Local resource management decisions, transportation arrangements, access conditions, tourism facilities, and regulatory requirements change with time. The Chilkoot Trail as the ecotourism experience of a lifetime should not be jeopardized through inadequate preparation for the long journey to northwestern North America or travel on the trail and its exit routes.

## Key Documents and Further Information

Two easy-to-read and informative pamphlets prepared by national park authorities are essential reading when planning to visit and hike Chilkoot Trail. The materials are: *Hiker's Guide to the Chilkoot Trail*, prepared jointly by Canadian Heritage Parks Canada and the U.S. National Park Service, and *Chilkoot Trail National Historic Site Hike Preparation Guide*, issued on an annual basis by Parks Canada. The purpose of the second document is to supplement and update the first.

Background material and further information may be obtained from:

Superintendent
Klondike Gold Rush
National Historic Park
P.O. Box 517
Skagway, Alaska
U.S.A. 99840
*Telephone:* (907) 983-2921
*Fax:* (907) 983-9249
*E-mail:* KLGO_Ranger_Activities@nps.gov

Department of Canadian Heritage
Yukon District
Parks Canada
205 – 300 Main Street
Whitehorse, Yukon, Canada
Y1A 2B5
*Telephone:* (867) 667-3910

# Reservations and Permits

Every person using and hiking the Canadian portion of the Chilkoot Trail requires a permit. Permit fees help offset the cost of trail and facility maintenance. Users without permits are subject to fines.

Backpackers may reserve their trail hiking dates by telephoning Canadian Heritage, Parks Canada, at:

1-800-661-0486 (calls originating in Canada and the United States)
1-867-667-3910 (local calls and calls from overseas).

Make your reservations Monday to Friday, from 8:00 a.m. to 4:30 p.m. Pacific Standard Time.

The trip permit is to be collected by noon on the day the trip begins; otherwise, the reservation for the entire trip is automatically cancelled – unless prior arrangements have been made.

In the interests of ecotourism and environmental stewardship, persons with reservations who no longer want to use them are requested to call and cancel the reservation.

Walk-in trip permits are issued on a first-come, first-served basis. Their availability cannot be guaranteed by Parks Canada. Cancelled reservations will be allocated at 1:00 p.m. each day. Reservations are not taken for day permits.

During the hiking season, backcountry permits can be paid for and picked up at the Trail Centre on Broadway near 2nd Avenue in Skagway, Alaska, from 8 a.m. to 6 p.m. (May and September) and 8 a.m. to 8 p.m. (June, July, and August). Phone: (907) 983-2921.

| | | |
|---|---|---|
| **Trip Permit:** | $35.00 per adult | *Fees are non-refundable* |
| (overnight) | $17.50 per youth (6-15) | *and are quoted in Canadian funds.* |
| **Season Pass:** | $105.00 | *Visa, MasterCard, cash,* |
| **Reservations:** | $10.00 | *or money order are accepted.* |
| **Day Permit:** | $5.00 | |
| | $2.50 per youth (6-15) | |

## Customs and Immigration

Travellers on the Chilkoot Trail cross an international boundary at Chilkoot Pass. Many will also cross the international boundary between Canada and the United States before and after their hike, depending upon the routes they take to reach the trailhead at Dyea and how they leave the area once they complete the hike. Travellers must carry appropriate identification throughout their Chilkoot Trail hike.

Travellers accessing or leaving Skagway via the Klondike Highway connecting Alaska with British Columbia and Yukon are required to clear Canadian customs at Fraser, B.C., or at Whitehorse, Yukon (if travelling south to north) or U.S. customs at Clifton, Alaska (if travelling north to south).

All hikers travelling north to south are required to register at the U.S. National Park Service Information Service in Skagway.

## Park Staff

Staff of the Canadian and U.S. national park authorities administer the Chilkoot Trail. Park staff are located in Skagway, Dyea, Sheep Camp, Chilkoot Pass, Lindeman City, and Whitehorse, as well as along the trail. Parks Canada and the U.S. staff conduct regular patrols along the trail from early June, when the trail is first marked for the summer hiking season, until the first week of September.

# Travel Plans

Travel to and from Chilkoot requires organization, first to reach and leave this part of Alaska, British Columbia, and Yukon, and second, in terms of getting on and off the trail. Importantly, all post-hike arrangements should be determined before setting out on the trail. Because availability and prices of various means of transportation services (boat, train, bus, shuttle) vary from year to year, contact should be made directly with the providers of the services.

Air and highway travel are preferred means to reach the Chilkoot area from distant locations. Whitehorse has an airport and the modern Klondike Highway connecting Skagway and Carcross to Whitehorse intersects with the Alaska Highway.

# Reaching Dyea

For persons arriving in Whitehorse, the road journey to Skagway can be completed by bus or rented vehicle.

To reach Dyea from Skagway, a distance of ten miles (16 km), travellers may use their own vehicle and park at the Dyea Campground, or engage private shuttle vans or taxies operating from Skagway.

Determine your trail exit plans when planning your trip to the trailhead. Consider these options: the private shuttle/taxies can provide transport at the end of the hike, from Log Cabin back to Skagway/Dyea; or arrange to have your vehicle taken to Log Cabin where it will await you at the end of the hike. If you arrive in two vehicles, leave one at Log Cabin and take the group in the second vehicle to the campground/parking area at Dyea.

# Leaving the Trail

You may leave the trail via the cut-off route from Bare Loon Lake to the White Pass & Yukon Route and from there to Log Cabin: or you can go to trail's end at Bennett and exit by foot, rail, or boat.

- Exit on foot to Log Cabin via the railway corridor.
- Exit by rail to Fraser (Canada Customs) or Skagway, where ongoing connections can be completed.
- Exit by chartered boat along Bennett Lake to Carcross, where bus connections can be made.
- The WP & YR has extended service from Bennett to Carcross: Check on seating availability.

# Heading South

Travellers who hike southwards can access Bennett or the trail (Bare Loon Lake) from Carcross, Log Cabin, or Skagway by reversing the alternatives set out above.

# Contacts

**Rail:**
White Pass & Yukon Route
*Telephone:* 1-800-343-7373
or (907) 983-2217
*Fax:* (907) 983-2734
*E-mail:* info@whitepass.net

**Boat:**
Bennett Charters
*Telephone:* (867) 667-1486

# Should I Hike the Trail?

The national park authorities provide guidance on who should hike the trail. Though relatively short in length, elevation gain along the trail, weather conditions and the change from trail conditions to more of a route along the way add considerable challenge to the thirty-three miles (53.1 km) to be travelled from trailhead to Bennett.

The park authorities also provide guidance on essential equipment/equipment checklist, safety, injuries, and evacuations, hiking/camping conditions, and winter travel.

*This trail traverses rocky and sometimes very steep snow-covered terrain and should only be attempted by persons who are physically fit and who are skilled in the areas of hiking and backpacking. Do not over-estimate your abilities on this challenging hike. Test your strength and endurance on shorter, less demanding backpacking trails prior to hiking the Chilkoot Trail. – Parks Canada*

# BIBLIOGRAPHY

Adney, E.T. 1900. *The Klondike Stampede of 1897-1898.* New York.

Bedard, Val and Judy. 1980. *A Pictorial Guide to the Chilkoot Trail.* Yakima, Washington.

Berton, Pierre. 1983. *The Klondike Quest, A Photographic Essay 1897-1899.* Toronto: McClelland and Stewart.

Berton, Pierre. 1987. *Klondike: The Last Great Gold Rush, 1896-1899.* Revised edition. Originally published in 1958. Toronto: McClelland and Stewart.

Canadian Environmental Advisory Council. 1991. A Protected Areas Vision for Canada. Ottawa: Minister of Supply and Services Canada.

Careless, Ric. 1997. *To Save the Wild Earth.* Vancouver: Raincoast Books.

Chicago Record Co., The. 1897. *Klondike: The Chicago Record's Book for Gold Seekers.* Chicago: Chicago Record.

Cruikshank, J. in collaboration with A. Sidney, K. Smith, and A. Ned. 1990. *Life Lived Like a Story.* Vancouver: UBC Press.

Ellenton, Sue. 1982. *Journey Skagway-Whitehorse. A Travellers' Guide to the Land and its People.* Whitehorse: Clifford Lee Foundation and the Yukon Conservation Society.

Emmons, G., and F. de Laguna. 1991. *The Tlingit Indians.* Seattle: University of Washington Press.

Federal-Provincial-Territorial Task Force. 2000. The Importance of Nature to Canadians: The Economic Significance of Nature-related Activities. Ottawa: Minister of Public Works and Government Services Canada.

Friesen, R.J. 1977. The Chilkoot: A Literature Review. Manuscript Report No. 20. Ottawa: National Historic Parks and Sites Branch, Parks Canada.

Greer, S. 1995. *Skookum Stories on the Chilkoot/Dyea Trail.* Carcross, Yukon: Carcross-Tagish First Nation.

Hems, D., and P. Nieuwhof. 1994. Bennett City: A Gold Rush Phenomenon. Research Bulletin No. 305. Ottawa: Parks Canada, Canadian Heritage.

Howe, Steve. 1995. "Hell Can't be Worse Than This Trail, Backpacker," *The Magazine of Wilderness Travel,* February, pp. 30-37, 93.

Ise, J. 1961. *Our National Park Policy: A Critical History.* Baltimore: Johns Hopkins University Press.

Krause, A. 1956. *The Tlingit Indians.* Trans. E. Gunther. Vancouver: Douglas & McIntyre.

McClellan, C. 1975. My Old People Say: An Ethnographic Survey of Southern Yukon Territory. National Museums of Canada, Publications in Ethnology, No. 6 (1) and No. 6 (2). Two volumes. Ottawa: National Museum of Man.

Minter, R. 1987. *The White Pass, Gateway to the Klondike.* Toronto: McClelland and Stewart.

Morrison, David R. 1968. *The Politics of the Yukon Territory, 1898-1909.* Toronto: University of Toronto Press.

Nelson, J.G., R. Butler, and G. Wall, eds. 1999. *Tourism and Sustainable Development: Monitoring, Planning, Managing, Decision Making, A Civic Approach.* 2nd ed. Department of Geography Publication Series No. 52 and Heritage Resource Centre Joint Publication No. 2. Waterloo, Ontario: University of Waterloo.

Neufeld, David. 1991. Boating on the Chilkoot. Research Bulletin No. 290, Parks Service. Ottawa: Environment Canada.

Neufeld, David, and Frank. Norris. 1996. *Chilkoot Trail: Heritage Route to the Klondike.* Whitehorse: Lost Moose.

Norris, Frank. 1996. Legacy of the Gold Rush: An Administrative History of the Klondike Gold Rush National Historical Park. Anchorage: National Park Service.

Olson, W. 1991. *The Tlingit: An Introduction to their Culture and History.*

Parks Canada. 1995. Chilkoot Trail National Historic Site, Winter Recreational Use Management Strategy. Whitehorse: Parks Canada.

Parks Canada. 1996. Chilkoot Trail National Historic Site, Commemorative Integrity Statement. Whitehorse: Parks Canada.

Parks Canada. 1998. Chilkoot Trail National Historic Site, 1998 Summer Recreational Use Study. Whitehorse: Parks Canada.

Penlington, Norman. 1972. *The Alaska Boundary Dispute: A Critical Reappraisal.* Toronto: McGraw-Hill Ryerson.

Rennicke, Jeff. 1997. Hiking the Chilkoot Trail, *National Geographic Traveler,* March/April, pp. 111-120.

Porsild, C. 1998. *Gamblers and Dreamers, Women, Men and Community in the Klondike.* Vancouver: UBC Press.

Rickard, T.A. 1944. *The Romance of Mining.* Toronto: MacMillan.

Robertson, William Norrie. 1930. *Yukon Memories.* Toronto: Hunter, Rose Co. Ltd.

Satterfield, Archie. 1978. *Chilkoot Pass: The Most Famous Trail in the North.* Revised and expanded ed. Originally published in 1973. Anchorage: Alaska Northwest Publ.

Satterfield, Archie. 1979. *Exploring the Yukon River.* Vancouver: Douglas & McIntyre. Originally published in 1975 as *The Yukon River Trail Guide.* Harrisburg, Pa.: Stackpole Books.

Scace, R.C. 1999. "An Ecotourism Perspective," in *Tourism and Sustainable Development: Monitoring, Planning, Managing, Decision Making. A Civic Approach,* Waterloo, Ontario: University of Waterloo, pp 81-110.

Scace, R.C., E. Grifone, and R. Usher. 1992. Ecotourism in Canada. Prepared for Canadian Environmental Advisory Council. Ottawa: Minister of Supply and Services Canada.

Sinclair, J.M. 1978. *Mission Klondike.* Vancouver: Mitchell Press.

Thorsell, J., ed. 1990. *Parks on the Borderline: Experience in Transfrontier Conservation.* IUCN Protected Area Programme Series No. 1. IUCN – The World Conservation Union, Gland, Switzerland.

Vickers, R. 1978. A Report on the 1977 Fieldwork of the Chilkoot-Archaeology Project. Research Bulletin No. 96, Parks Canada, Ottawa.

Weaver, D.G. 1997. "A Regional Framework for Planning Ecotourism in Saskatchewan," *The Canadian Geographer* 41(3): 281-93.

Wight, P. 1993. "Ecotourism – Ethics or Eco-sell?", *Journal of Travel Research* 31: 3-9.

Wilson, G. 1997. *The Klondike Gold Rush: Photographs from 1896–1899.* Whitehorse: Wolf Creek Books Inc.

Wright, A. 1976. *Prelude to Bonanza. The Discovery and Exploration of the Yukon.* Sidney, B.C.: Gray's Publ.

# Index

# About the Authors

**Allan Ingelson**, formerly an associate curator with the Glenbow Museum in Calgary, Alberta, has lectured at the University of Calgary since 1991. His research interests include environmental regulation, cultural and historical resource management and natural resources law. He makes his home in Calgary, Alberta.

**Michael Mahony**, a freelance photographer and avid hiker, has photographed the natural landscapes of Northern and Western Canada, the United States, and the Philippines. He resides in Calgary, Alberta.

**Robert Scace**, a geographer and practising environmental consultant for over thirty years, has studied a spectrum of environments, from the urban and industrialized to the wild and uninhabited. He has an abiding personal and professional interest in planning, management, human use, and facility assessment in national and historic parks, heritage river corridors, and other valued heritage landscapes. He lives in Calgary, Alberta.